From Egypt to Babylon

Paul Collins

From Egypt to Babylon

THE INTERNATIONAL AGE 1550–500 BC

HARVARD UNIVERSITY PRESS

CAMBRIDGE, MASSACHUSETTS
2008

©2008 The Trustees of the British Museum

Paul Collins has asserted the right to be identified as the
author of this work

First published in 2008 by The British Museum Press
A division of The British Museum Company Ltd

Library of Congress Cataloging-in-Publication Data

Collins, Paul.
 From Egypt to Babylon : the international age,
1550-500 BC / Paul Collins.
 p. cm.
ISBN-13: 978-0-674-03096-1 (alk. paper) 1. Middle
East–History–To 622. I. Title.
 DS62.23.C66 2008
 939'.402–dc22

 2008007142

Designed by Turchini Design
Printed by South China Printing Company

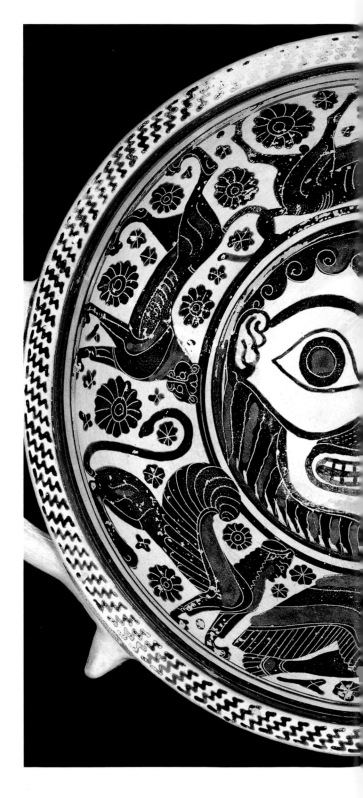

Contents

Acknowledgements

I would like to thank John Curtis for supporting the idea of my writing the book, and Jonathan Tubb for suggesting I approach British Museum Press. Rosemary Bradley, Carolyn Jones and Laura Lappin at British Museum Press have been a constant source of encouragement and enthusiasm, skilfully guiding the book to completion. In addition, thanks go to John Banks for his careful editing and Lisa Baylis for her new photography. Thanks are also due to my colleagues who read parts of the manuscript or fielded questions in their areas of expertise: Irving Finkel, Dominique Collon, Jon Taylor, Sarah Collins, and colleagues in the Department of Ancient Egypt and Sudan.
I would particularly like to acknowledge Lesley Fitton who read the entire manuscript and gave invaluable advice. Clifton Wilkinson also deserves thanks not only for reading the text as an 'interested layman' but for improving it through his skills as a writer and editor.

Chronology

	EGYPT AND NUBIA	EAST MEDITERRANEAN	AEGEAN WORLD	ANATOLIA	SYRIA	ASSYRIA	BABYLONIA	IRAN
1550	1535 Expulsion of the Hyksos		Shaft graves at Mycenae	Hittite expansion Hatti under pressure	Rise of Mitanni		1531 Fall of Babylon (Low Chronology) Kassites claim the throne	
1500	Thutmose I (1504–1492) Expansion into Nubia Thutmose III (1479–1425)	1450 Thutmose III captures Megiddo	Tholos tombs at Mycenae		Thutmose I reaches Euphrates		1480 Sealand conquered by Kassites	Sukkalmah dynasty ends
1450			Destruction of Minoan centres on Crete		Thutmose III reaches Euphrates	Mitanni conquers Ashur		
1400	Peace with Mitanni Amenhotep III (1390–1352)		Mycenaean palaces built	Tudhaliya II expands Hittite control Hatti under pressure	Mitannian peace with Egypt Mitanni under pressure	Ashur-uballit I (1363–1328)		Kings of Susa and Anshan
1350	Akhenaten (1353–1336) Tutankhamun (1336–1327)		Knossos destroyed Fortification of Mycenaean sites Uluburun shipwreck	Suppiluliuma I (1344–1322)	Suppiluliuma I conquers Syria		Kurigalzu II installed by Ashur-uballit I	Untash Napirisha
1300	Sety I (1294–1279) Ramesses II (1279–1213) 1258 Egyptian-Hittite treaty			Muwatalli treaty with Alaksandu of Wilusa 1258 Hittite-Egyptian treaty	Sety I conquers Kadesh 1274 Battle of Kadesh	Assyria annexes Mitanni		
1250			Lion Gate built at Mycenae	Troy destroyed by earthquake		Tukulti-Ninurta I (1243–1207)	1226 Tukulti-Ninurta I conquers Babylon	
1200	Ramesses III (1184–1153)	Ramesses III repels Libyans and Sea Peoples	Competition between Mycenaean centres Fall of palaces	Breakdown among Hittite vassals Troy destroyed Hattusa abandoned	Ugarit destroyed		Shutruk-Nahhunte ransacks Babylonia Last Kassite king	Shutruk-Nahhunte (1185–1155)
1150	Ramesses VI (1143–1136)	Egypt abandons Canaan		Kaska and Mushki on the move	Aramaean populations on the move	Tiglath-pileser I (1114–1076)	Nebuchadnezzar I (1125–1104)	Nebuchadnezzar I defeats Elamites
1100	Civil war Nubia lost Political division	Phoenician connections with Cyprus continue	Decrease in population on Greek mainland	Neo-Hittite dynasties	Assyria loses Syria			
1050		Iron working on Cyprus Philistines attempt expansion		Phrygians settle			Aramaean and Chaldaean populations settle	

	EGYPT AND NUBIA	EAST MEDITERRANEAN	AEGEAN WORLD	ANATOLIA	SYRIA	ASSYRIA	BABYLONIA	IRAN
1000	Libyans increasingly important	Tribal leaders extend their territories			Tribal leaders extend their territories			Earliest Luristan bronzes
950	Sheshonq I (945–924)	**930** Division of Israel and Judah **925** Sheshonq I raids Philistia and Israel	Greek contacts with east revive		Aramaean populations settle	Assyria revives	Chaldaean tribes dominate Sealand	
900		Phoenicians establish colonies **880** Samaria capital of Israel			Assyrian campaigns **853** Battle of Qarqar	Ashurnasirpal II (883–859) Shalmaneser III (858–824)	Nabu-apla-iddina	
850	Political division	Jehu of Israel (841–814)	Greeks adopt Phoenician alphabet	Rise of Urartu		Rebellion in Assyria	Babylonia kingless	
800			**776** First Olympic games	Argishti I (785–765) of Urartu Phrygia dominates central Anatolia				
750	Piy of Kush (743–712) Shabaqo (712–698)	**722** Israel conquered by Assyria	Orientalizing period Homer	Midas of Phrygia (720–690)	**732** Damascus conquered by Assyria	Tiglath-pileser III (744–727) Sargon II (721–705) Sennacherib (704–681)	Marduk-apla-iddina II of Bit-Yakin	Hasanlu destroyed
700	Taharqo (690–664) **664** Assyrian invasion Psamtek I (664–610)		Spartan conquest of Messenia	Gordion sacked by Cimmerians **652** Gyges of Lydia killed		Ashurbanipal (668–631)	**689** Babylon sacked by Assyria	Medes control important centres Battle of Til-Tuba
650	Necho II (610–595)	Josiah of Judah (640–609) Egypt and Babylon battle for region	Periander of Corinth (625–585)	Alyattes of Lydia (610–560)	**609** Fall of Harran	**612** Fall of Nineveh	**648** Babylon sacked by Assyria Nabopolassar (626–605)	Susa plundered by Assyria
600	Amasis (570–526)	**597** and **586** Fall of Jerusalem	Solon archon at Athens	Croesus of Lydia (560–547)			Nebuchadnezzar II (604–562) Nabonidus (559–539)	Cyrus II (559–530)
550	**525** Persian conquest	**539** Persian conquest	Reforms of Cleisthenes at Athens	**547** Persian conquest	**539** Persian conquest		**539** Persian conquest	Persian conquest of Media Cambyses (530–522) Darius I (521–486)

Preface

This book is intended to provide interested non-experts with a history of the years 1550–500 BC. The region of the world explored stretches from the Aegean Sea to the highlands of Iran and from central Africa to the Black Sea. This immense area was populated by diverse societies with a wide variety of cultures and languages, and it has been usual, even in studies that cover a similar geographical area, to investigate these largely independently of each other. This is necessary to avoid confusion when examining many of the fascinating aspects that distinguish them, such as religious beliefs, customs, political ideology and artistic expression. However, such approaches often make it difficult to grasp the broader picture of political and economic interaction across and between cultural regions which also helped to shape them. In this book I have attempted to integrate the political histories of many of these societies to provide an overview of interconnections through time.

Interaction between people over vast distances was nothing new. By 6000 BC obsidian (volcanic glass) was being traded between Anatolia and sites in southwest Iran and the eastern Mediterranean. A thousand years later, the spectacular blue stone lapis lazuli was being obtained from northern Afghanistan and passed along routes until pieces had travelled as far west as Egypt. Relatively large-scale movements of metal ores became increasingly important after 4000 BC. However, the first well-documented period of true internationalism began around 1550 BC when the wider region began to be linked as never before by military expansion, diplomatic exchanges and movements of goods and peoples over enormous distances, resulting in cultural transfers, technological and social revolutions, and political unity.

The complexities of reconstructing the ancient past mean that attempting a narrative history of the early eastern Mediterranean and Middle East is fraught with difficulties; indeed, it has been argued that the paucity of source material and the difficulties of interpretation make it impossible. None the less, at a general level, I believe it is possible to provide a historical survey which highlights the crucial interrelationships between states. This then is a political history – the source material for the period means that it is largely a story of 'kings and battles' – but interrelations were primarily driven by economic concerns and the demand for resources; their movement and acquisition

therefore play a central role in the account. Such interrelationships also influenced the cultural development of various societies as revealed by their material remains, especially objects of the elite who benefited most obviously from the international exchanges. The majority of the photographs which accompany the text are examples of such objects drawn from the rich collections of the British Museum – one of the few places in the world where it is possible to undertake on foot the kind of cross-cultural explorations attempted in this book.

I have tried to avoid footnotes as they distract from the narrative flow, although occasionally they are used to highlight debate over particular issues. Readers who are motivated to explore the original sources or other interpretations of the period in question are encouraged to investigate the publications with extensive bibliographies listed in Further Reading. The term Iraq (a name applied to the region of the modern country from at least the sixth century AD) is used in preference to the Greek term Mesopotamia which is becoming less meaningful for younger generations of readers. The geographical term Anatolia is used for the peninsula that is now occupied by the modern states of Turkey and Armenia. East Mediterranean refers to the coast of Syria and the modern states of Lebanon, Jordan, Israel and the territories of the Palestinian Authority. All dates are BC (BCE) unless otherwise indicated.

Problems of Chronology

Building a chronology for the ancient world is an extremely complex undertaking which involves combining 'relative' dating methods, such as the stratigraphy of archaeological excavations, with absolute chronologies based on calendrical and astronomical records obtained from ancient texts, and on scientific methods such as radio-carbon dating and thermoluminescence. Unfortunately, none of these approaches on its own is totally reliable, and the fragmented nature of the surviving sources means that the relationship between them is open to debate.

It is possible to reconstruct a reasonably precise outline of Egyptian, Assyrian and Babylonian chronology based on surviving king lists and other written documents back to around 1400. In addition there are other helpful data such as the record of a solar eclipse recorded in an Assyrian document that can be equated by modern astronomers with one that took place on 15 June 763. However, there remain disagreements about the length of certain reigns as well as debates about reconstructing periods of political breakdown when more than one king might have been ruling at the same time.

Before 1400, chronologies are much less precise, largely reflecting the poorer survival of useful evidence. As a result the debates over an absolute chronology for both Egypt and Babylonia are much fiercer. For example, some certainty would appear to be provided by the so-called 'Venus Tablets of Ammisaduqa'. These clay cuneiform tablets purport to record the appearances of the planet Venus during the early years of the reign of Ammisaduqa, the second to last ruler of Hammurabi's dynasty at Babylon. Modern astronomers have used the information in the tablets to work out the exact date when Venus would have been visible. Unfortunately, there are a number of possibilities. Combining

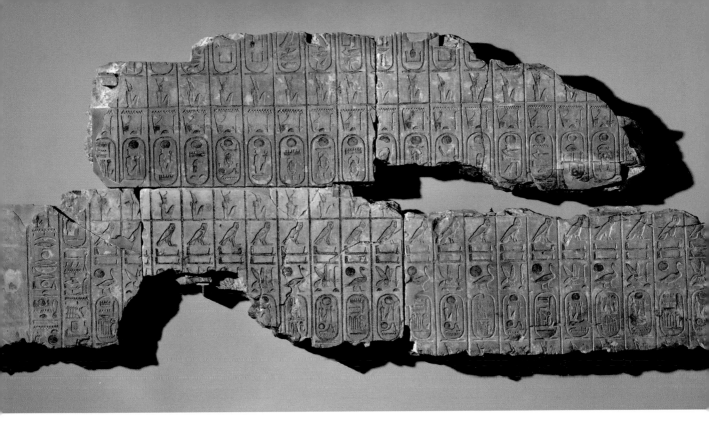

the options with archaeological and historical evidence, a number of likely dates have been proposed. Thus we are faced with a range of possible years for the destruction of Babylon under Ammisaduqa's successor: 1651 (High Chronology), 1595 (Middle Chronology), 1531 (Low Chronology) or 1499 (Ultra-Low Chronology). In past publications and museum displays, the Middle Chronology has been generally used because it is a compromise between the High Chronology, favoured by astronomical data, and the lower chronologies increasingly being favoured by the archaeological and textual evidence. In fact the Middle Chronology is generally no longer accepted as a tenable option by scholars and therefore to retain it simply because it is familiar serves no useful purpose. I have been persuaded by the Low Chronology and therefore, for only the first two chapters of the book, readers will find the dates (and thus the relationship of events) at odds with those described in other publications. I hope that this approach will serve to stimulate further discussion about the possible reconstructions of this crucial period.

Similar problems confront Egyptologists whose chronologies are dependent to some extent on correlations with the Assyrian/Babylonian sequences. Dates of Egyptian kings have been calculated on the basis of so-called Sothic calendars which survive from a number of reigns. These texts record the appearances of the dog-star Sirius, allowing modern astronomers to calculate their exact dates. However, it is unknown where

In Egypt hieroglyphic writing was in use by around 3000 to record the Egyptian language. From about 2600 onwards hieroglyphs were reserved largely for monumental inscriptions. Some of these are important sources for reconstructing the chronology of the rulers of Egypt and include lists of kings. This example comes from the memorial temple of Ramesses II (1279–1213) at Abydos. However, it mentions only kings relevant to the temple and its cult. No kings dating about 2160–2040 and about 1750–1650 are recorded, nor are the rulers associated with the so-called Amarna period, 1353–1323. EA 117

11

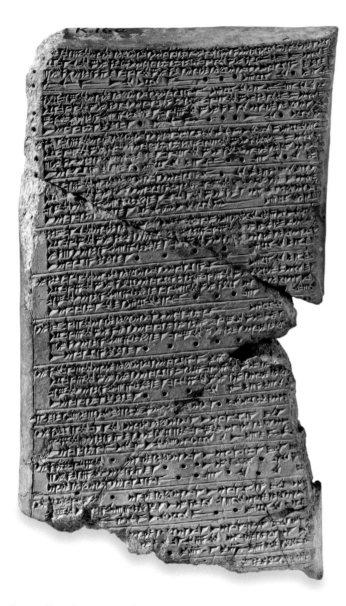

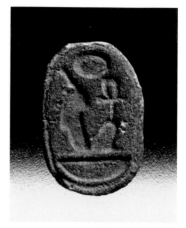

Found on the island of Rhodes, this seal, in the shape of a scarab beetle, a form taken by a manifestation of the Egyptian sun god, is decorated on the underside with the name of the Egyptian king Amenhotep III (1390–1352). This scarab was one of the earliest finds in the Aegean that provided a fixed point in time to date the Mycenaean material with which it was associated. Links like this have allowed archaeologists to establish a relative chronology for the Aegean in the second millennium. GR 1870.10-8.130

The cuneiform (wedge-shaped) script was developed in southern Iraq at the end of the fourth millennium. The early script was used to convey Sumerian but was later developed to record other languages. By 1600 the main written language of Iraq was Semitic Akkadian. This cuneiform tablet is one of the most important (and controversial) for helping to reconstruct the chronology of ancient Iraq before around 1400. The text purports to record observations of the planet Venus made in the reign of Ammisaduqa, king of Babylon. Modern astronomers have used the details of the observations in an attempt to calculate the dates of Ammisaduqa. Unfortunately, however, there is much uncertainty in the dating because the records are so inconsistent. ME K.160

in Egypt the observations were made, which makes an enormous difference to the results – sightings made in the south of Egypt would produce a later date than those made further north. Astronomical data also provide a number of possible dates for the year that Ramesses II came to the throne (1304, 1290, 1279 or 1274) which obviously has implications for the dates of earlier and later rulers. The widely accepted date of 1279 for Ramesses' accession is used here.

The chronology of other areas explored in the book is largely reliant on correlations being established between them and the chronologies of Iraq and Egypt. For example, although it is possible to establish a reasonably secure sequence of Hittite kings, the exact length of their reigns is unknown and can be reconstructed only by references to them in contemporary documents which mention rulers in the Assyrian, Babylonian and/or Egyptian sequences. Similarly, various possible chronologies have been proposed by different scholars for the kings of Israel and Judah.

In regions where there are few or no contemporary written documents things become even more problematic. Aegean chronology is based on a sequence of change over time in the archaeological record. Important markers are variations in the forms and styles of pottery and seals which can sometimes be related to the absolute dates of other regions. For example, a type of Aegean pottery might be found in a context in Egypt which can be dated to a particular king. This sequence is relatively secure back to around 1370 on the basis of the Egyptian chronology. One of the most controversial dates in Aegean chronology is the eruption of the volcano of Thera (Santorini). Archaeology shows that the eruption occurred at the end of a phase archaeologists term Late Minoan IA (LM IA) defined principally by styles of pottery found on Crete and elsewhere. Imports of this pottery to Egypt suggest a date for the destruction in the second half of the sixteenth century, i.e. 1540–1520. However, recent scientific data such as radio-carbon dates from Thera, including those derived from an olive tree buried in the eruption, evidence of volcanic ash in Greenland ice-cores and changes in the growth of trees as reflected in tree-rings resulting from climatic changes possibly caused by a volcanic eruption, point to a date in the later seventeenth century. However, establishing a relationship between the Thera eruption and the Greenland ash and climatic change has been critically challenged. And although the radio-carbon analysis points to a late seventeenth-century date, the data are not unambiguous.

Debates about the evidence will continue, but, as archaeological work uncovers more data, ancient texts are translated and interpreted, and scientific dating techniques are improved, we can expect the chronologies of the wider region to be further refined and integrated.

A Fractured World

1600–1550 BC

By the beginning of the sixteenth century BC the influence of a number of kingdoms that had once dominated extensive territories within the region stretching from the Aegean and northwest Africa to the mountains of western Iran had greatly diminished. Moving across these lands around 1600, a traveller would have passed through a kaleidoscope of states and settled and mobile communities forming networks of close relationships or heated rivalries. Although many kingdoms were prosperous, often centred on cities containing sumptuous palaces and temples, none possessed the authority and prestige that some states had exerted a century or so before. Let us have an imaginary merchant set out across this vast area starting at the city of Susa in southwest Iran. He would be leaving one of the most important centres of the region of Elam ruled for centuries by the *sukkalmahs*, 'grand regents'. Situated at the edge of the fertile plains of southern Iraq, Susa gave access to the rich resources of the mountains and plateau of Iran where abundant supplies of stones and metal could be obtained. The *sukkalmahs*, who ruled a wide territory stretching through the eastern mountains, had once exerted tremendous political and economic influence in the kingdoms scattered through Iraq and Syria. That authority, however, had been weakened by the unification of southern and central Iraq under Hammurabi of Babylon (1728–1686) a hundred years before.[1]

Leaving Susa, perhaps joining a caravan of donkeys carrying tin ores or an extended family taking their flocks of sheep to new pastures, our merchant might head northwest along the edge of the foothills of the mountains before moving on to the flat plains of southern Iraq following ancient tracks and natural passages. Skirting areas of vast marshes, lagoons and waterways, where hunters and fishermen lived in houses built from the surrounding reeds, the routes led through areas cleared of vegetation over millennia to form rich agricultural land for growing wheat and flax and plantations of date palms. The region, crossed by multiple branches of the rivers Tigris and Euphrates and further divided by a network of constructed canals which made transport easy and brought water to more distant regions of the plains, was the home to ancient cities and a multitude of people with

1 Based on the so-called Low Chronology adopted here (see pp. 10–11).

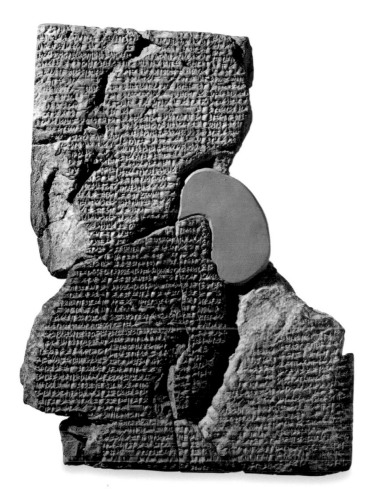

This cuneiform tablet in Babylonian Akkadian dates to around 1600 and comes from Sippar. It tells how the god Enlil decided to destroy humans with famine, drought and flood because he was disturbed by their noise (overpopulation). A man called Atrahasis is advised by the god Enki to overcome these disasters. He finally builds a boat, loads it with his possessions and animals, and thus survives the flood. ME 78941

different languages and lifestyles: city folk, mobile pastoralists, tribal communities in scattered villages. The great city of Babylon remained the centre of a politically significant state but the successors of King Hammurabi had slowly lost widespread control following rebellions by some cities and, of particular significance, the increasing loss of lucrative trade connections to and from the Persian Gulf with the emergence of a dynasty of so-called 'Sealand' rulers who were extending their authority over the broad marshes and date palm groves of southern Iraq.

North of Babylon the rivers Tigris and Euphrates flow at their closest, and from here, moving upstream, the landscape slowly changes from the flat plains of the south into rolling steppe-land where sufficient rain falls throughout the year and farmers had only limited need for irrigation that was so necessary in southern Iraq and Elam. A significant route between Iraq and Iran followed the river Diyala, a major tributary of the Tigris which carves a passage from the east through the densely wooded Zagros Mountains. Taking this direction and then heading north the merchant would pass through many small kingdoms such as Arrapha, perhaps paying taxes in some cities or being greeted by relations and business clients in others. Some paths would eventually lead back to the Tigris where the river could be crossed at the trading city of Ashur. Built on a high bluff overlooking the river

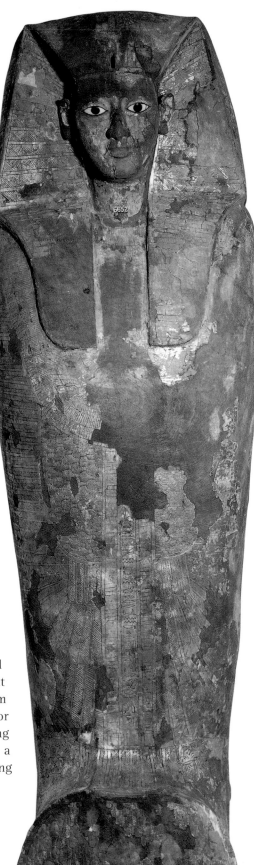

King Nubkheperra Intef's coffin was buried in a large tomb at Thebes about 1600. By this time the royal court had relocated from Memphis to Thebes, and northern Egypt was dominated by the so-called Hyksos kings. The coffin was found in AD 1827 and the tomb where it was discovered has been recently re-excavated by the German Archaeological Institute in Egypt. EA 6652

crossing, Ashur had controlled the movement of raw resources and manufactured goods at this point for centuries, though the city's once extensive network of merchant colonies stretching through Anatolia no longer existed.

Crossing the rolling plains of northern Iraq and Syria, with its abundant wheat fields and herds of cattle, the traveller would have passed through cities, towns and villages, as well as pastoralist and tribal encampments in which the common language spoken was Hurrian; people speaking this language had settled throughout the mountains and plains from southeast Anatolia across north Syria and Iraq into northwest Iran during the third millennium. At the edges of the cultivated areas and pasture lands the steppe was home to wild donkeys, gazelle and ostriches hunted by both lions and humans. Major centres such as Nagar (Tell Brak) controlled extensive tracts of fertile land as well as the routes which fanned out in all directions from the city towards its subject settlements and beyond. The many rivers that water this rich farming region coalesce to create the Khabur, a major tributary of the Euphrates. Following the Khabur south, the merchant would enter the territory of Hana with its capital at Terqa, a kingdom which had emerged to control this part of Syria following Hammurabi's destruction of the kingdom of Mari a hundred years before.

Northwards, beside the wide Euphrates, routes led through the states of Tuttul and Emar before striking out across the steppe for Halab (Aleppo), capital of the kingdom of Yamhad. Yamhad had dominated northern Syria for centuries either through subject states or allies including Carchemish, Emar and Ebla and even now remained a significant power. Its authority extended to the routes leading

north through the mountain ranges that form the natural border between the plains of Syria and Iraq and the highlands of Anatolia. However, if our merchant continued to the west he would reach the fertile valley created by the river Orontes which flows into the Mediterranean Sea. At the southern end of the Orontes Valley lay the prosperous kingdom of Qatna which, like so many of the other states the traveller had visited, was dominated by an impressive mud-brick palace of its ruler. Crossing the mountains which divide inland Syria from the coast would bring the merchant to Ugarit and its nearby port. For centuries Ugarit had been home to traders, native and foreign, moving metals and other materials between the Near Eastern states and the kingdoms occupying the lands around the eastern Mediterranean, northeast Africa and the Aegean. With the decline of once powerful states such as Babylon and Yamhad, economies had weakened and there were no longer any large-scale consumers of the materials exchanged at Ugarit. But trade continued and connections reached out into the Mediterranean and south through other coastal trading centres such as the ancient city of Byblos which for centuries had supplied cedar wood from the forests covering the mountains behind the settlement. This was the land of the Canaanites and, at a time when no foreign power dominated the region, their cities were flourishing. Inland from the coast were numerous city-states among which Hazor dominated the region of the Galilee. Many Canaanite cities such as Megiddo, Dan and Jericho, though tiny when compared with the large urban centres of Iraq, were protected by massive rampart walls. They had strong cultural, commercial and diplomatic ties with the rulers of northern Egypt.

Passing south through the city of Gaza the merchant would cross into Egypt and reach the extensive farm lands of the Nile Delta. Here he would find communities very similar to those he had left in Canaan. During the so-called Middle Kingdom (2050–1650) Egypt had dominated the Nile Valley deep into central Africa, and the country's wealth attracted people from Crete and Cyprus as well as large numbers of Canaanite and perhaps Hurrian settlers who had moved into the Delta. By 1650 this influx of people had transformed the Nile Delta into a cultural extension of Canaan. Egyptian control of the north had weakened and the royal court and seat of government moved to Thebes 'the Southern City'. Initially the Delta was split between various rulers until around 1600 when a single line of kings established their authority as far south as the city of Hermopolis. This was the kingdom of the *hekau khasut* (or, as the later Greeks would call them, Hyksos), 'rulers of mountainous lands', who ruled over the *Aamu*, people from Canaan. By this time the Hyksos had adopted many of the traditional Egyptian royal titles and administered their lands from Memphis. Their capital, however, was Avaris (Tell el-Dab'a) in the eastern Delta from where trade links stretched into Canaan and across the Mediterranean Sea to Cyprus (ancient Alashiya).

South of Hermopolis lay the territory of the princes of Thebes that reached to the first cataract of the Nile. Beyond the cataract was Nubia, the domain of the cattle-breeders and fierce warriors of the king of Kush with his capital at Kerma. When the Egyptians had controlled this region of the Nile, they had constructed forts designed to protect them from the famous Kushite archers. With the decline of Egyptian authority, the Kushite kings took control of the region's immense resources in materials and labour power. The Egyptian forts still functioned as trade posts but now they paid tax to the ruler of Kerma. Much of the king's wealth came from his control of the rich gold mines of Nubia, and commercial connections existed between Kush and the Hyksos with gold moving north to Avaris, bypassing Thebes along a western oasis desert route.

right
The potters of Kush were able to produce incredibly fine vessels by hand, without using a wheel, such as this example from Kerma which dates to the years around 1750–1550. EA 55424

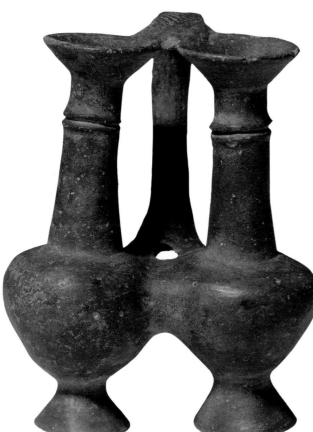

left
The surviving contents of vessels like this one from Cyprus (1650–1450) have been analysed and shown to be opium. Such juglets were exported to Egypt and the eastern Mediterranean, suggesting that opium was one of the exports of Cyprus at this time. GR 1868.9-5.18 (Vases c 117)

right
The so-called Master of Animals, depicted in this Minoan gold pendant of about 1850–1550, is known in Near Eastern imagery although it is more common in Minoan art for the central figure to be female. The male wears a typical Minoan skirt and stands among lotus flowers common in Egyptian representations. The pendant thus reflects Minoan contacts with Egypt and the eastern Mediterranean. GR 1892.5-20.8 (Jewellery 762)

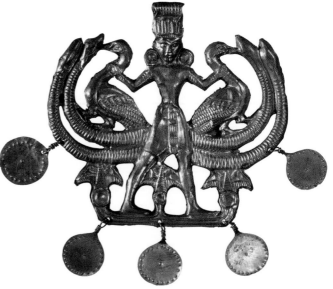

From Avaris ships sailed to Cyprus where urban centres were developing across the island and sources of copper were being mined. From here the merchant might take a boat the short journey to Ugarit or perhaps sail around Cyprus and on to Crete. For centuries the island of Crete had shared a common Minoan culture but was politically divided between rulers controlling their territory from large stone palaces that also acted as cult centres. The most important of these elaborate complexes were Knossos, Phaistos, Mallia and Zakros. In the days of a unified Egypt and a strong Babylon, Minoan merchants were based at Ugarit, and their so-called Kamares pottery found its way along the trade routes to the Nile Valley. By 1600, however, the eastern connections were limited and only small quantities of high-value items were now exchanged for Near Eastern tin and Anatolian copper. None the less, Minoan connections reached out to the small kingdoms of the Greek mainland; at Mycenae local rulers expressed their growing status by being buried with precious objects, some of which were imported from Crete, in the first of a series of elaborate shaft tombs. Minoan influence also stretched to the coast of Anatolia through the islands of the Cyclades.

The Minoan contacts with the Greek mainland and Anatolia gave the Cretan rulers access to metals and other exotic materials. After sailing past the Minoanized islands of the Aegean, our merchant arriving in western Anatolia would find a land divided between numerous kingdoms jostling for access to resources and territory. Parallel ranges of mountains ran eastwards towards the high central plateau and bounded the territories of independent states. As the merchant passed through this dramatic landscape of mountains and plains he would have met people speaking native Anatolian languages and other groups who spoke so-called Indo-European tongues. The latter belonged to migrant people who had entered Anatolia from Europe in the third millennium and had settled across the region. Among them were the Hittites, who by 1600 had established a kingdom around the southern bend of the great Halys River (Kilizirmak) focused on the city of Kussara. From here routes led through passes of the Anti-Taurus Mountains to the fertile plains of Cilicia and north Syria. Donkey caravans had passed this way in earlier centuries carrying gold, silver and copper from the mountains of Anatolia. Thus our merchant was brought back to the kingdoms of Carchemish and Yamhad and the river Euphrates flowing south through Babylon to the 'Sealand' and the Gulf.

The fragmented political world travelled by our imaginary merchant was a complex web of shifting alliances, as well as tribal, ethnic and local rivalries and feuds – which probably means that such a journey would have been extremely difficult if not impossible. The absence of powerful states that could maintain security for travellers over vast distances and between regions would have limited trading opportunities. Indeed, outside of Egypt, Iraq and the Aegean, the lack of writing reflected weak economies, and contact was piecemeal and local. This picture was transformed in the decades around 1550 when the entire region witnessed the emergence and expansion of several strong centralized kingdoms that would ultimately form a close-knit club of rival superpowers.

CHAPTER 1

The Rise of the Great Powers
1550–1500 BC

'One chief is in Avaris, another in Kush, and I sit (here) associated with an Asiatic and a Nubian! Each man has his slice in this Egypt and so the land is partitioned with me!'

So complained King Kamose (1555–1550) from Thebes about the division of Egypt.

The Theban princes of central Egypt had every reason to attempt political expansion. The notion of a unified country was embedded in Egyptian royal ideology, and the rulers of the 'Southern City' could trace their line, at least theoretically, to kings of earlier periods who had controlled the Nile Valley from Nubia to the Mediterranean. Ideology aside, however, there were more pressing reasons for the Theban rulers to attempt an extension of their authority: trapped as they were between the Hyksos kings of Avaris to the north and the king of Kush to the south, they had no direct control of the lucrative resources of either central Africa or the eastern Mediterranean. Tradition claims that, about 1560, hostilities broke out between the Theban ruler Seqenenre and the Hyksos king Apepi; a later story tells of a quarrel provoked by Apepi who complained that the noise of hippopotami at Thebes was keeping him awake (clearly a contrived complaint as Thebes lies some 650 kilometres (400 miles) from the Hyksos capital of Avaris). Conflict, however, seems to have followed and Seqenenre's mummy shows that he died a violent death, his head cut open by an axe blade, perhaps in battle against his northern enemy.

It was, however, Seqenenre's successor Kamose who was more successful against the Hyksos and their vassals. His propaganda presented

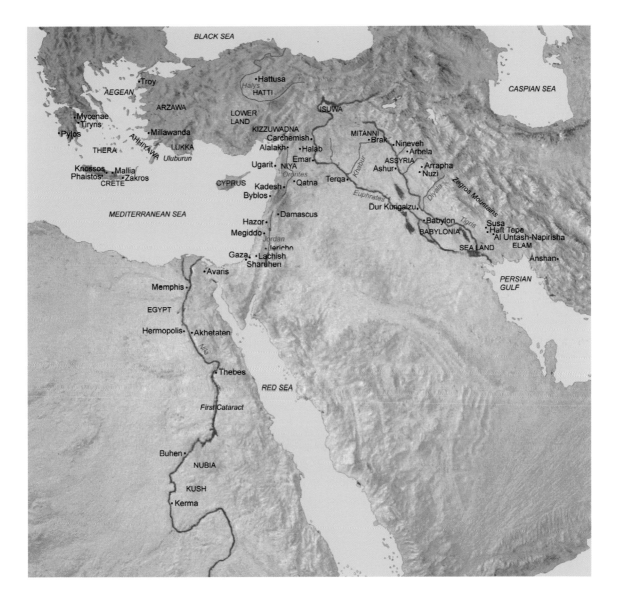

his campaigns as ridding Egypt of foreign rulers. Kamose first turned to Kush where the forts along the Nile were stormed and the largest, Buhen, heavily burnt. Kamose had new fortifications built, demonstrating to the king of Kush his determination to dominate the river. With his southern border more secure Kamose now raided Apepi's territory. Marching north accompanied by a battle fleet on the river he fought his way as far as Avaris itself but the city was not taken and Kamose withdrew.

Map showing sites mentioned in chapters 1–3.

21

The battles that Kamose waged against the Hyksos were presented as great victories on the monuments he erected but control of the Delta remained in the hands of the kings of Avaris. When Kamose died around 1550, his son and successor Ahmose was a young boy and there were no follow-up campaigns from Thebes. For about a decade the three kingdoms of the Nile warily watched each other until the calm ended when Ahmose renewed the conflict. His forces attacked the north and in a series of campaigns over a number of years the Theban army reached Avaris, which was put under siege. Ultimately, the Hyksos forces and their followers were forced to withdraw to the fortified cities of southern Canaan. Ahmose pushed home his advantage and pursued the Hyksos leaders; the Canaanite citadels were besieged and sacked. One of the greatest of these strongholds was the city of Sharuhen (possibly modern Tell el-'Ajjul, close to Gaza) which was heavily defended by a walled rampart and a deep ditch; it took Ahmose three years to force its submission.

Many of the fortified cities of southern Canaan fell over the following years either to Egyptian forces or to neighbouring city-states as new alliances were forged, old scores settled and opportunities for expansion emerged. Despite such upheavals, the wider economy was strengthened by the unification of Egypt and trade continued between the coastal cities of Canaan and Avaris where Ahmose constructed new fortifications and an elaborate palace complex. The east Mediterranean trade routes brought to Egypt the produce of Canaan, especially the prized cedars of Lebanon, so necessary for large constructions and ship building, as well as exotic imagery such as the Minoan-style griffin that appears on an axe of Ahmose.

As Egypt entered a period of expanding wealth and power, other kingdoms were flexing their military muscles in attempts at maintaining their security and acquiring resources. In central Anatolia the Hittites controlled an extensive territory, the land of Hatti, reaching from the city of Kussara northwards to the mountainous site of Hattusa. Around 1560, a new Hittite king, Hattusili I, established his court at Hattusa, adopting the city's name as his own. Although situated on a high ridge forming a natural stronghold, the new capital was vulnerable to attack from tribal groups and kingdoms in the mountains to the north and Hattusili therefore marched into these regions to secure that border of his kingdom. However, it was the rich markets of Syria which attracted the warrior's real attention. Various passes, including the so-called Cilician Gates, led through the mountains of southeast Anatolia and gave access to Syria. Now Hattusili launched his forces in this direction, and the city of Alalakh on the Orontes was overwhelmed and plundered, its wealth carried off to Hattusa.

Shabti, or Egyptian funerary figurines, were buried with the deceased to assist them in the next world. This limestone example is the earliest surviving one made for a king, and a rare image of King Ahmose (1550–1525), the ruler responsible for completing the process of driving the Hyksos out of Egypt. EA 32191

Hattusili now turned against Arzawa, an important kingdom lying to the west of the land of Hatti, and, although just a raid for cattle and sheep, it was a demonstration of Hittite strength to the western states of Anatolia. None the less, Hattusili was now faced by a major crisis. Hurrians, possibly the emerging kingdom of Mitanni on the Khabur plains of north Syria, attacked Hatti from the southeast. All the territory conquered by Hattusili revolted against him leaving just the heartland of Hatti. The Hittite king fought back, besieging cities and eventually re-establishing his authority across the region. This success encouraged Hattusili to march again into northwestern Syria, where he plundered a number of small states; people, animals and much booty were carried back to Hattusa and the supply routes from Syria were secured. Maintaining access to the resources of the Syrian plains remained of central concern to Hattusili's successor Mursili I, who knew that the one obstacle to Hittite authority in the region was Yamhad, the kingdom that had dominated the plains of Syria for centuries. In 1531 the Hittite army swept into Syria and sacked Halab, capital of Yamhad. If this event was not extraordinary enough, Mursili now saw that the way along the Euphrates lay open to Babylon. In a daring raid, the Hittites marched some 800 kilometres (500 miles) and plundered the city, the centre of one of the most important states in southern Iraq, before withdrawing home to Hatti laden with riches.

Following the Hittite attack, the collapse of the royal houses of Yamhad and Babylon allowed other rulers to claim these ancient centres of power. In Syria, the Mitannian kingdom gradually extended its control over the lands and subject

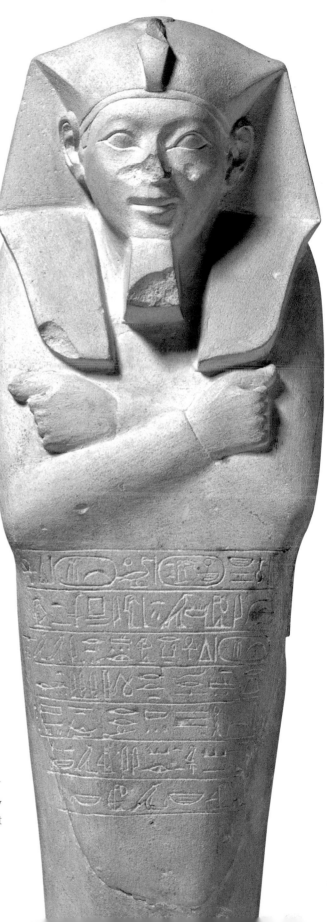

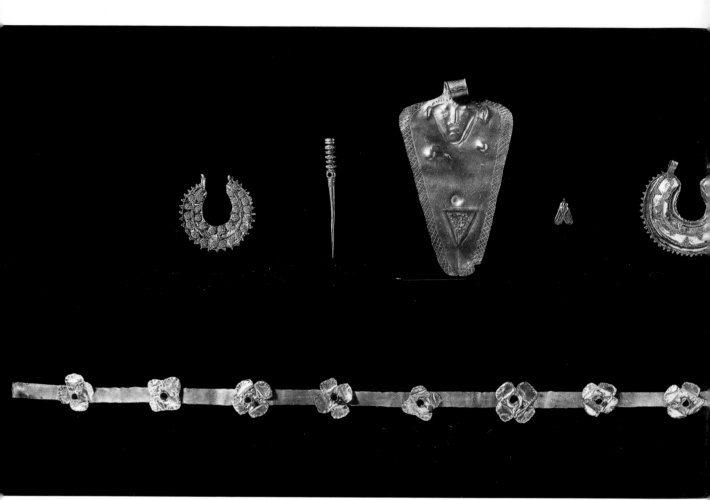

states once ruled from Halab, appointing its own rulers or receiving acknowledgement of overlordship through treaties, gifts and taxes. By this time, the military might of kingdoms such as Mitanni was dependent on the use of battle chariots. By 1700 a technological revolution had occurred when traditional heavy wagons with four solid wheels, hauled by donkeys, were transformed into light chariots with two multi-spoked wheels pulled by horses. These new vehicles had become possible only with the introduction from Central Asia of sufficiently strong breeds of horses. Such animals were bred in areas to the north and east of Iraq and their acquisition would remain a priority for all future rulers of the region. By the mid-sixteenth century larger kingdoms could muster hundreds of chariots, each one a mobile platform from which an archer could launch arrows from composite bows at slower-moving enemy infantry. From

above
Tell el-'Ajjul may be the site of Sharuhen, the last stronghold of the Hyksos armies (an alternative suggestion is Tell Fara South). Some wealthy inhabitants had time to hide this gold hoard before the city was destroyed, possibly by Egyptian forces, in about 1535. The stylized pendant relates to the cult of the Canaanite fertility goddess Astarte.
ME 130760-4; ME 130775; ME 130769

below

In southern Iraq, terracotta moulds like this one were used to produce plaques, perhaps intended for private devotions or simply as decoration. During the period 1800–1550, when this example was made, horses were becoming a common sight in the region, having been introduced from Iran. They were used to pull light chariots but were not sufficiently strong to be ridden as cavalry; here the rider sits bareback, without stirrups, and straddles the horse towards its rump, a position from where it is difficult to control the animal. ME 22958

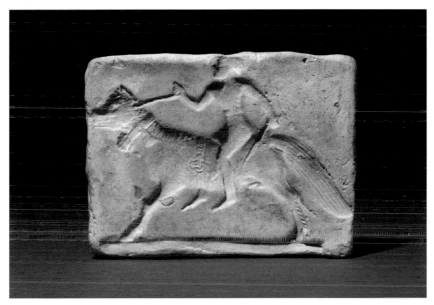

Anatolia and the plains of Syria, horses and chariots were introduced to Egypt, perhaps by the Hyksos kings, and through Crete they were brought to the Mycenaean kingdoms of the Greek mainland.

Hittite chariots had carried the armies of Mursili into southern Iraq, where later generations would recall the pillaging of Babylon as a momentous event; the Hittites were said to have removed the cult statue of Marduk, the patron god of Babylon, and his departure was believed to signal divine displeasure with the city and its ruler. The statue was carried to Hana on the Euphrates, perhaps suggesting that kingdom's active assistance or at least neutrality in the advance of the Hittite army to the south. One of the local rulers within the state of Hana had a non-local name; he can be identified as belonging to a people called Kassites. The Kassites were related groups that had spread from their homeland in the

Zagros Mountains across the plains of southern Iraq as labourers, mercenaries and hostile attackers. They were among the numerous tribes with different origins, languages and traditions that formed an important element of the population of southern Iraq. Local Kassite leaders had risen to prominence and, with the collapse of the old royal house of Babylon, a line of Kassite rulers took advantage of the political chaos to establish their control over the region, eventually creating a unified country, Babylonia.

If the fall of Babylon to the Hittites was viewed as earth-shattering, another event that may have occurred around the same time was literally that. In the Aegean, the volcanic island of Thera blew itself apart.[1] Thera was an almost complete ring of land, formed from the rim of a huge volcanic crater or caldera flooded with sea water, with a central island. The main island ring had formed a natural link by boat between Minoan Crete to the south with the Cycladic islands and the Greek mainland and western Anatolia. On the southern side of the island (near the modern settlement of Akrotiri) lay a thriving port which, because of its close relationship with Crete, had the all the appearances of a Minoan town. Thera's inhabitants had experienced major earthquakes which had caused extensive damage to buildings and roads but these had been repaired. Now, however, a series of violent eruptions from the central volcano began to take place over a number of months, covering the island with layers of pumice but apparently giving the inhabitants sufficient warning to escape. The final enormous eruption tore the volcano apart and vast amounts of pumice and ash were hurled into the atmosphere. Tens of metres of ash fell back on Thera while massive quantities were blown to the east over Rhodes and southwestern Anatolia. Such a significant ash fall would have disrupted agriculture and communications for years. Crete, however, escaped the worst of the eruptions, with only a few centimetres of ash falling in places. Tsunamis generated by the explosion smashed into the island, swamping ports, pushing over walls and sinking boats but the effects were not disastrous in the long term. However, as the basis of power in the Minoan palaces of Crete was, as elsewhere, effective agricultural production in the surrounding countryside, disturbances of this kind may have weakened their position to some extent even though the palaces, nearby towns and country estates continued to flourish.

For months the eruption interrupted trade; the loss of Thera as a seaport was a major calamity. None the less, Crete remained the centre of Aegean trade, the channel for both resources and new ideas. Copper from

1 The dating of the Thera eruption is fiercely debated and, although archaeology suggests that it occurred some time around 1540, other methods for dating the destruction suggest that the event may have occurred as much as a century earlier (see p.13).

left

The Minoans developed two scripts: Cretan Hieroglyphic, which died out by 1600, and Linear A, both of which remain undeciphered. Linear A is known from many sites on Crete as well as some Aegean islands such as Thera. The script was used on unbaked clay tablets for administration as well as being inscribed on a variety of objects, such as this bronze double axe (about 1700–1450), which were probably intended for dedication in a sanctuary. GR 1954.10-20.1

below

Bull-jumping is frequently shown in Minoan art, including frescos. It may have formed a part of ritual activity. The sculptural group of a bull and acrobat dating to about 1700–1450 is solid cast. Minoan bronzes are often poor in tin, which was an expensive import from the Near East, and this resulted in an alloy that does not flow well into a mould: this may account for the acrobat's missing legs. GR 1966.3-28.1

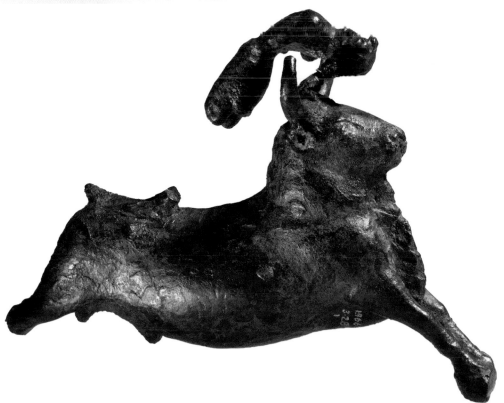

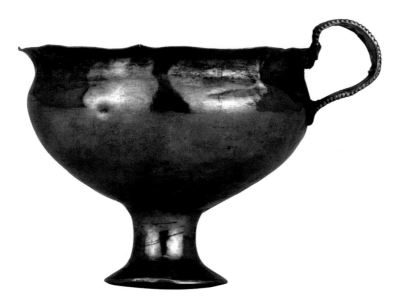

left
Dating to around 1500,
this goblet is made of sheet
gold and, like the vessels from
the shaft graves at Mycenae,
it shows influences in style
and manufacture both from
Minoan Crete and from
Mycenaean Greece. It may
have been made by a Cretan
artisan working on the Greek
mainland for a rich patron.
GR 1900.7-27.1 (Jewellery 820)

the Laurion mines of Attica on the Greek mainland was mixed with tin acquired through the ports of the eastern Mediterranean to make bronze. However, the desire by the elite for additional prestigious materials such as gold, ivory and exotic stones also encouraged wider connections. In Greece, the local sources of copper and silver were utilized to create prestige objects for Mycenaean leaders but surplus metal also paid for ostentatious goods obtained through Crete to express the chieftains' growing personal status. At Mycenae, for example, elaborate shaft graves, the earliest constructed at the beginning of the sixteenth century, contained burials with not only magnificent cups and death masks made from imported gold but also many finely crafted Minoan vessels as well as exotic objects like a silver rhyton (a ritual pouring vessel) in the shape of a stag, similar to examples used among the Hittites and no doubt carried from Anatolia through Crete to its final resting place.

Cretan stylistic influences were carried beyond the Aegean to the eastern Mediterranean where palaces were decorated by travelling artists skilled in the Minoan art of fresco painting. Painted plaster had been used to decorate walls in Crete for centuries, and by 1550 the walls of elite buildings at Knossos and elsewhere were covered in images of fluid landscapes filled with animals and humans. Wonderful frescos were buried on Thera by the volcanic eruption. In Syria, less sophisticated frescos covered the walls of Alalakh's royal palace before it was destroyed by Hattusili I. Further south in Canaan, Minoan-style frescos were created at

right
This beautiful mummy mask
from Thebes, Egypt, belonged
to Satdjehuty, a high-ranking
lady favoured by Ahmose-
Nefertari, the wife of Ahmose I
(1550–1525) and the mother
of Amenhotep I (1525–1504).
EA 29770

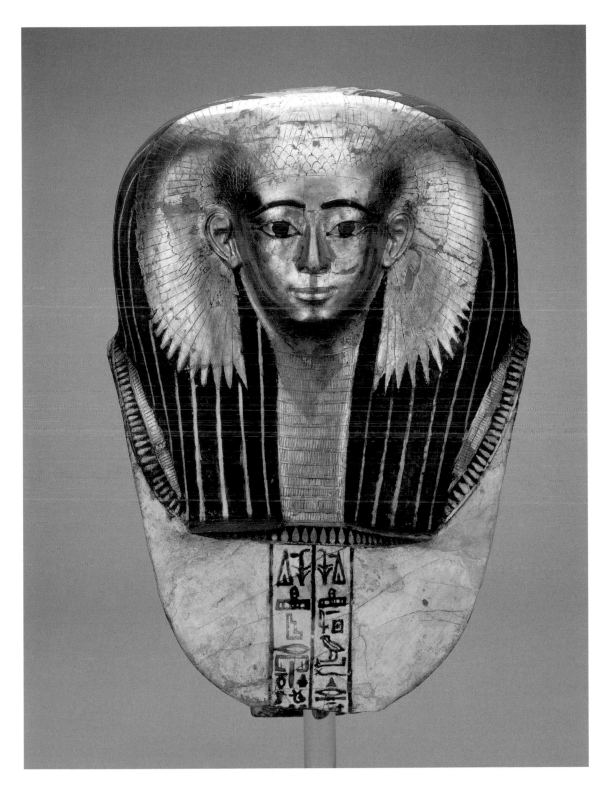

Tell Kabri, while in Egypt by the end of the century new royal buildings at Avaris were covered in images of Minoan bull-leapers and acrobats. These exotic designs, such as the Aegean manner of depicting animals with a 'flying gallop', were valued in the Delta and Canaan but after 1500 they tended to be overwhelmed or adapted by Egyptian iconography.

The growth of Egyptian power and influence was maintained with the accession of Amenhotep I (1525–1504) to the throne of Egypt. He initiated an aggressive push against the king of Kush's authority over the Nile Valley south of the first cataract. A series of military successes by Amenhotep resulted in Egypt's power reaching deep into Nubia. The result was spectacular financial gains for Egypt since it was increasingly dominating access to the enormous gold reserves of the region as well as the lucrative trade along the Nile with central Africa. This rapidly began to improve the overall economy of Egypt and the upturn in prosperity rippled across the Near East encouraging greater interaction and rivalry between kingdoms.

Although Egypt's unification and expansion were bringing increasing wealth and stability, the rapid expansion of the Hittite kings over central and southeastern Anatolia, with its varied peoples and terrains, was followed by instability and rivalry as neighbouring kingdoms sought to undermine the regime or benefit from its success. Problems became apparent a number of years after Mursili I's triumphs against Yamhad and Babylon when the king was assassinated. His successor Hantili attempted to maintain Hittite influence in Syria but the Hurrians now regularly plundered Hatti from the southeast. By the end of Hantili's reign Hittite power had weakened further and, on claiming the throne, his son-in-law was assassinated by his own son. Such instability encouraged Arzawa to attack from the southwest. Of greater significance, however, was the hostility of the emerging state of Kizzuwadna to the south in the rich and productive lands of Cilicia. This threatened to cut off Hittite access to the resources of Syria, which was itself increasingly dominated by the Hurrian kingdom of Mitanni as it extended its influence over the small kingdoms and tribal groups, and thus further restricted Hittite trading contacts.

CHAPTER 2

The Birth of Empires
1500–1400 BC

Although both Ahmose and Amenhotep I had enforced an Egyptian presence in Nubia as far as the second cataract of the Nile and thereby achieved access to the gold mines in the eastern desert, the kingdom of Kush remained a threat to Egypt's domination of the region. It was Thutmose I (1504–1492) who consolidated the earlier campaigns, victoriously leading his armies to Kerma, capital of the king of Kush, and then deep into Africa beyond the fourth cataract of the Nile. After these great successes Thutmose turned his attention to the resources of Canaan which were under strong Egyptian authority only as far as Gaza. Further north the larger city-states such as Hazor and Megiddo had been weakened by either Egyptian attacks or inter-state quarrels following the defeat of the Hyksos, and Thutmose took advantage to make a triumphal march all the way to Syria, reaching inland as far as the Euphrates River where he set up a commemorative carved stone stela. His forces avoided direct confrontation with the state that now dominated north and east Syria and was known to the Egyptians as Nahrin 'rivers', in other words Mitanni, but the Egyptian army skirmished with some Mitannian vassals. The daring expedition allowed the king to seize plunder including horses and to hunt the wild elephants that lived at that time in the region of Niya on the river Orontes south of Mitannian-dominated territory.

From his capital at Washshukanni[1] in the Khabur region of Syria, the Mitannian king Parrattarna dominated an assortment of vassal or allied states stretching across the plains of Syria and northern Iraq: a homogeneous area of rain-fed agriculture containing a multilingual and

1 The exact location of the city has yet to be determined.

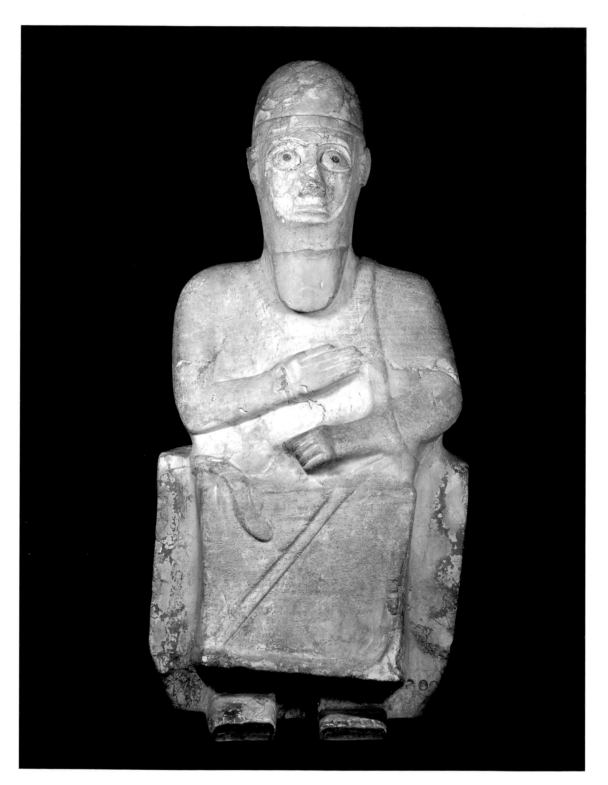

ethnically mixed population but with a large number of Hurrian speakers. Among these rulers loyal to Parrattarna was Idrimi (about 1470), who was descended from the once powerful rulers of Yamhad. Hostilities, perhaps with Mitanni in the decades following the Hittite sack of the capital Halab, forced Idrimi and his family to seek refuge in Emar, centre of the kingdom of Ashtata on the Euphrates. However, dissatisfied with his existence as a minor royal in exile, Idrimi took his chariot and squire and, sheltering among the nomads of the desert, made his way to Canaan. Here he found other people from Halab as well as from Mukish, a region held by Alalakh, and they recognized and embraced him as a member of the Yamhad royal family. For seven years Idrimi lived among these groups described as *habiru*, in other words, political refugees and people without royal protection and therefore outside the law. Eventually, Idrimi and his followers sailed north along the Mediterranean coast and landed in Mukish where he was welcomed, establishing alliances with local rulers. During Idrimi's time in exile, King Parrattarna had viewed him with hostility. Now Idrimi sent the Mitannian king a greeting-present, the traditional form of establishing and maintaining friendly relations between rulers, even those of different rank, and reminded him of earlier oaths sworn between the kings of Halab and the kings of Mitanni. Parrattarna accepted the present and permitted Idrimi to be established as the ruler of Alalakh after determining the boundaries of the state. Although he was subject to Mitanni, Idrimi was sufficiently independent to engage in military action and diplomacy as long as it was approved by Parrattarna or did not interfere with Mitannian policy. He plundered Hittite territory to the north of Alalakh and established a treaty with the king of Kizzuwadna.

A treaty between Kizzuwadna and a Mitannian subject ruler like Idrimi would certainly have alarmed the Hittites who had already established their own pact with the king of Kizzuwadna. During the late sixteenth century the Hittites had experienced a period of instability with a series of royal assassinations and usurpations, as well as the loss of access to Syrian trade and incursions from the west by states such as Arzawa. This chaotic situation improved, however, when Telepinu seized the throne of Hatti around 1480. He was successful in re-establishing the northern and eastern frontiers of the kingdom and in pushing south towards Cilicia and the frontier of Kizzuwadna, a kingdom with which he drew up a treaty. Although not an insignificant state, Kizzuwadna, like many others across the entire region, walked a political tightrope, balancing its needs and security against the potential dangers of siding with a larger kingdom. In this case the choice was either Hatti or Mitanni. Choosing to enter into a relationship with Mitannian-dominated Alalakh might have resulted in

This statue of King Idrimi (about 1470) was found at Alalakh. It is inscribed in faulty Akkadian, using a poor cuneiform script, with an account of his rise to the throne. The inscription may have been carved long after Idrimi's death but, if it is contemporary with the king, it contains the earliest-known reference to the land of Canaan. ME 130738a

animosity from the Hittites. However, the kings of Hattusa were no longer the power they had been, and a policy of friendship with Kizzuwadna was maintained, their treaty ensuring the movement of people, herds and goods across the borders. The successors of Telepinu preserved the frontiers of Hatti although the kingdom was always vulnerable to attack from neighbouring regions. This was especially true at the northern frontiers beyond which the Kaska people lived. On at least one occasion the Kaska raided south, capturing cities, goods and livestock. The Hittite kings reacted by fortifying the capital Hattusa as the main line of defence against these troublesome people.

The Hittites remained a powerful state but their influence had diminished since the days of Hattusili I and Mursili I. Mitannian dominance, however, continued to grow throughout the fifteenth century. The lands that owed allegiance to Mitanni shared a culture reflected in common forms of painted pottery, and within this region technological developments occurred which spread to neighbouring and distant kingdoms along the exchange routes. Around 1500 the technique of transforming glass into vessels was developed. Generally made from quartz sand mixed with soda or potash and lime, and then heated to high temperatures in shallow crucibles, the glass could be coloured by adding mineral oxides, and when sufficiently hot the resulting liquid was drawn into long trails. These trails of molten glass were coiled around an earthenware core which, when the glass had cooled and solidified, was scraped out leaving a glass vessel which could be finished by having its surfaces ground and polished. At sites throughout northern Syria and Iraq, such as

Alalakh, Nagar (Tell Brak), Nineveh, Ashur and Nuzi, such glass vessels were sometimes further decorated with thin threads of glass carefully laid over the outer surface. Other vessels were made from mosaic glass: thin cylinders of coloured glass were laid side by side in patterns before being heated and formed into vessels. Glass was developed in workshops where objects were being moulded from faience, a mix of alkali and quartz fired at a lower temperature so that only the outer surface is vitrified or 'glazed'. Faience objects were extensively made from Egypt to Iran in moulds, and small, easily transportable vases, statuettes, seals, beads and amulets were produced and carried along the trade routes. Faience became increasingly popular as a cheap substitute for highly prized glass objects.

Although the rulers of Syria could express their prestige by using the latest technology to own beautiful glass objects, their wealth was based on a rural economy centred in villages and country estates around the urban centres. This was true of all the kingdoms of the wider region and none more so than across the rich plains of Babylonia. The world's first cities had emerged here in the fourth millennium BC, and, sustained by the abundant agricultural resources, dynasties of rulers had maintained their ancient traditions for thousands of years. As the Kassite kings of Babylon extended their authority over the cities and tribal groups, they too would champion and defend not their own gods and customs but rather, in the convention of all rulers with a claim to legitimacy, the culture of Babylonia. Around 1480 the Sealand was conquered by the Kassite kings, and the rich trade with the Persian Gulf as well as access to the area's extensive date palm plantations stimulated the economy and encouraged further stability. The centralization of southern Iraq on the city of Babylon was expressed by the Kassite claim that the statue of Marduk had been recovered, indicating that the gods themselves had sanctioned the dynasty's right to rule.

From Anatolia and Egypt to Babylonia, powerful kingdoms were emerging to dominate the smaller states between them. With political stability came economic strength. Despite the need to crush an uprising in Kush, peace prevailed in Egypt under Thutmose II (1492–1479). His son succeeded him as Thutmose III but the boy was very young and Hatshepsut, a wife of Thutmose II, acted as regent, eventually taking on the attributes of kingship (1473–1458). The prosperity of Egypt continued to grow under her rule and the produce of the east Mediterranean (cedars, perfumed oils, copper) and Africa (gold, ebony, ivory) flowed into the country. The importance of contacts with lands that could supply luxury goods was made explicit by Hatshepsut in the decoration of her funerary temple in western Thebes. Here she had described and portrayed an expedition to the

Although this conical rhyton, a ritual pouring vessel or sprinkler, was found in Egypt it was a type of object that was first developed in Minoan Crete. The unusual shape evidently appealed to the Egyptian elite, who had it copied in faience. EA 22731

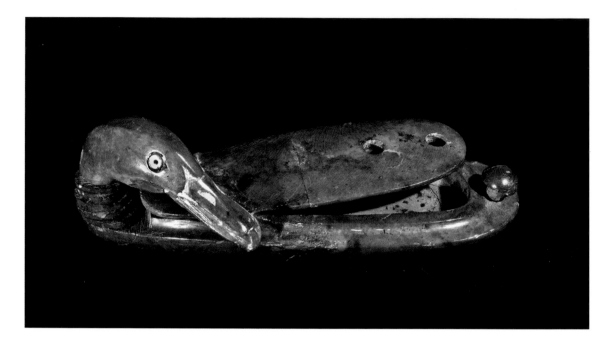

land of Punt (perhaps modern Somalia or Ethiopia). A fleet of five Egyptian ships set out from a port on the Red Sea and sailed south where they were welcomed by the king and queen of Punt. The expedition returned with incense and fragrant unguents, used for cosmetics and in religious ceremonies, as well as exotic animals and plants.

As earlier, Egyptian contacts with the Aegean were frequently through Cyprus and the cities of the east Mediterranean coast. Minoan and Canaanite pottery and their contents found their way to Egypt by sea and by land. Small ships sailed through the Aegean from island to island or along the coast of the eastern Mediterranean calling at ports to sell pottery and picking up wares to be sold farther along in their journey. Local potters imitated some of the interesting designs that had arrived as an extension to their own production. Metals from Iran and Anatolia, wood from the Lebanon, textiles and agricultural products from centres across the region also moved along these exchange routes either as royal enterprises or through independent traders. Among these resources and products were exotic items sent between kings as presents, bribes or tribute. Such widespread commercial connections are reflected by paintings in the tombs of some Egyptian officials under Hatshepsut and Thutmose III. Delegations of people the Egyptians identified as Keftiu (Aegeans), as well as Syrians, Hittites and Africans, are depicted presenting tribute to the Egyptian ruler or his representative. The Egyptians welcomed

Toilet or cosmetic boxes in the shape of a duck, like this one from the Mitannian-period palace at Alalakh, were extremely popular throughout the eastern Mediterranean in the second half of the second millennium. Although Egyptian in origin, many were produced by Canaanite artisans. ME 135060

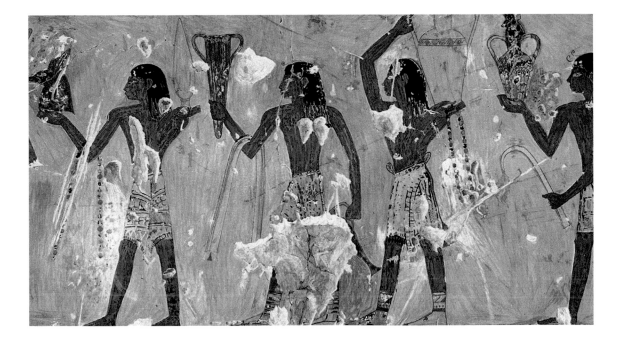

these exotic visitors but the elaborate goods they carried were largely diplomatic greeting-presents and gifts intended to encourage trade relations rather than symbols of submission. The produce of Egypt (grain) and Africa (gold) was exchanged for metals, woods and other materials not available locally, and the tremendous wealth now available to Egypt's rulers was invested in enormous building projects, especially grandiose temples at the dynastic centre of Thebes.

Wall painting from the Theban tomb of Menkheperrasoneb, dating to around 1450, showing people from the Aegean region bringing gifts to Egypt.

The importance of Crete within this network of trade connections was shaken in the years around 1450 when the island experienced widespread destructions. The majority of the Minoan palaces, towns and country villas were severely damaged, perhaps by earthquakes but largely as the result of conflict, probably between the competing kingdoms of the island. Only Knossos survived unscathed, perhaps because it was responsible for the devastations having expanded aggressively across Crete at the expense of the other palaces. Towns shrank as populations abandoned them for the country. None the less, Minoan life continued with traditional frescos painted at Knossos and fine pottery still produced. Increasingly, however, Mycenaean influence appeared throughout Crete from this time onwards. Indeed, the Greek language was recorded in Linear B on administrative clay tablets at Knossos. Warriors from the kingdoms on the Greek mainland may have contributed to the destruction of the Minoan palaces and, even if they were not among the soldiers attacking the ancient

centres, they almost certainly took advantage of their fall to establish a foothold on Crete. The result was a mixing of mainland and Cretan influences in the island's arts and crafts.

The growing power and wealth of the Mycenaean Greek kings is seen in their sophisticated and very conspicuous tholos tombs. This form of tomb, consisting of an artificial mound of earth over a circular stone vaulted chamber which was approached by a passage (dromos), had been developing for decades. By the middle of the fifteenth century, however, very elaborate and enormously expensive examples were being constructed. For example, the rulers of the wealthy kingdom of Mycenae had a number of massive tholos tombs constructed over the century following the creation of the last shaft grave around 1480. The large dromos passages of these tombs were filled in following a burial, with the idea that they could be cleared for future interments.

During the time that Knossos was establishing itself as the dominant centre on Crete, in Egypt Thutmose III had became sole ruler in 1458 on the death of Hatshepsut. Although she had sought prestige in the exotica of Punt, Thutmose saw wealth and glory in the lucrative trading ports of Canaan and the rich kingdoms of Syria. The opportunity for a campaign in this region presented itself immediately when some states in Canaan that Thutmose considered should have been loyal to Egypt rebelled. Leading his army out of Egypt to the garrison town of Sharuhen, he moved first to Gaza on the coast and then north along the coastal plain to the town of Yahem. Here Thutmose learned that the powerful ruler of Kadesh had joined forces with princes of other states as far north as Mitanni, whose king had probably encouraged this opposition to Egypt's advance into the region. The coalition had gathered to face the Egyptians outside the city of Megiddo. Thutmose pressed forward through the mountain pass leading on to the plains around Megiddo and a major battle ensued. The Egyptian army pushed the Canaanite/Syrian forces back to Megiddo itself where they sought refuge behind the city walls. However, rather than taking advantage of the situation to pursue and cut off their enemy's retreat, the

Jars like this one from Knossos on Crete were used in Minoan palaces to store large quantities of agricultural produce, mainly grain, olive oil and wine. Gathered from the surrounding countryside, it was then used or redistributed. GR 1884.8-7.1 (Vases a 739)

Egyptian soldiers were distracted by the rich plunder left on the battlefield, including chariots covered in gold and silver. Thutmose was therefore forced to besiege Megiddo by surrounding it with a ditch and a palisade constructed from the wood of the region's fruit trees. After seven months the city surrendered and the princes offered Thutmose tribute. In the established tradition of the time, Thutmose reappointed each of the princes to their territory on the basis that their position was now dependent on the Egyptian king's favour; in return they would supply him with regular tribute and troops when he needed them. The rewards of the war for Egypt were enormous both in the short term – the campaign alone gained for Thutmose 340 prisoners, 2,041 horses, 924 chariots, 1,929 cows, 20,500 sheep and luxurious objects from Syria of gold, silver and lapis lazuli, as well as 200,000 sacks of wheat harvested from the fields of Megiddo – and in the long term with a regular income from the loyal princes.

None the less, the loyalty of some vassal rulers proved less than solid despite the presence of Egyptian troops and administrators across the region. Over the following nine years Thutmose returned repeatedly to the coastal plain of Canaan as far north as Syria. One garrison was established on the coast north of Byblos from where campaigns could be launched into

This fine jar is decorated in the so-called 'Marine Style' which originated in Crete but became popular in Mycenaean pottery workshops on the Greek mainland from 1500. Such Aegean pottery was attractive to the Egyptians, and small quantities have been found in Egypt. This ointment jar was found at Armant in Egypt and may have held perfumed oil which was produced in Mycenaean Greece.
GR 1890.9-22.1 (Vases a 651)

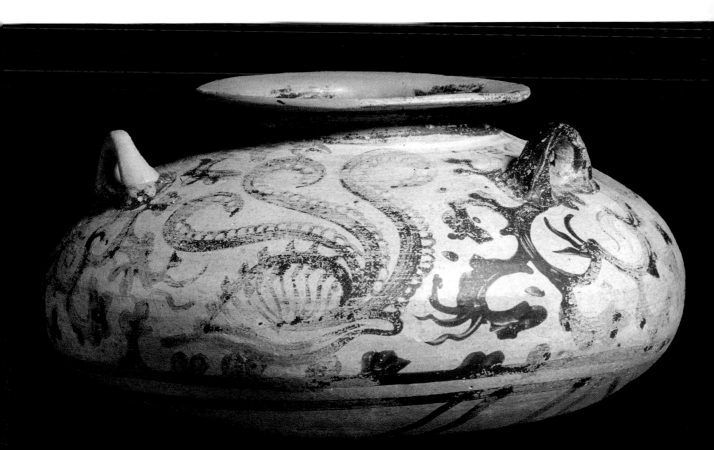

Egyptians probably began producing glass in quantity only after Syrian artisans brought the technique to Egypt. On this blue glass jug the trees, dots, scales and the name of the king, Thutmose III (1478–1425), are enamelled, the earliest-known example of this technique in Egypt. EA 47620

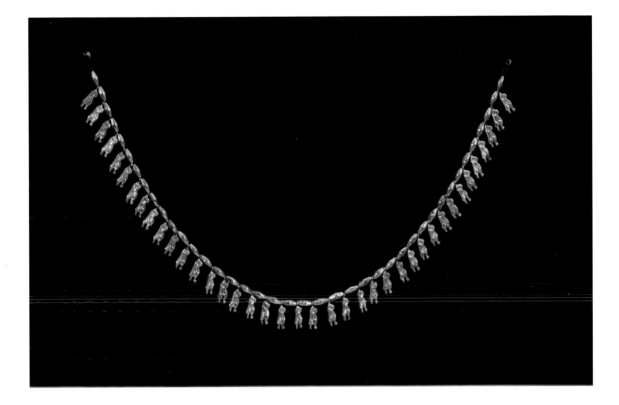

Syria, especially against the troublesome kingdom of Kadesh with its links northeast through Qatna to the realm of Mitanni. The Egyptians were particularly impressed by the region's extensive agriculture and vineyards. Along the coast of Egypt-dominated Canaan were a number of wealthy fortified port cities including Sidon and Byblos that lay on routes leading into the interior. Although these now sent tribute to Egypt, the city-states remained important independent centres for the manufacture and export of goods as well as for the exchange of resources arriving from all directions by land and sea. Egypt was a major consumer of many of these products but the cities also acted as middlemen in the trade across the wider region. One of the greatest of these commercial centres, however, lay beyond Egypt's direct political control. On the north Syrian coast lay the city of Ugarit and its bustling port. As they had for centuries, merchants from across the Near East gathered in the city to conduct business; traders from Cyprus exchanged their copper for raw resources and finished goods; other merchants dealt in metals (especially tin to be mixed with copper to make bronze), wine, olive oil, textiles or wood; grain from the Syrian plains was transported to Anatolia; and Minoan and Mycenaean pottery arrived at the port as part of the city's maritime links with Crete and the Aegean.

Amulets of the Egyptian goddess Taweret, who protected the mother and child from dangers during childbirth, have been widely found in the eastern Mediterranean. A large number of gold pendant amulets, similar to these, were discovered in the burial of the wives of Thutmose III and suggest that one of the main preoccupations of these women was with supplying the king with an heir.
EA 59418

The phenomenal growth of Egyptian authority through Canaan as far as Syria was of obvious concern to states such as Kadesh on the Orontes River and others further east, such as Qatna, Alalakh, Halab, Carchemish and Emar, who all had close relationships with or allegiances to Mitanni. Although Ugarit thrived as an independent port, wider access by these Syrian kingdoms to cedar, copper and other prized products was jeopardized by Egypt's domination of the coast. In 1447 Thutmose III decided to make his presence felt among these hostile states. Marching from the coastal garrison towns, the Egyptian armed forces passed through the territory of Qatna until, in the plains west of Halab, the army engaged for the first time with troops from Mitanni itself. The Mitannians were forced to withdraw across the Euphrates and Thutmose followed them to the river. Here he ordered prefabricated cedar boats to be placed on carts at Byblos and dragged by bulls across Syria to the Euphrates. From the region of Carchemish, the Egyptians sailed along the river, which they described as flowing 'upside down', that is, in the opposite direction to the Nile, plundering the countryside along the banks as far as Emar. Having set up his own carved stone stela next to that of his grandfather, Thutmose left the river and followed the overland caravan route west to the Orontes and the land of Niya where he hunted elephants.

Although the campaign had not established Egyptian authority over inland Syria, the plundering of Mitanni's vassals and the defeat of a Mitannian army was a tremendous achievement for Thutmose III. This was recognized by the rulers of Babylonia and Hatti, who sent embassies bearing gifts to the Egyptian king. Thutmose had already received gifts of friendship some years earlier from the small state of Assyria to the east of the Mitannian heartland. This diplomatic gesture was no doubt motivated by Mitannian attempts to expand its authority in that direction and, despite the defeat of its army by the Egyptians, Mitanni remained the major power in Syria. Indeed, Thutmose was forced to return to the region once again to crush a rebellion by Kadesh which had probably been supported by Mitanni now under King Saushtatar, one of that kingdom's most powerful rulers.

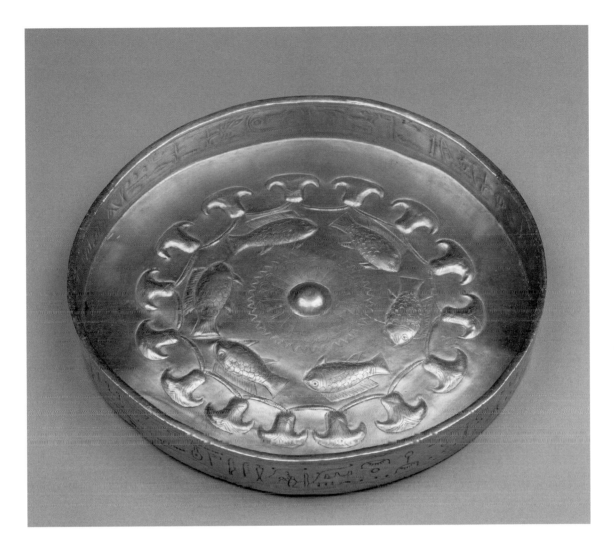

above
Flat-bottomed bowls, such as this gold example, were produced in Syria. However, the hieroglyphic inscription on the bowl informs us that Thutmose III presented it to the general Djehuti for his successes 'in all foreign lands and in the isles in the midst of the great sea'. Louvre Museum N 713

opposite
A distinctive style of painted pottery developed across north Syria and northern Iraq in the period when the region was dominated by Mitanni. This example comes from Alalakh (where it is known as 'Atchana Ware'). When related pottery is found in the east, it is known as 'Nuzi Ware'. ME 126193

The proceeds resulting from the campaigns of Thutmose III were extravagantly expended on the building and furnishings of temples throughout Egypt. Syrian technology such as glass vessel production, if not actual glass workers, was introduced into Egypt. Canaanite and Syrian connections were also present at the royal court in the form of some of Thutmose's wives. Three of his queens had northern names and were themselves fabulously wealthy. These women had probably arrived in the Nile Valley with their rich dowry from a Syrian kingdom which had established an alliance with Thutmose. Such diplomatic marriages between rulers had been going on for centuries but would become a significant factor in state diplomacy as international relations intensified.

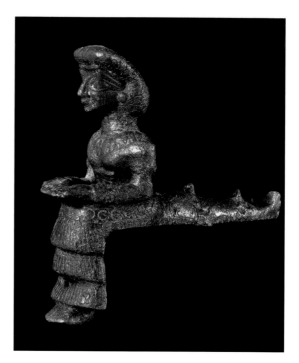

This Elamite bronze figure was originally fitted on to a larger object such as a piece of furniture. The hair style is very similar to that of terracotta figurines from Susa also dating to the years after 1450. ME 132960

The elderly Thutmose took his son Amenhotep II as co-regent for two years, 1427–1425; Amenhotep's sole reign of some twenty-five years was largely peaceful, providing stability and wealth. However, Kadesh and its Syrian neighbours continued to present problems on the northern frontiers. In either his seventh or ninth year a major rebellion by seven local chieftains in Canaan was crushed and the bodies of the dead rebels were carried down the Nile hanging from the king's boat; six were exposed on the temple walls at Thebes and one taken all the way to the fourth cataract where it hung as a warning to the local population. Amenhotep acquired a huge amount of plunder from this campaign including an astonishing 746 kilos of gold and 300 chariots. Such was his achievement that Hatti and Babylon once again sent diplomatic gifts to Egypt requesting greeting-presents in exchange. Although portrayed in the Egyptian tradition as grovelling suppliants, the foreign embassies brought with them not only rich presents but the possibility of peace between the regions which was as much a boon to Egypt as to the kings of Hattusa and Babylon. Among the diplomatic exchanges, Amenhotep was keen to emphasize the arrival of representatives of the kingdoms of Nahrin, in other words the states owing allegiance to Mitanni. Peace between the two great powers of Egypt and Mitanni was welcomed after years of warfare, and resulted in Egypt leaving Syria largely alone and focusing its permanent political control on the coastal plain of Canaan. Increasingly stable relations across the region

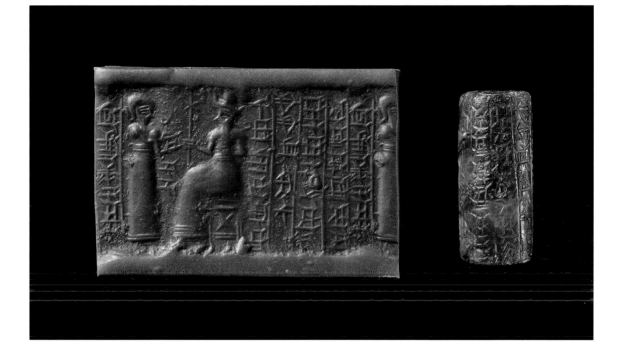

were reflected in Egypt by the growing popularity of Syrian objects as prestige symbols. For example, glass vessels imitating marble became prized in Egypt and were copied there, as were silver and gold 'flat-bottomed' vessels originating from Syria. Indeed, even the cults of Canaanite and Syrian gods such as Reshef and Astarte were now promoted in Egypt.

One kingdom that did not send a greeting-present to Amenhotep following his military successes was Assyria. This was because the northern plains around the river Tigris had by this time been conquered by Saushtatar of Mitanni. He was at the height of his power with territory stretching from Ugarit and Kizzuwadna, which Saushtatar claimed as client states, eastwards to beyond the ancient trading city of Ashur. Saushtatar plundered Ashur and had the gold and silver doors of the city's main temple carried back to his capital Washshukanni where he hung them in his palace. The fertile lands of Assyria stretching east to the kingdom of Arrapha and its large Hurrian population were also brought under the authority of the Mitannian king. Within Arrapha lay the small town of Nuzi at the foothills of the Zagros Mountains on a route linking the resources of Iran with Assyria. Populated largely by Hurrians but including Kassites, Assyrians and other groups, the town thrived on an economy based on the local agriculture, animal husbandry and trade by private

Impressions made by Elamite cylinder seals, like this jasper example depicting a worshipper standing before a seated god, have been found at Haft Tepe in southwest Iran dating to around 1400. Inscriptions using cuneiform were now written in Elamite (a language that is still only partially understood).
ME 140793

45

This terracotta figurine was excavated at Susa, where some two hundred essentially identical examples were discovered, all made in moulds. The woman represented may be a goddess, perhaps associated with fertility since her sexual features are exaggerated. ME 91823

individuals as well as by the local government. Objects were imported both for local consumption and for re-export along the trade routes, and there was small-scale production of pottery, metalwork and glass within the town. Indeed, Nuzi was typical of the walled settlements that dotted the landscape, and its mayor maintained relations with neighbouring settlements and people. For Mitanni, apart from the control of regular trade, tribute and taxes, one of the major attractions of dominating such towns in northern Iraq was the supply of horses which were traded through them from the east.

The trade routes running south from Arrapha, following the foothills of the Zagros Mountains, ultimately reached the plains around Susa and the lands of Elam. The once powerful dynasty of the *sukkalmahs* had come to an end in the first half of the fifteenth century. The close political and economic links with its western neighbour of the Sealand were reduced with the conquest of that region by the Kassites of Babylon, and Elam had become divided into numerous small kingdoms scattered through the mountains and valleys. By the end of the century a line of local rulers were describing themselves as kings of Susa and Anshan (Tal-i Malyan), although the title may not have reflected the actual territory they controlled which may have been more limited in extent. However, around 1400 one of these kings, Tepti-ahar, had sufficient wealth and workforce to have a very elaborate mud-brick tomb and the massive mud-brick terraces of a temple precinct constructed at Haft Tepe, perhaps the royal centre of his small state. The scale of the buildings points to Elam's revival, as trade and diplomacy linked the region with the growing economies of the wider world.

CHAPTER 3

Power and Prestige
1400–1300 BC

In the years around 1400 much of the Near East was effectively divided between four major kingdoms. To the southwest lay Egypt which dominated both Nubia and cities and states in Canaan as far north as the kingdom of Kadesh. Much of northern Syria and Iraq lay under the authority of Mitanni with its influence reaching to the Mediterranean and southeast Anatolia through alliances with states such as Ugarit and Kizzuwadna and in the east by dominating kingdoms such as Ashur and Arrapha. Central Anatolia was subjugated by the Hittites, and the Kassite kings of Babylon had unified the cities and tribes of southern Iraq into a single country with their influence extending through the Persian Gulf. Between and beyond these powerful states and their subjects and vassals lay smaller kingdoms and regions under the control of local rulers and warlords either too distant to be incorporated effectively or sufficiently powerful to resist subjugation.

To the west of the Hittite kingdom the political world of Anatolia was, like its geography, fragmented, and a number of states, often in close alliances, created continual problems for the rulers of Hatti as they sought access to political influence and trade routes. By the late fifteenth century there had been a rapid succession of Hittite rulers reflecting the continued pressures the kingdom faced from its neighbours and the loss of lucrative connections to the south, especially those through Kizzuwadna which was now linked by treaty with the kingdom of Mitanni, the dominant power in Syria. A vigorous attempt to reverse the apparent decline in Hittite fortunes began with the accession to the Hittite throne of Tudhaliya II.[1] The

1 Some scholars think that there may have been an earlier Hittite king called Tudhaliya (I) who was responsible for some of the actions assigned here to Tudhaliya II.

restoration of Hittite influence beyond the homeland was achieved only after a significant struggle. Indeed, the very rebellions and assassinations that had led the king to the throne were probably viewed as a source of Hittite weakness by kingdoms in the west of Anatolia and resulted in the creation of a hostile military confederacy consisting of Arzawa and its allies. Time and again Tudhaliya led his forces against this considerable threat to Hatti; after four campaigns he had devastated many of the threatening countries. In an attempt to weaken these aggressive states, Tudhaliya transported large numbers of their infantry and chariots back to Hattusa. Perhaps it was the dangers posed by the evidently vigorous Hatti that resulted in the rapid formation of yet another coalition against Tudhaliya, this time consisting of at least twenty western lands. Led by the state of Assuwa, the alliance included many countries along the Aegean coast, which revealed the far-reaching impact of Tudhaliya's campaigns and the recognition of the threat posed by a revitalized Hatti. Again Tudhaliya reports a major success in battle, leading 10,000 foot-soldiers and 600 teams of horses for chariots back to Hattusa along with other animals and booty. A significant western danger to Hatti had thereby been reduced in a spectacular fashion with the added bonus of substantial plunder for the new king. However, while Tudhaliya was fighting the lands of Assuwa, the Kaska swept into Hatti from the north and devastated the country. On his return the Hittite king drove the Kaska out and pursued them in a series of campaigns into their own territory.

In the centre of this Hittite haematite stamp seal dating to around 1400 are the name and title of the owner. They are written in Hittite hieroglyphs that record Luwian, a language closely related to Hittite. Seals like this may have been used by storehouse administrators who monitored the collection and movement of royal income in the form of agricultural products, textiles and metals. ME 115655

Such was the situation that nearly every Hittite king had to face; a constant struggle to maintain the security of the homeland against potentially hostile neighbours. Tudhaliya had secured, at least temporarily, the borders of his realm in the west and the north although the country had been ravaged. Problems, however, also existed to the east of Hatti which had the dire prospect of drawing in Mitannian forces. The kingdom of Isuwa lay between Hatti and Mitanni and, like Kizzuwadna, it fluctuated between the two powers. Tudhaliya considered that it belonged within the Hittite sphere of influence and complained to the new Mitannian king Artatama that he was sheltering people of Isuwa and should return them. The request was refused and, during the time that Tudhaliya was occupied with campaigns elsewhere, Mitanni invaded Isuwa to demonstrate its authority in the region. Tudhaliya was able to restore some hold over the pro-Hittite towns but the two major kingdoms now eyed each other warily across this disputed territory.

Of greater significance for the Mitannian king, however, were Hittite advances into Kizzuwadna which, probably under considerable pressure, changed its allegiance to Tudhaliya. The route to Syria was thus reopened for the Hittites, allowing their forces to attack as far as Halab. Although they did not establish a permanent presence in Syria, the Hittites now represented a considerable menace to Mitanni's control of its western subjects and the opening moves had been made in a struggle for the domination of the region.

Hittite expansion encouraged Mitanni to draw closer to its old enemy of Egypt, whose own Syrian vassals were potentially threatened by the Hittite advances. Battles between Egypt and Mitanni for the control of Syria had given way under Amenhotep II and Saushtatar to a diplomatic relationship where each side acknowledged the reality of the situation with the kingdoms of the region divided between them. Conflict still took place at crucial border regions, and Thutmose IV on coming to the Egyptian throne in 1400 launched a campaign into southern Syria to confirm his control. Ultimately, however, diplomacy won the day and Thutmose spent much of his reign negotiating a treaty with his Mitannian former opponent. Eventually a deal was struck and the marriage between the Egyptian king and the daughter of Artatama gave Egypt control of Kadesh and the states of Amurru and Ugarit.

The powerful kingdoms increasingly interacted with each other as if they were members of an exclusive club or extended family, and the rulers of Egypt, Mitanni and Babylon began to correspond, calling each other 'brother'. Marriages between members of the club reinforced this notion, and gifts of friendship moved people, animals and exotic goods between

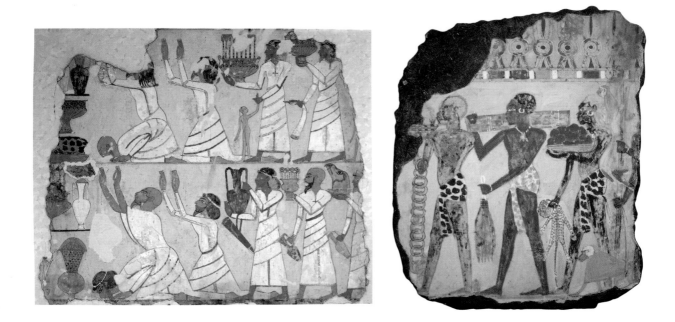

courts. Although marriages between ruling families as well as the exchange of diplomatic gifts and niceties had always been important methods of cementing dealings between states, regular relations on a truly international scale probably began only under Thutmose IV with his marriage to the Mitannian princess. Kings of the Near East would send their daughters to become wives of rulers that they considered to be their inferiors. Egypt, on the other hand, had a different cultural outlook; the rulers of Egypt would never allow their daughters to marry other kings but accepted and asked for foreign wives as a sign of their superiority. Everybody was happy.

The friendship between Egypt and Mitanni brought peace and prosperity. With the Egyptian empire reaching from Nubia in central Africa north along the Mediterranean coast to Syria, the country under Amenhotep III (1390–1352) entered a period of splendour reflected in ambitious building projects. Nubia was ruled directly through a viceroy and a military government which ensured continued access to the wealth of Africa – a campaign in Amenhotep's fifth year was necessary to prevent Nubians from interfering with the transport of gold. In contrast, local rulers in Canaan were forced to recognize Egypt's authority and supplied

These three fragments of painted plaster come from the tomb of Sebekhotep, a senior treasury official during the reign of Thutmose IV (1400–1390). They were part of scenes showing Sebekhotep receiving the produce of the Near East and Africa on behalf of the king.

far left
Syrians pay homage, some carrying vessels made of gold inlaid with semi-precious stones. One man leads a small girl by the hand, while another carries an elephant tusk. EA 37991

left
Three Nubians carry luxury items characteristic of their country: gold rings, jasper, ebony logs, giraffe tails, a leopard skin, a live baboon and a monkey. EA 922

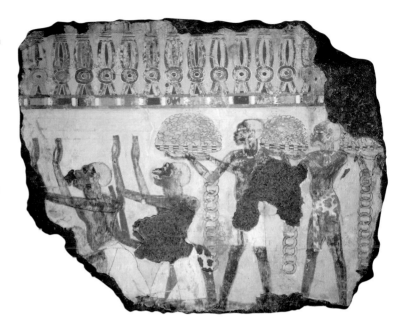

regular deliveries of tribute and, as required, trade goods and emergency materials and personnel. The vassal kings were expected to report on activities in their region and would undertake military operations against their neighbours. They also had to deal with local *habiru* groups who were a continual menace to the smooth running of states. Independent action was tolerated as long as Egypt's interests were not damaged, and many princes engaged in local negotiations and subtle manipulation to gain political and economic advantages. Sons of rulers were sent to Egypt for training (they were really political hostages) and their daughters might become minor wives of the Egyptian king. As an extra safeguard, Egyptian officials and troops were stationed in Gaza, Kumidi, and Sumur on the coast. Diplomats and officials were exchanged between courts and they were often accompanied on their journeys by merchants – the local rulers were held responsible for the safe passage of such caravans of people, materials and goods.

The results of this developing interaction between the great kingdoms were royal courts of extraordinary luxury and, with Egypt as the leading member of the international club with its apparently unlimited reserves of gold, its objects and imagery spread across the Near East and the eastern

above
Nubians arrive and carry plates of gold with interlinked rings of gold over their arms. EA 921

Mediterranean – an increasingly cosmopolitan region of the world. Indeed, the amount of Egyptian material on the Greek mainland increased dramatically under Amenhotep III. The names of Aegean cities including Mycenae, Phaistos and Knossos appear on statue bases of the king reflecting Egyptian knowledge of the wealthy rulers of Mycenaean Greece and Crete at the edge of the circle of great powers. Knossos remained an important centre following the destruction of Minoan palaces across Crete and was now very much part of the Mycenaean world. On the Greek mainland, for the first time, palaces were constructed at the centre of some of the more important kingdoms. At Mycenae and Tiryns they were built on natural rock outcrops (*acropoleis*) above the rest of the settlement, while other Mycenaean centres, without the natural fortress, had the palace positioned on slightly higher ground. These large buildings, based on a 'megaron' arrangement (a main hall approached through a porch and usually having a central hearth flanked by corridors and rooms) and perhaps related to earlier architecture found in Anatolia such as at Troy, were the hub of the local economies with the distribution of products like wool and perfumed oil in exchange for imported luxury materials like copper, tin, gold and ivory.

Mycenaean culture permeated the Aegean along exchange routes that had earlier seen the spread of Minoan culture. But traders were not the only people to move between the islands of the Aegean, mainland Greece and western Anatolia. Warriors saw opportunities to carve out their own centres away from the established Mycenaean kingdoms. Among them was a man called Attarsiya, described by the Hittites as 'the Man of Ahhiya', perhaps a reference to Achaean Greeks. He had established a base in western Anatolia with a small army of infantry and chariots and forced a local leader called Madduwatta to seek refuge at the Hittite court. The Hittite king Tudhaliya established Madduwatta as a vassal ruler in territory lying between Hatti and the state of Arzawa. Perhaps with Hittite prompting, Madduwatta saw an opportunity to extend his authority and invaded Arzawa under King Kupanta-Kurunta. The campaign, however, ended in failure. Madduwatta was forced to flee and Hittite troops had to be sent to his rescue. Since military action against Arzawa had not worked, Madduwatta now tried diplomacy. He concluded a treaty with Kupanta-Kurunta and married one of the king's daughters. It was probably unclear to the Hittites whether Madduwatta was a true friend of Hatti or had ambitions of his own.

During the time that the Hittites looked west towards the Aegean, the kingdoms of Syria remained relatively peaceful, encouraged by the good relations established between their Egyptian and Mitannian overlords. This

King Amenhotep III (1390–1352) commissioned a large number of statues of himself in Thebes, mostly, like this colossal example, for his mortuary temple on the west bank of the Nile. EA 7

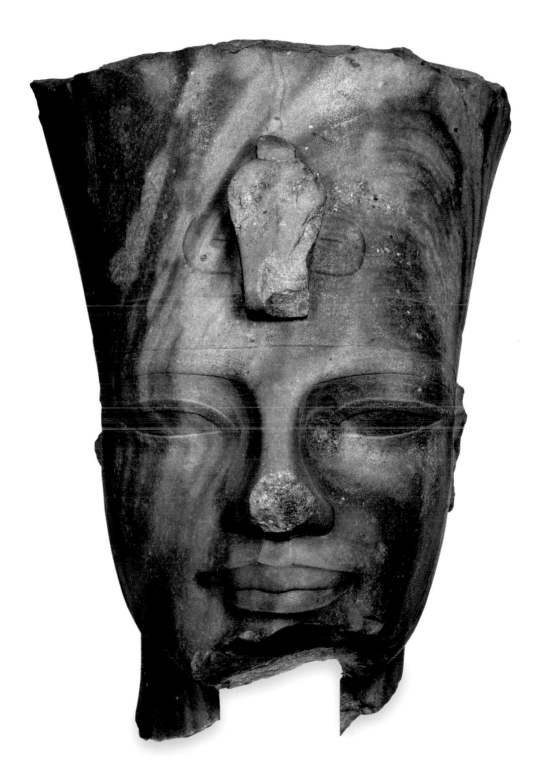

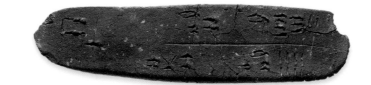

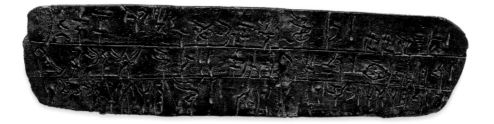

friendship was maintained under Amenhotep III with his marriage around 1380 to Kelhu-Heba, the daughter of King Shuttarna II of Mitanni. The Mitannian king even sent a statue of Shaushga, the Hurrian war goddess, on loan to Egypt. Other, more distant, kings had also joined the international club as peace allowed the movement of diplomats, merchants and gifts across the wider Near East. Kurigalzu I of Babylon sent a daughter to become one of Amenhotep's wives, as did his son and successor Kadeshman-Enlil (1374–1360) who, among the regular exchange of gifts, received a range of ebony furniture overlaid with gold for his new palace as a greeting-gift from the Egyptian king. In return the Babylonian king could potentially have sent highly prized horses, bred on the plains of southern Iraq, and some of the rare stones and metals that were carried from the mountains of Iran. Much of this material, such as silver, tin and lapis lazuli, entered Babylonia from the southeast, through the kingdom of Elam. Here, from around 1400, an energetic dynasty of rulers at the old Elamite capital of Susa had created a stable realm and established relations with the kings of Babylon through marriage; the practice of Elamite princes taking a Babylonian princess as their wife would continue for generations.

The international correspondence that connected the royal courts of the great powers and the small Canaanite and Syrian vassal kingdoms was conducted in the diplomatic language of Akkadian. This presented no problems for the scribes of Assyria and Babylonia where Akkadian was the native language and had been written on clay tablets in the cuneiform script for millennia. However, elsewhere local scribes had to be trained in cuneiform, and among the Akkadian texts they copied out was the tale of

These tablets, made of unbaked clay, formed part of the archives of the palace of Knossos. The fire that destroyed the palace baked the clay. The archives recorded goods and people under the palace's control. The language represented is Greek and reflects Mycenaean domination at Knossos from about 1450 onwards. Archives of Linear B tablets have also been found in the Mycenaean palaces of the Greek mainland. The smaller of these tablets records numbers of sheep at Phaistos; the larger concerns the offering of oil to various deities. GR 1910.4-23.1, 2

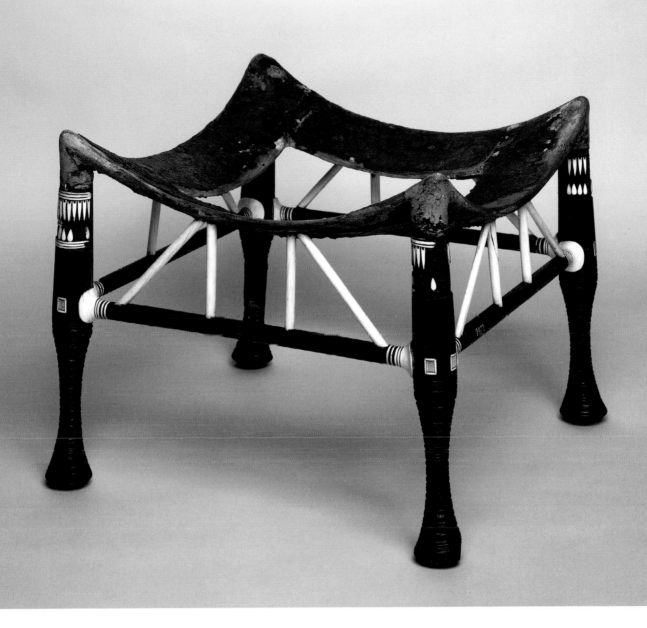

Exotic woods were imported into Egypt, which has little wood, from central Africa and the east Mediterranean and made into high-status furniture. The cylindrical legs of this stool from Thebes are incised and inlaid with small pieces of ivory in lotus petal and drop shapes. It provides evidence of the fine-quality furniture, often decorated with paint or inlays of wood, ivory, semi-precious stones or even gold, sent as gifts to foreign courts. EA 2472

the hero Gilgamesh and his search for immortality.[2] The story was known in Egypt, Hatti and Canaan and such was its appeal that scribes at Hattusa adapted the story and produced their own versions written in Hittite and Hurrian.

Despite the pleasures of court life available in states across much of the region, they were seldom enjoyed by the ruler of Hatti. When Tudhaliya died around 1370 his successor Arnuwanda I was faced not only by the continued menace of the Kaska people on the northern frontier but also by a rebellion that broke out in the state of Hapalla to the west of Hatti. The Hittite king looked to his father's appointee Madduwatta to deal with the latter problem. Madduwatta's efforts were successful but he followed up his campaigns by advancing into the so-called Lukka lands of southwest Anatolia. This was a step too far and Arnuwanda tried to rein in his increasingly powerful vassal. Madduwatta agreed to hand over Hapalla but not his other conquests. Never one to miss an opportunity, Madduwatta joined forces with Attarsiya of Ahhiya, the very man from whom he had fled years before, and ships of the Lukka lands and ships of Ahhiya plundered the coastal settlements of Cyprus, which were increasingly prosperous thanks to their export of copper mined from rich deposits on the island.

From Cyprus boats could reach Ugarit, one of the richest kingdoms on the coast of Syria. Nominally in the Egyptian sphere of control, in reality Ugarit acted largely independently; its ruler Ammishtamru paid lip-service to Amenhotep III through correspondence and gifts. The wealth of Ammishtamru and his successors was reflected in a large, handsomely built, stone palace. The city of Ugarit was ideally situated to benefit from trade routes which ran from inland Syria as well as the maritime exchange systems of the eastern Mediterranean. Merchants from Cyprus were based here and boats brought Cretan and Mycenaean pottery to the port. Ugarit exported olive oil and wine; wool and linen cloth were manufactured and sold; and wood and grain were brought to the city for distribution. Some local merchants were in the service of the king and were given gold to make purchases, although the palace also fitted out trading ships.

Further inland, however, the dominant kingdom of Mitanni faced internal problems. Artashumara, the legitimate successor of Shuttarna II, was assassinated and, around 1360, his young brother Tushratta was

This Syrian bronze figure probably represents the Canaanite god Baal who embodied royal power. Originally the eyes would have been inlaid, and he wielded a weapon. Much of our knowledge about Canaanite gods comes from the local Canaanite literature, particularly from an archive of cuneiform tablets from Ugarit. ME 134627

2 Gilgamesh was probably a real king of the Sumerian city of Uruk in southern Iraq around 2700. A series of stories concerning his heroic exploits were written down around 2000 and, during the first half of the second millennium, they were developed into an epic tale. Cuneiform clay tablets inscribed with the Gilgamesh epic have been found at Hattusa, Ugarit, Emar and Megiddo.

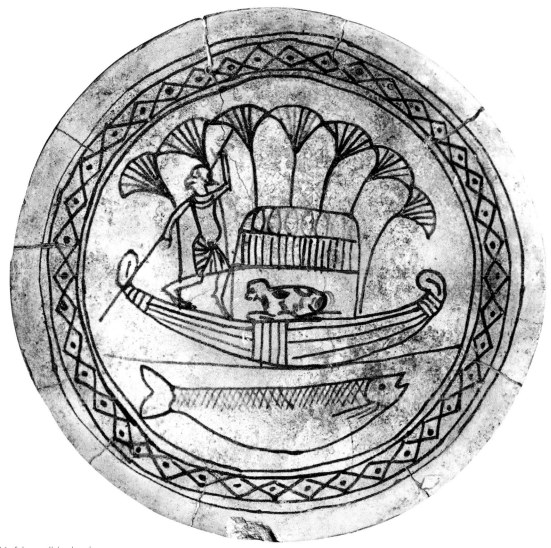

This faience dish, showing a man wearing an Egyptian kilt and punting a papyrus boat, comes from a tomb at Enkomi on Cyprus. The Enkomi tombs contained a rich mixture of local and imported products, illustrating the key position occupied by Cyprus in cultural exchanges. GR 1897.4–1.1042

placed on the throne. After a number of years Tushratta was able to take revenge on the regicides and he reopened relations with Egypt, attempting to restore the credibility of Mitanni as a member of the circle of international powers. As a greeting-gift for his sister he sent gold toggle-pins, gold earrings and a ring, along with a stone scent container full of oil. To his brother-in-law Amenhotep III he sent five chariots and five teams of horses. In addition, Tushratta was able to send a chariot, two horses and a male and female attendant from the booty he had gained by successfully repulsing an invading Hittite army.

This Hittite defeat at the hands of Mitanni was part of the much larger problems now confronting Hatti as pressure on the kingdom from the surrounding regions reached desperate levels. Once again the Kaska swept in from the north, devastating the homeland. They even stormed Hattusa itself, forcing the royal court to flee. At the same time soldiers from Arzawa advanced through the south of the Hittite realm. It was perhaps at this point that Amenhotep III corresponded with King Tarhundaradu of Arzawa when it appeared as if that kingdom was about to become the dominant power in Anatolia. The Egyptian king sent a greeting-gift with his messenger requesting a daughter of Tarhundaradu to marry, noting at the same time that he had heard that Hatti had been destroyed.

Despite what looked like a hopeless situation for the Hittites, the new king Tudhaliya III (about 1355–1345), aided by his son Suppiluliuma, fought back by first attacking the Kaska tribes. Having weakened or driven back many of these people, the Hittite forces were able to strike west, re-establishing Hittite control over many of the countries and attacking enemy states. However, the kingdom of Arzawa remained the greatest threat to Hatti.

Sporting a distinctive Hittite version of the horned headdress worn by Near Eastern deities, this tiny gold figure (nearly 4 cm high) from Anatolia is perhaps a warrior or hunting god. The Hittites adopted many of the deities of the surrounding regions, including those of the Hurrians. ME 126389

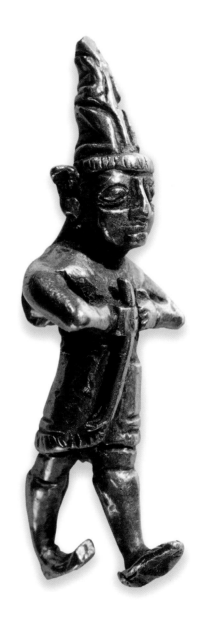

Suppiluliuma led the troops to the southwest and the so-called Lower Land which had been occupied by Arzawa. A struggle ensued between the two major powers but eventually Suppiluliuma regained control of the territory. However, Arzawa remained independent and powerful and could potentially call upon support from other western states.

While Hatti attempted to restore its control over central Anatolia, relations between Mitanni and Egypt were finally re-cemented around 1355 by the marriage of Tushratta's daughter Taduhepa to Amenhotep III. An enormous number of precious objects were sent as a wedding present to Egypt, the highlights of which were horses, a chariot covered in gold, bridles and horse equipment of gold, precious stones and ivory, weapons of various kinds overlaid with gold, bracelets, anklets, necklaces, clothing, shoes, scent containers with exotic oils and lesser objects including tens of arrows, javelins and blankets. But an underlying reason for Tushratta's rich gifts was the need for Egyptian support to shore up his rule which was attracting rival claimants. Within a few years of the marriage, however, Amenhotep III died (1352) and was succeeded on the throne by his son Amenhotep IV. Tushratta now looked to the new ruler of the Egyptian empire to maintain friendly relations. He sent letters imploring Amenhotep to honour promises made by his father, especially concerning solid gold statues which had not been sent. He even wrote to the Queen Mother Tiye asking her to intercede on his behalf. As a reminder of the long relationship between the two courts, Tushratta sent an image of the goddess Shaushga to Egypt as his father had done in less unstable times. But Tushratta's hold on the throne of Mitanni was looking increasingly tenuous and his membership of the elite club was on the verge of being cancelled. Indeed, a rival called Artatama had established his authority in the eastern lands of Mitanni, and the Hittites, keen to encourage the breakup of the state, established a treaty with this newcomer.

Pressure on Mitanni was intensified following events at the Hittite court. By Tudhaliya III's death some time after 1350, Hittite authority had been re-established in much of the homeland. He was succeeded by one of his sons, also called Tudhaliya. Although the new ruler was recognized by the nobles of Hatti, his appointment must have been resented by Suppiluliuma, who had been largely responsible for leading the Hittite armies to victory. The inevitable result was that Suppiluliuma and his followers revolted and his brother was killed. Once he had dealt with opposition at court and established himself on the throne around 1344, Suppiluliuma set about re-establishing his centre of power by refortifying the capital Hattusa. From here he launched campaigns into Kizzuwadna and Isuwa. Hittite power was once again reaching out towards Syria where

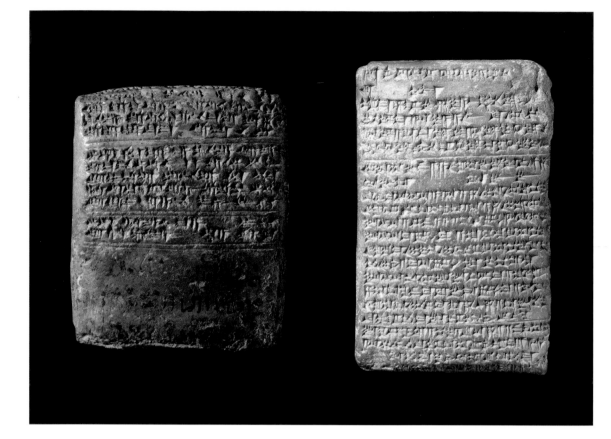

the Mitannian kingdom was threatening to fall apart.

Attempts to further isolate Tushratta were achieved when Suppiluliuma joined the international family of powers by establishing diplomatic relations with Egypt and Babylon. Within a few years of his accession Suppiluliuma had married Tawananna, daughter of Burnaburiash II (1359–1333) king of Babylon, and the expected exchange of rich presents took place. Many of the exotic items that the Babylonian king could send to his royal 'brother' included objects manufactured from materials obtained from connections with Iran but also from the Gulf, where the most important trading centre was the island of Bahrain or, as it was called by the Babylonians, Dilmun. The island

These clay tablets are part of a collection of 382 cuneiform documents discovered in AD 1887 in Egypt, at the site of Tell el-Amarna. They represent the correspondence of Egypt's vassal rulers in Canaan as well as several letters sent to the Egyptian king by rulers of the other great Near Eastern powers during the period about 1360 to 1336.

above left
This letter is addressed to Amenhotep III from Tushratta, king of Mitanni. The letter includes greetings to his daughter Taduhepa, who had become one of Amenhotep's many brides. Three lines of Egyptian, written in black ink, were added when the letter arrived in Egypt. ME E29793

above right
The Babylonian king Burnaburiash II complains that Amenhotep IV has not sent him as many valuable gifts as were sent to his predecessor. He then asks why the Assyrians have been allowed to come to Egypt since he claims they are his vassals. Finally he announces the dispatch of lapis lazuli and horses. ME E29785

was now directly controlled by the Babylonian king through a governor. Burnaburiash had also sent a daughter to Egypt to marry Amenhotep IV and received in return an enormous range of gifts including a ship overlaid with gold, as well as gilded beds, a throne and chairs, together with vessels of silver and bronze, fine linen, containers of oil, ebony and ivory objects, a gilded statue of the king with its pedestal overlaid with silver, figures of the king's wife and daughter and exotic objects from Canaan.

Egypt was transformed by the enormous wealth and power available to it from the empire. At the royal court there was an increasing focus on the cult of the sun god who was believed to rule both Egypt and foreign lands – the latter were thus no longer viewed as representative of chaos but none the less owed the king, as a manifestation of the god, their submission. Under Amenhotep IV this development reached its apex when the sun disk, or Aten, together with the royal family (who became the sole intermediaries for the deity), came to replace the state gods, especially Amun of Thebes. With the support of the army and the court, images of Amun were removed and the wealth of the Theban temples reduced. In his fifth year (1348) Amenhotep IV changed his name to Akhenaten ('glory of the sun-disk') and focused his reign on creating a new city called Akhetaten on the east bank of the Nile. The royal administration was moved to Akhetaten, from where the king monitored the disintegration of Mitannian power. Despite the political problems in north Syria, the Canaanite world remained securely under Egyptian control and trade flourished with quantities of Mycenaean pottery delivered to the king's new city. Egyptian subject states in southern Syria were expected to contain any local problems themselves, as had been the policy under Akhenaten's father.

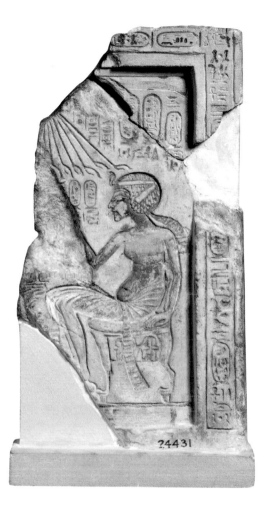

This small stela, depicting Amenhotep IV (1353–1336), is clearly associated with religious developments which culminated during his reign in the establishment of Akhetaten (Tell el-Amarna) from where this stela probably comes. The relaxed pose of the king, his accentuated stomach and head and the motif of the sun disk (Aten) with its life-giving rays reflect the notion that Akhenaten was the sole intermediary of the Aten, and thus all addresses to the deity had to go through him. Houses contained small shrines to the king for this purpose. EA 24431

Akhenaten was not the only powerful ruler to establish his own royal city. The Elamite king Untash-Napirisha (about 1340) demonstrated his immense wealth through extensive building projects. Although he decorated Susa with many monumental constructions, it was the establishment of a new cult centre called Al Untash-Napirisha (city of Untash-Napirisha) that was his greatest achievement in architecture. Located between the lowlands and highlands of Elam, the site consisted of numerous temples and a huge stepped platform or ziggurat built of millions of sun-dried bricks with a 2-metre-thick skin of baked bricks. Stairways led up four levels, some 12 metres (39 feet) high, to a shrine on the summit faced with glazed blue and green plaques. Untash-Napirisha added to his prestige by conducting military campaigns to the east of the Tigris but diplomacy ensured his connections with the international club when he married the daughter of Burnaburiash II, whose extended family now included the royal houses of Elam, Egypt and Hatti.

A decorative glazed wall plaque from Al Untash-Napirisha (Choga Zanbil) with a cuneiform inscription which reads: 'palace of Untash-Napirisha' (around 1340). ME 132225

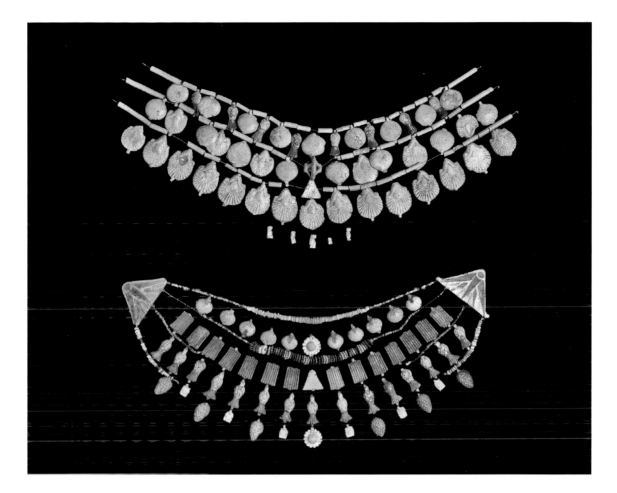

Of all the members of the great powers, it was the Hittites who were most active militarily. Within four or five years of taking the throne Suppiluliuma was ready to launch an attack on Mitanni using the excuse of an anti-Hittite uprising in Isuwa. The Hittite army crushed the rebellion and then marched south into Mitanni itself. In an extremely rapid advance Suppiluliuma reached the Mitannian capital Washshukanni which was stormed and plundered. Tushratta fled. Suppiluliuma turned west, claiming and plundering all of Mitanni's client and vassal states including Qatna, Kadesh and territories as far south as Damascus. The Hittite king set up one of his sons in Halab as viceroy of the conquered territory with responsibility for defending it. The only kingdom that had lain within Mitanni's western sphere that did not fall or submit to the Hittites was Carchemish.

Although Kadesh was a state over which Egypt might claim authority

By the mid-fourteenth century the city of Lachish was part of the Egyptian empire under a vassal king Shipti-ba'al. These necklaces from a small sanctuary in Lachish illustrate the strongly Egyptianizing style of Cannanite art around this time. ME 132125-6

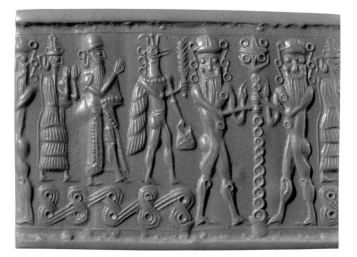

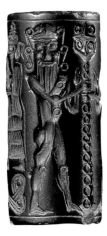

there was no reaction to the Hittite conquests from Akhenaten. Presumably the Egyptian ruler had no desire to fill the vacuum left by the collapse of Mitannian authority in the region or to engage in the kind of conflict that had existed in Syria at the end of the previous century. Indeed, Suppiluliuma and Akhenaten exchanged messengers and greeting-gifts. As long as Egypt's true subjects were not threatened by the Hittites it was sufficient to rely on local vassal rulers to maintain the borders, and their pleas for help were carefully managed in a policy of divide and rule. It was also apparent that the Hittites were facing significant opposition from some states that had either remained loyal to Mitanni or saw opportunities to establish their independence. To counter these problems Suppiluliuma sought an ally in King Niqmaddu II of Ugarit. Niqmaddu had friendly relations with Egypt, presenting himself as Akhenaten's loyal subject and even requesting on one occasion that he should be sent an Egyptian physician. Now, however, Niqmaddu was faced with a difficult decision. Should he join forces with his neighbours against the advancing Hittites or ally himself with Suppiluliuma? He chose to throw in his lot with Hatti with the result that Ugarit was attacked by the local kingdoms. Suppiluliuma sent an army to his aid and, having defeated the hostile states, the Hittite king transferred substantial amounts of territory and plunder to Ugarit which was tied by treaty to Hatti.

The Hittite conquests of Syria were given a further boost when Tushratta was assassinated. However, the collapse of Mitanni had encouraged the expansion of the kingdom of Assyria. Although part of

A Mitannian seal dating to between 1350 and 1250. The seal design, depicting the goddess Lamma, a worshipper and a griffin demon together with hero figures, is strongly influenced by Assyrian art, reflecting the increasing importance of the kingdom to the east of Mitanni during this period. ME 89556

Mitanni's realm at the start of the century, Assyria had reclaimed its independence as Mitannian authority had been eroded. Under Ashur-uballit I (1363–1328) Assyrian forces annexed the important grain-growing regions to the north and east of the capital Ashur which included the towns of Nineveh and Arbela. Ashur-uballit attempted to open relations with Egypt by sending Akhenaten a gift of a chariot, two horses and a piece of lapis lazuli. This was a tentative diplomatic approach and he made no claim to brotherhood, the true sign of being a member of the international club. None the less, the mere act of correspondence with Egypt annoyed Burnaburiash II of Babylon, who claimed that Assyria was his vassal and that Ashur-uballit's messengers should be sent away empty-handed. However, this was wishful thinking by the Babylonian king, and the Assyrians took full advantage of the political chaos in Syria.

Meanwhile Tushratta's son Shattiwaza had fled to Babylon and from there had gone to Hatti where he had thrown himself on the mercy of Suppiluliuma. The Mitannian capital Washshukanni had been abandoned to Artatama II and his son Shuttarna III whose pretensions to the Mitannian throne the Hittites had earlier supported. Shuttarna attempted to ward off any ambitions the Assyrians might have had of advancing into the heartland of Mitanni by returning the gold and silver doors of the Ashur temple that had been carried off as booty nearly a century before. However, Ashur-uballit was not willing to miss an opportunity to further expand Assyrian control, and his army advanced to the walls of Washshukanni. The Hittites recognized that they could no longer rely on Shuttarna's loyalty and Suppiluliuma sent his forces to Washshukanni. The Assyrians withdrew and Shattiwaza was appointed by the Hittites as king of what remained of the state of Mitanni, his actions answerable to another son of Suppiluliuma who had been appointed as viceroy in Carchemish following the earlier fall of that city after an eight-day siege.

The small kingdom of Mitanni now lay between the Hittite empire in Syria and the kingdom of Assyria in northern Iraq. Despite its withdrawal in the face of a Hittite army, Assyria was rapidly developing into a major power. Even Babylon could no longer ignore this fact and recognized the kingdom to its north in a marriage between Ashur-uballit's daughter with a son of Burnaburiash II. The couple produced a son, Karahardash, who was appointed king of Babylon on the death of Burnaburiash (1333) but he was almost immediately killed in a revolt at court. The murder of his grandson produced a swift response from Ashur-uballit, who invaded Babylonia and, the following year, installed Kurigalzu II, a member of the Babylonian royal family, on the throne. There was no attempt by Assyria to dominate Babylonia, which retained its independence. Kurigalzu II

refurbished numerous temples and also undertook extensive building work at the site of Dur Kurigalzu close to where the Diyala River flowed into the Tigris. This was one end of a major land route between the Iranian plateau and the Babylonian plains, and the city controlled the movement of exotic materials such as lapis lazuli. This beautiful blue stone originating in Afghanistan was regularly part of greeting-gifts sent to Egypt where, on the death of Tutankhamun (1327), it was used to embellish his magnificent death mask.

By stabilizing Babylon and expanding his authority over Nuzi in the east and as far as Hittite-dominated Mitanni in the west, Ashur-uballit of Assyria had moved on to the world stage. Now when he corresponded with the Egyptian ruler he described himself not only as a 'great king' but also as his 'brother'. The international family had welcomed a new member. Other kings had also been accepted as 'brothers' including the ruler of Cyprus whose ships moved consignments, including ingots of copper, around the eastern Mediterranean and jostled for markets alongside those of Ugarit and numerous other coastal states. The crucial links with Egypt were maintained but under Tutankhamun (1336–1327) the royal centre of Akhetaten had been abandoned and the Egyptian royal court had returned to Memphis with the restoration of the state cult based at Thebes – clearly Akhenaten's theological and political experiment had failed. At the same time, tensions between Egyptian and Hittite states in Syria were growing. Amurru attempted to establish itself as a buffer state, playing off the two powers but skirmishes by their armies pointed to the possibility of all-out war between them.

Quite suddenly the continued strain that existed between Egypt and Hatti over the control of Syria was given a dramatic twist. The widow of Tutankhamun, Ankhesenamum, wrote to Suppiluliuma asking for one of his sons as a husband. The throne of Egypt was within Suppiluliuma's grasp but he hesitated, unable to believe the authenticity of the request. A Hittite official was sent to Egypt to investigate and he returned to Hattusa with an Egyptian representative. Finally, Suppiluliuma was persuaded to send his son Zannanza south, but he died on the way. He perhaps died from plague, but the Hittites believed it was the result of foul play, possibly at the hands of Tutankhamun's successor Aya (1327–1323) who denied any responsibility. A Hittite army plundered cities in southern Syria and relations between the two kingdoms reached breaking point. However, the threat of war was reduced when Suppiluliuma died from plague in 1322. Within a year his successor Arnuwanda II also fell ill and died, and plague ravaged the country, decimating the population.

The reaction from Hatti's Anatolian neighbours was predictable. The

Vases, painted with scenes of humans and animals, were popular exports from Mycenaean Greece to the island of Cyprus where this one was found. Such chariot processions on vases may have been inspired by contemporary fresco paintings which decorated the walls of Mycenaean palaces. GR 1911.4-28.1

Kaska people, who had already crossed the northern frontiers while Suppiluliuma had been occupied in Syria, now pushed their advantage and occupied areas of the Hittite homeland. It was fortunate for the new Hittite ruler, Suppiluliuma's youngest son Mursili II (1321–1295), that the Syrian kingdoms, under the firm authority of Hittite viceroys, initially remained loyal. Successful campaigns against the Kaska occupied his early years on the throne but then a greater menace emerged when the king of Arzawa formed an alliance with the king of Ahhiyawa, possibly the Mycenaean island of Rhodes or a confederation of islands off the western coast of Anatolia. To make things worse for the Hittites, Millawanda (Miletos), one of their subject states on the Aegean coast, also sided with the king of Ahhiyawa. To counter both Mycenaean influence and the threat of

Dating around 1325, this Egyptian papyrus is a combination of recipes and magical spells for various ailments. One of the main concerns is skin complaints which are to be treated with spells that include words to be spoken in foreign languages. The language of Crete is mentioned, as is 'the Asiatic disease', possibly leprosy. Other spells are in a Northwest Semitic language which might represent the earliest attested examples of Canaanite and Aramaic. EA 10059

Arzawa, Mursili led a huge Hittite army to the west. Arzawan forces were decisively defeated and Mursili deported thousands of the local people. The once powerful country of Arzawa was reduced to a Hittite subject state and its king and his family and followers fled to the islands of Ahhiyawa.

Many of the small Mycenaean kingdoms of the Aegean islands and Greek mainland were consolidating their authority at this time and major palace complexes were being constructed in some of the more powerful centres. Fortifications created from enormous blocks of stone, similar to those built by the Hittites at Hattusa, were being erected in kingdoms such as Tiryns and Mycenae, where the citadels were surrounded by massively thick walls. These constructions were expressions of local power but also served as defences against rival kingdoms. That inter-state conflict was a

feature of the Mycenaean world is perhaps reflected in the final destruction of Knossos which had already occurred on Crete some time around 1350.

Southern Syria also remained a source of instability in the wider region and, after the general Horemheb claimed the throne of Egypt on the death of Aya, he confronted the Hittites in an attempt to recover Kadesh and Amurru around 1315. The Hittites were successful in asserting their authority, but only for a while, and over the following years a number of Syrian states including Kadesh rebelled and had to be brought back into line.

Despite the hostilities that dogged both powerful and insignificant kingdoms, the fourteenth century witnessed unprecedented royal prosperity. This depended on the smooth flow of materials and finished products along the network of land and sea routes. Rulers demanded or requested the safe passage of their merchants who were not to be taxed in the lands and cities they passed through. Such journeys, whether taken at the behest of a ruler or by independent traders, could prove to be extremely dangerous. In the years around 1310, a trading vessel hugging the southern coast of Anatolia (off the Uluburun promontory) got into serious trouble and sank, coming to rest on a steep rocky incline. Some of the crew may have managed to scramble ashore but the cargo was lost. Approximately ten tons of Cypriot copper in the form of oxhide ingots together with Canaanite jars, ingots of glass, logs of Egyptian ebony, ostrich eggshells and elephant tusks as well as Canaanite jewellery and Egyptian objects of gold, electrum, silver and stone were strewn across the floor of the sea. It is possible that this was a royal consignment, perhaps a greeting-gift, sent from a ruler in Cyprus or Canaan and destined for a western Anatolian or Mycenaean kingdom. Perhaps the local ruler sent a complaint that his expected greeting-gift had failed to arrive and a minor diplomatic incident occurred. Although many of the items on the ship were suitable for ceremonial exchange between elites, other items such as scrap metal, clay bowls and glass beads were not. The ship clearly belonged to a high-status trader who may have been acting as a royal agent but he also traded on his own, probably through multiple ports on the way to present the greeting-gift.

Empires Collide
1300–1200 BC

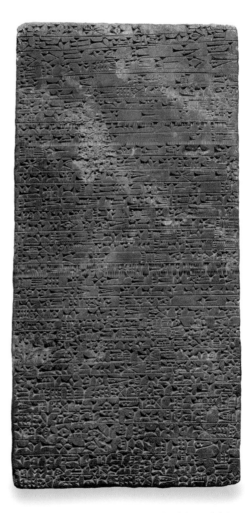

Assyria's presence on the international stage as established by Ashur-uballit I was not easily maintained by his immediate successors. The capital Ashur was near to the frontier with Babylonia and, despite close relations between the Babylonian and Assyrian royal families, the potential for hostilities was always present. Under Adad-nirari I (1305–1274), however, Assyrian forces were able to push the Babylonian frontier southwards to the region of the Diyala River and the important trade route to the Iranian plateau. While the northern and eastern borders of Assyria abutted mountains where pastoralist groups had to be contained, to the west lay the remnants of the heartland of Mitanni, known to the Assyrians as the land of Hanigalbat and technically a client state of the Hittites. The ruler of Mitanni, Shattuara, was hostile to Assyria, and Adad-nirari marched against him and forced the Mitannian king to recognize Assyria as his overlord through regular payments of tribute.

Adad-nirari had calculated correctly since the Hittites failed to react as the territory of Mitanni was removed from their control – they were heavily committed elsewhere. The Hittite

This gypsum slab was found in the temple of the god Ashur in the city of Ashur. It commemorates the restoration of the temple by Adad-nirari I (1305–1274) and describes his military exploits including his conquest of the remnants of the kingdom of Mitanni which brought Assyrian authority to the borders of the Hittite empire. ME 90978

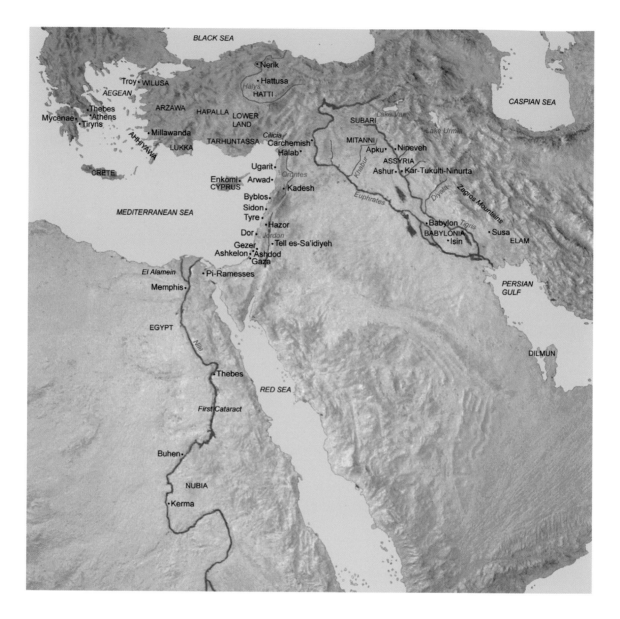

Map showing sites mentioned in chapters 4–5.

empire inherited by Muwatalli II (1295–1272) appeared relatively stable, with the troublesome Kaska people, at least for the moment, held in check at the northern frontier, and Syria largely peaceful under the Hittite viceroys of Carchemish and Halab. However, a problem had emerged in the northwest of Anatolia where a local warlord called Piyamaradu was attempting to carve out his own kingdom in the land of Wilusa which owed its loyalty to Hatti. Piyamaradu had also managed to marry one of his daughters to the ruler of Millawanda who had close ties with the

Mycenaean Greek world of Ahhiyawa which was always open to opportunities for expansion on the mainland. A Hittite army was able to dislodge Piyamaradu from Wilusan territory and he and his followers fled. Muwatalli now drew up a treaty with Alaksandu, the ruler of Wilusa, who was required to report any rebellious activities in the region to the Hittite king. In addition Alaksandu was obliged to send infantry and chariotry should the Hittites be attacked by other members of the international club of powers, listed in the treaty as Egypt, Babylon, Mitanni and Assyria. There was a clear recognition that war between members of the family of rulers was a real possibility.

The point of greatest friction that had potential to ignite such a war between the superpowers was at the border between the Hittite and Egyptian vassal states in Syria. Although Egypt under Horemheb had sent troops to the region to confirm its control, the rapid change of ruler between his successor Ramesses I (1295–1294) and his son Sety I (1294–1279) stalled any plans for confronting Hittite authority in the region. Control over their northern subjects became increasingly important for the Egyptians as a source of revenues – the African gold mines were starting to become exhausted and attempts were made to expand into other regions of Nubia in search of new supplies – which were needed to fund Sety's ambitious programme of temple refurbishment and building. Initially, the focus of the Egyptian army was on the local rulers along the Canaanite coast, including Gaza and Tyre as well as various Bedouin groups who were forced to submit. Sety now set his sight on the reconquest of Kadesh and Amurru which had been under Hittite control since the campaigns of Suppiluliuma some fifty years earlier. The Egyptian campaign was a success and, by bringing Kadesh over to the Egyptian side, challenged Hittite authority at a time when Muwatalli's forces were possibly occupied in Anatolia. Within a few years, Sety returned to southern Syria to consolidate his control over the region but this time the Egyptians met substantial opposition from a Hittite army. This first major encounter between the two powers was claimed as a victory by Sety with Hittite prisoners taken back in triumph to Egypt. None the less, the region of Kadesh remained a source of contention.

Although major campaigns into Syria by the Egyptian king further inflamed the tensions along the southern borders of the Hittite realm, Muwatalli also faced continuing threats from the Kaska people. The Hittite capital Hattusa was a convenient base from which to launch campaigns against these troublesome people to the north, but the city's location made it vulnerable to their attack and it was also geographically inconvenient for campaigns into Syria. All these factors, and possibly the desire to create

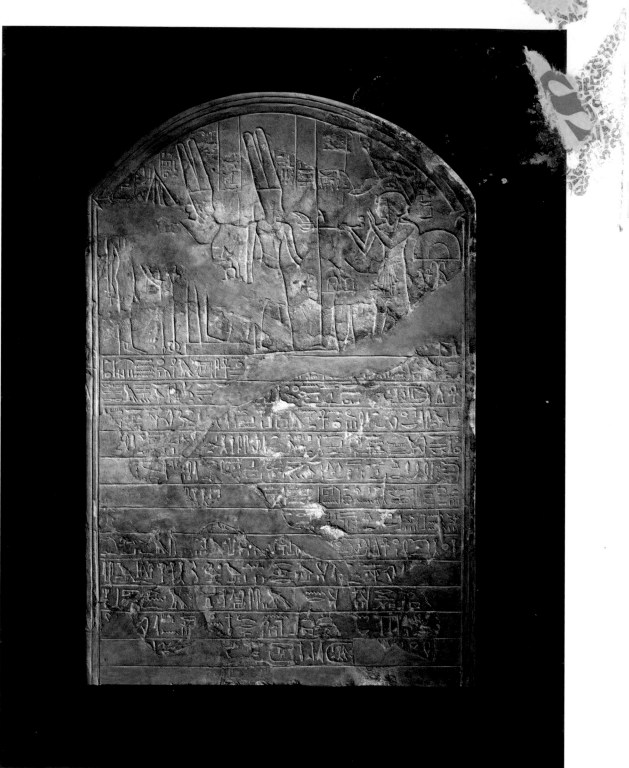

his own royal city, prompted Muwatalli to transfer the capital to the city of Tarhuntassa several hundred kilometres to the south.[1] Hattusa and the northern region of Hatti were placed under the rule of Muwatalli's brother, Hattusili, with the job of confronting the Kaska menace. Through military action and treaties with local cities and tribes he began slowly to push the Hittite frontier northwards.

The Hittites could now devote their energies to protecting and advancing their borders in Syria. Tensions between Egypt and Hatti remained strained and showed no sign of easing when Sety I died in 1279 and was succeeded by his son Ramesses II. By Ramesses' fourth year it had become apparent that some Syrian states were once again fluctuating in their allegiance to Egypt and he led an expedition to southern Syria to enforce Egyptian authority. However, by the following year of 1274, Kadesh had switched its loyalty to Hatti. Muwatalli was now in a position to confront the Egyptians and called upon the local rulers of his empire to provide troops. According to Ramesses at least sixteen countries supplied the Hittites with forces including Arzawa, Kizzuwadna, Carchemish, Ugarit and Kadesh. In total Muwatalli's army included some 3,500 chariots and 37,000 infantry. Ramesses gathered his forces at his newly founded royal city of Pi-Ramesses (an extension of Avaris) in the eastern Delta. Moving along the coastal plain of Canaan the Egyptian forces divided into four divisions with Ramesses leading the way. As the king prepared to cross the Orontes Valley with just one division, the other three having spread out some distance to the rear, he received word that the Hittite army posed no threat since it was gathered in the land of Halab. The Egyptians therefore advanced to the northeast of Kadesh and prepared to lay siege to the rebellious city. However, the information passed to Ramesses concerning the location of the Hittite army had been a ruse and Muwatalli had in fact gathered his forces just across the Orontes from Kadesh. The Hittites advanced across the river and caught one of the advancing Egyptian divisions in total surprise and it was routed. Ramesses and his troops put up resistance and with the arrival of more Egyptian soldiers were able to inflict some damage on Muwatalli's forces. The Egyptians managed to withdraw, although Hittite chariotry continued to harass

opposite
A sandstone stela of Sety I (1294–1279) which was set up at Buhen, a strategically important site in Nubia giving access to quarries and mines in the Eastern Desert. There was an increase in Egyptian activity in Nubia at this time. EA 1189

During the thirteenth century, Egyptian officials and soldiers were stationed in the larger cities of Canaan. It may be for this reason that Egyptian styles of burial practice, as exemplified by this clay mummy-like coffin lid from Lachish, were adopted at these sites. ME 1980-12-14,4297

1 The location of the city has yet to be determined but possibly lies in the region of the Lower Land.

them for some distance. While both sides claimed victory, the region of Kadesh and Amurru as far south as Damascus was effectively left under Hittite control. Even though Ramesses returned to Syria in his eighth and ninth years, marching down the Orontes Valley, Kadesh remained in Hittite hands and ill-feeling between the two sides continued to simmer.

During the time that the Hittites were occupied by campaigns in Anatolia and Syria, Assyria had claimed Mitanni as a client state. However, when the Mitannian king Shattuara died, his son Wasashatta rebelled against Assyria. He sought help from the Hittites but they were unresponsive; perhaps Assyria was not considered a sufficient threat, especially with the more immediate problem of Egypt, or the Hittites simply recognized the inevitability of Assyria's takeover of Mitanni. Whatever the reason, the Hittites did not intervene and Mitanni was again forced to submit to Assyria. The Assyrian king, Adad-nirari, whose western border now abutted the land of Carchemish, wrote to Muwatalli claiming brotherhood with the Hittite king as a fully fledged member of the international club. His right to membership, however, was rejected by Muwatalli on the grounds that only friends call each other brothers, and since no earlier Hittite ruler had acknowledged Assyria in this fashion why should Muwatalli? While Adad-nirari might, with some justification, call himself a great king, he and Muwatalli could hardly be described as friends following Assyria's annexation of Mitanni.

These events may have occurred towards the end of Muwatalli's reign and, after he died in 1272, his son and successor Urhi-Teshub had to face the reality of Assyria's presence on the international scene. Urhi-Teshub's uncle Hattusili, who was the most powerful prince in Hatti, accepted the accession of his nephew to the Hittite throne and perhaps advised that the royal seat be moved back to Hattusa, which was within his sphere of control. There was reason to distrust the power that Hattusili wielded, especially his military abilities. Indeed, among his conquests Hattusili had even managed to retake the city of Nerik which had been lost to the Kaska people as much as a century before. Urhi-Teshub therefore began to strip his uncle of many of his duties, prompting Hattusili to rebel, fomenting a civil war. A large number of the Hittite nobility joined with the older, experienced man and Urhi-Teshub's forces were defeated around 1264. Although Urhi-Teshub was provided by his uncle with a small kingdom in Syria to manage, he actively attempted to regain the Hittite throne by seeking help from Babylon and as a result was exiled to western Anatolia.

Hattusili recognized that he would be viewed as a usurper by the other great powers and he expended considerable efforts having his position accepted by them. Closer ties were established with Babylon under King

Ramesses II (1279–1213) was distinguished from neighbouring rulers by the royal attributes that appear on this statue of the king. He is shown wearing the two crowns of Upper and Lower Egypt; in his hands are the crook and the flail; and on his brow is the *uraeus*, the cobra snake ready to attack his enemies. The statue comes from the temple of Khnum, the god of the first cataract area, located on the island of Elephantine. EA 67

Kadashman-Turgu (1281–1264). However, Egypt remained hostile and when Urhi-Teshub sought refuge from his Anatolian exile at the court of Ramesses II he was welcomed. Hattusili wrote to the Egyptian king asking that his nephew be sent home, but the request was refused. In response, the Babylonian king detained the Egyptian ambassador at his court; Hattusili's legitimacy had been accepted by at least one of the great powers. Indeed, when Kadashman-Enlil II (1263–1255) succeeded to the throne of Babylon, traditional greeting-gifts were exchanged between the 'brothers' as well as specialists such as physicians and conjurers. As for the Assyrians, Hattusili complained in a letter that they failed to send him an ambassador and fine gifts as was the custom when a new king came to the throne. From Ashur, Shalmaneser I (1273–1244) responded that this was because Hatussili was a substitute king; Urhi-Teshub still had powerful supporters.

Shalmaneser tightened Assyrian control over Syria and, when his client ruler in Mitanni, Shattuara II, rebelled, an Assyrian official was appointed to replace him. Other governors were installed throughout the region in fortified centres and Assyrian armies conquered new territory on the upper Euphrates where a Hittite army was defeated. With Hattusili faced by a powerful rival in Assyria and Ramesses spending resources on expensive campaigns to Syria, both Egypt and Hatti eventually realized that peace would benefit them both. Negotiations between the Hittites and the Egyptians were eventually concluded with a formal treaty in 1258. Hattusili received recognition as the legitimate Hittite king (Urhi-Teshub had lost any chances of being restored to the throne as the realities of international diplomacy swept him aside) and each side acknowledged the other's territory (the Hittites

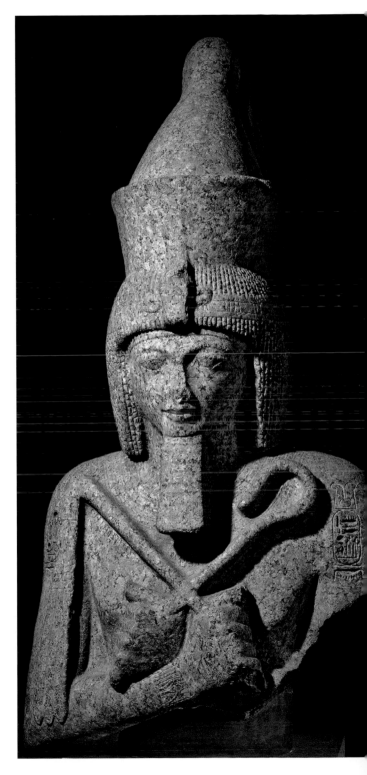

retained Amurru and Kadesh) and agreed to aid the other if there was rebellion or attack from a third party. Thirteen years later the relationship between Hatti and Egypt was cemented when a daughter of Hattusili became a 'great royal wife' of Ramesses and the marriage was suitably celebrated with great festivities and the exchange of magnificent gifts. Some time later, a second Hittite princess joined her sister as a minor wife of the Egyptian king and again innumerable rich gifts moved between the courts including vast numbers of horses, cattle and goats.

The end of conflict in southern Syria brought peace and stability. International trade began to flourish as borders were opened from the Aegean to Bahrain. A central cog in the engine of exchange was the wealthy and influential kingdom of Ugarit which was now thriving as it had done in the middle of the last century. Like many of the cities of coastal and inland Syria and Canaan, Ugarit was the centre of import, export and manufacture. Other prosperous cities included Byblos, Sidon and Tyre. Luxurious objects made of prestige materials were created in workshops throughout the region for the wealthy elite and as greeting-gifts for the royal courts; an international style of art had already been in existence for one hundred years, through which the owners, whether in Egypt, the Aegean, Anatolia or Babylon, could express their shared membership or relationship with the great powers. Such images included scenes of lions or supernatural creatures such as sphinxes, griffins or winged lions attacking other animals, or scenes of hunting, and animals grazing among exotic, stylized vegetation.

Peace also allowed rulers to focus their energies on protecting vulnerable borders. Ramesses II, like his father before him, had to repel Libyan attacks from the west, an area possibly suffering from increasing

These small gold figures representing Hittite gods were excavated at Carchemish, the centre of the Hittite viceroyship in Syria. Many are inlaid with steatite or lapis lazuli (a rare blue stone imported from Afghanistan). ME 116232

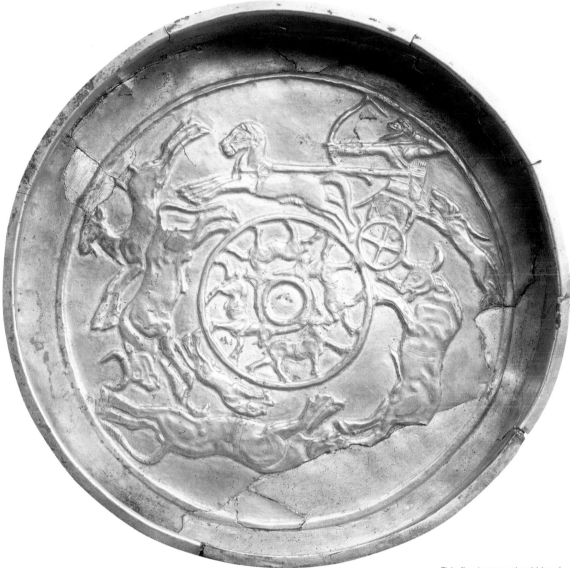

This flat-bottomed gold bowl was discovered on the acropolis of Ugarit. Scenes of hunting from a chariot were popular on elite objects across the wider region – an illustration of power which contrasts with the more neutral international images of fantastic and real creatures among stylized vegetation. Louvre Museum AO 17208

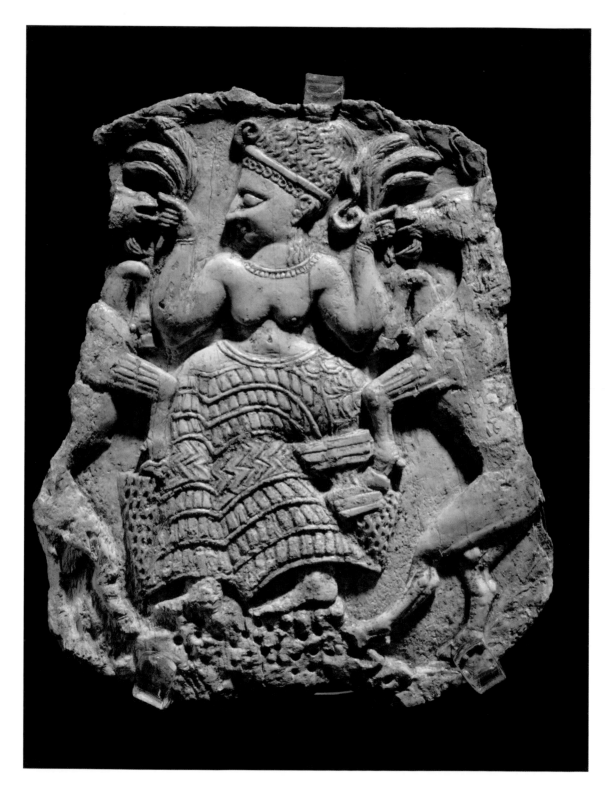

drought and famine. The Egyptian king initiated a major defensive programme: a chain of fortresses was built stretching from the Delta to el-Alamein, while, in the eastern Delta, the site of Pi-Ramesses was expanded to control the strategic route leading to Canaan. Soldiers and *habiru* groups were employed in the construction of these centres. In Canaan itself the garrison fortresses were strongly maintained at a number of sites (Beth Shean, Gaza, Dor, Tell es-Sa'idiyeh) where mercenary fighters from Syria and southeast Anatolia identified as Peleset and Tjeker were settled. Towns in Canaan shifted between Egyptian and local control as dictated by changing local economic and political circumstances. Some sites were strengthened while others were downgraded and the inhabitants moved between them as they sought security and employment. For similar reasons, other groups moved between Egypt and Canaan: perhaps among them were *habiru* (Hebrews?) who had worked on some of Ramesses' building projects and, led by a charismatic leader with the Egyptian name of Moses, ultimately joined the inhabitants of the Canaanite hill country. To the south of Egypt, Ramesses maintained strong control over Nubia where massive building projects were undertaken, including the great temples at Abu Simbel.

Although peace brought great prosperity to many of the Hittite-dominated cities in Syria, there were continued threats to Hittite control of western Anatolia. A major uprising in the Lukka lands involved the king of Ahhiyawa and the warlord Piyamaradu who had caused problems for Muwatalli in Wilusa years before. Hattusili launched a campaign to the

opposite
The imagery carved on this ivory lid, discovered in a private tomb at Ugarit's port (modern Minet el-Beida), is largely drawn from the Aegean, although its mixture of regional styles and iconography reflects the very personal nature of seaborne mercantile relations. Louvre Museum AO 11601

This ivory, fish-shaped cosmetic box was discovered inside a bronze bowl which had been strapped, using Egyptian linen, over the genitals of a body found in a grave at Tell es-Sa'idiyeh in Jordan. The incorporation of objects into tight binding around the body is related to the Egyptian practice of mummification and reflects the strong Egyptian influence at the site. ME 1987.7-27.138

Several gods and goddesses were imported from Syria-Canaan into Egypt with the conquest of parts of the region. This stela, belonging to Qeh, a foreman of workmen at Thebes around 1250, shows the major Asiatic deities. In the lower register Qeh and his family worship Anat, goddess of war. Reshef (a Canaanite war deity) is on the right in the upper scene, along with the Egyptian god Min on the left. Min and Reshef were associated with the goddess Qedeshet, shown naked, standing on a lion and holding flowers and snakes. EA 191

Lukka lands and the Hittite armies crushed the revolt. Piyamaradu fled to Millawanda, subject territory of Ahhiyawa, and from there probably to the islands off the Anatolian coast. Hattusili wrote to the king of Ahhiyawa requesting him not to give Piyamaradu shelter while he remained hostile to Hatti. The king of Ahhiyawa was addressed in the letter as 'brother' indicating equality with the Hittite ruler. This significant Mycenaean power in western Anatolia as represented by Ahhiyawa may be reflected in the later tales about the Trojan War which some traditions date to this period. Indeed, in the mid-thirteenth century the citadel of Troy was protected by impressive fortifications with watchtowers built into the imposing walls, and behind the walls were spacious buildings built on a

A bull's head is the most popular form for Mycenaean clay vessels that would have been used for the sprinkling or pouring of liquids as part of a religious ritual. These examples, from the island of Kárpathos in the Aegean Sea on the left and from Enkomi on Cyprus on the right, are hollow, with an opening at the back and a hole in the muzzle to allow the liquid to escape. GR 1887.5-1.6 (Vases a 971)

series of terraces leading up to the royal palace. However, although Troy suffered a violent destruction some time around 1250, this was the result of an earthquake rather than conflict.

By this time many of the Mycenaean rulers on the Greek mainland had accrued sufficient wealth and power to construct citadels on a grand scale as well as to have their palaces elaborated; the great Lion Gate at Mycenae, for example, was erected around 1250. Luxury products were produced for the elite and exchanged with neighbouring princes. The main export was probably perfumed oils produced under palace supervision. As elsewhere in the wider region the palaces were only one component of the exchange system, which involved people at all levels of society. Peace in Syria further encouraged the trade which connected the Mycenaean kings with Egypt, Cyprus and the Near East. The standard of living of the Aegean elite, and to some extent of the population as a whole, was dependent on the exchange networks with the Near East, especially for gold, ivory, tin and glass. Copper was much in demand and, although a significant source was the mines in southern Attica, the importation of the metal from Cyprus became increasingly important during the thirteenth century. It was a natural expansion of Mycenaean interests to establish footholds along the western coast of Anatolia and challenge the control of strategic centres such as Troy, probably the principal city of the land of Wilusa, which had suffered a number of military attacks and occupations. The city's control of the sea route to the Black Sea and therefore Mycenaean access to the

opposite
Compositions of fights between real and mythological animals, as
on this beautifully carved chalcedony cylinder seal, were typically
produced in the reign of the Assyrian king Tukulti-Ninurta I
(1243–1207). Winged animals, demons and humans continued to
be carved on seals into the first millennium BC. The theme spread
into the Mediterranean world, where, for example, the winged
horse Pegasus appears. ME 129572

right
Monkeys were not native to Iraq and would have been imported,
probably from Africa or India. Kings prided themselves on the
collections of exotic animals they acquired as booty or tribute.
This stone statue was found in a palace at the site of
Kar Tukulti-Ninurta in Assyria. ME 116388

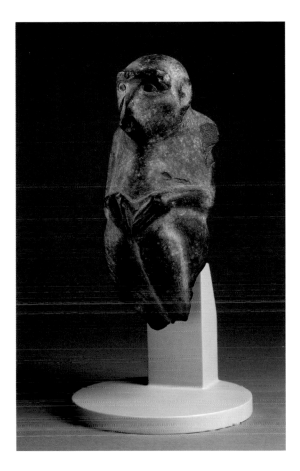

resources-rich settlements and people of the Caucasus was extremely
important, as is perhaps reflected in the legend of the journey to this
region by Jason in search of the Golden Fleece.

Mycenaean kingdoms continued to cause problems for Hattusili's
successor Tudhaliya IV (1239–1209) and there was a deteriorating
situation for the Hittites in western Anatolia. The pro-Hittite ruler of
Wilusa called Walmu had been deposed but he was reinstalled by a Hittite
army. However, the Lukka lands had again rebelled and Ahhiyawa was
giving support to rebels and dissidents from Millawanda. Tudhaliya's
forces attacked Millawanda and it capitulated, recognizing the Hittite king
as its overlord. Ahhiyawa had lost an important base on the mainland and
Tudhaliya now attempted to curtail Ahhiyawan political and commercial
activities further through a treaty with Amurru in Syria; a ban was placed
on merchant traffic between Ahhiyawa and Assyria via the harbours of
Amurru. In the treaty, Tudhaliya listed rulers considered of equal rank to
himself: Egypt, Babylonia, Assyria and Ahhiyawa. However, the last name

was ruled through by the scribe, suggesting that this Mycenaean kingdom was to be relegated to second rank.

With the west secured, Tudhaliya could benefit from the prosperity of his empire and he undertook massive building projects at Hattusa, including the elaboration of a religious site close to the capital (Yazilikya) where, on the walls of a natural chamber, the gods and goddesses of the empire were carved in relief. However, following the earlier clashes between Hittite and Assyrian armies in the mountains of southeast Anatolia, the new king of Assyria, Tukulti-Ninurta I (1243–1207), saw opportunities to extend his control of the region. He invaded the land of Subari which controlled important routes across the Euphrates into Anatolia and gave access to rich copper mines. The threatened loss of this lucrative area was of major concern to the Hittites. Tudhaliya reinstated Ugarit's obligation to provide him with military aid, but none the less Subari fell to the Assyrians and Tukulti-Ninurta now turned to the region southwest of Lake Van, which had been heavily fortified by the Hittites. The Hittite and Assyrian armies clashed and again Tukulti-Ninurta emerged victorious. Hittite authority had been seriously damaged.

Having consolidated his hold over southeast Anatolia, Tukulti-Ninurta turned to face the king of Babylon, Kashtiliash IV (1232–1225). Taking advantage of the Assyrian campaigns in Hittite territory, Kashtiliash had attempted to push his frontier with Assyria northwards. Tukulti-Ninurta swiftly engaged the Babylonian army in battle and claimed to have personally captured Kashtiliash, who was taken in chains to Ashur. The Assyrians then advanced on the city of Babylon itself, which was plundered before the whole of the country was subjugated. Strategically and commercially important areas of Babylonia were annexed to Assyria and Tukulti-Ninurta took the throne of Babylon himself, although after a few years he abandoned that idea and ruled northern Babylonia through a succession of puppet kings. The expansion of Assyrian control across much of Babylonia, especially the lands east of the Tigris, threatened to cut off Elam from the lucrative trade routes running from Iran through the region. Around 1224 the Elamite king Kiden-Hutran advanced with an army into Babylonia, sacked cities and removed Tukulti-Ninurta's appointee. The same thing happened some five or so years later when another Assyrian appointee was attacked.

Despite the problems with governing such a vast realm, especially with the Elamites determined to pursue their interests in Babylonia, the Assyrian king now had access to enormous resources. Tukulti-Ninurta undertook impressive building projects at Ashur and founded a magnificent new royal city, Kar-Tukulti-Ninurta, across the river Tigris

This granite lid from Thebes belonged to the sarcophagus of a man called Setjau, who around 1230 was the viceroy of Nubia. The office of the viceroy of Nubia was a very important position at this time, overseeing Egypt's access to the wealth of these lands. EA 78

from the capital. Control of the trans-Iranian trade routes by Assyria, which so threatened the Elamite kings, brought exotic stones such as lapis lazuli from Afghanistan to the royal court. It is possible that lapis lazuli found in Greece (at Thebes) may have been sent as a greeting-gift by Tukulti-Ninurta to one of the Mycenaean kings, despite the ban on traffic imposed by the Hittites. Some of the lapis lazuli pieces are cylinder seals that either were Cypriot in origin or had been extensively recut on the island; the kings of Cyprus played a crucial role in the wider network of connections.

The importance of Cyprus was underscored by a Hittite attack on the island. The target may have been the island's copper deposits following the loss of the important mines of southeast Anatolia to the Assyrians. It is also possible that Tudhaliya was forced to act when the grain supply transferred by sea from both Syria and Egypt to the coast of Anatolia was threatened by Cypriot ships or because the island provided naval bases for pirates and raiders. Grain imports were vital to the survival of the Hittite realm and deliveries may have become increasingly erratic. The new Egyptian king Merneptah (1213–1203) referred to grain shipments that kept Hatti alive, and the Hittite king requested that Ugarit should speedily supply a ship and crew to transport hundreds of tonnes of grain.

It is possible that ongoing drought contributed to the problems facing the major powers. In his fifth year Merneptah repulsed a large coalition of Libyans and their families moving towards the western Delta. These people were now joined by mercenary groups from the Aegean and Anatolia (some of whom also formed elements in the Egyptian and Hittite armies): Sherden, Teresh, Sheklesh, Ekwesh and Lukka. Other military expeditions were launched by Merneptah into Canaan to deal with rebellious vassals such as Ashkelon, Gezer and more mobile populations including a people called Israel.

As instability threatened lines of supply and communication across the eastern Mediterranean, internal problems exacerbated the difficulties at some

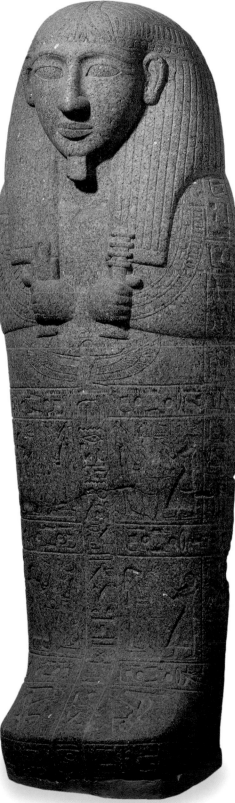

This pomegranate vessel, from Enkomi, is one of several found on the island of Cyprus where they were probably produced. Slightly different versions of these vessels were also made in Egypt, Syria and the eastern Mediterranean. GR 1897.4-1.1052 (Glass 14)

of the royal courts. In Assyria, the rapid creation by Tukulti-Ninurta of an empire stretching from Babylon to Anatolia led in his old age to rivalry for the throne. In 1207 the great warrior was assassinated by one of his sons. In Hatti, struggles for the throne may have arisen even before Tudhaliya died in 1209, and his cousin Kurunta possibly seized the throne before being replaced by the legitimate heir Arnuwanda III. However, the new Hittite king lived only a few years before the throne passed in turn to his brother Suppiluliuma II around 1205. The rapid change of ruler led to the inevitable breakdown in loyalty among the Hittite vassals. Although much of Syria remained secure under the control of the viceroy at Carchemish, the Lukka lands and the kingdom of Tarhuntassa along the southern Anatolian coast rebelled. Suppiluliuma was able to conquer and annex much of this territory, but major problems continued in the Mediterranean, where he was forced to undertake three naval battles against enemy groups who were based on Cyprus.

Piratical activity increased as economic and political conditions deteriorated at the edges of the western empires. Raiders began to attack coastal settlements of Cyprus and Syria in greater numbers. A ruler of Cyprus appealed for help from Ugarit against such enemies but the kingdom's troops and probably also its ships were engaged in supporting the Hittites. In turn, Ugarit sought help from the viceroy of Carchemish but was simply told to 'remain firm'. Yet, despite the troubled times, ships still attempted to make the journey from Canaan or Cyprus to the Aegean. In about 1200, one such merchant vessel ripped its hull open on a pinnacle of rock near the surface of the sea at Cape Gelidonya in southeast Anatolia and sank. The greater part of the cargo consisted of the ingredients for making bronze objects and included both Cypriot scrap bronze tools, intended to be recycled, and ingots of both copper and tin, meant to be mixed to form new bronze. Such trade, especially through cities such as Sidon and Tyre, managed to survive despite the upheavals that engulfed neighbouring areas over the following years.

CHAPTER 5

Collapse and Transformation
1200–1100 BC

In the early decades of the twelfth century the economic engine that had sustained the great powers began to falter. Although many of the problems besetting the settled communities around the eastern Mediterranean were familiar to the inhabitants of the region's towns and cities – seaborne raiders, such as those from the Lukka land of southwest Anatolia, troublesome pastoralist groups and stateless bands such as the *habiru* menacing Canaanite and Syrian states by disrupting communication and trade routes – the troubles were exacerbated by the fact that the Hittite and Egyptian empires were overstretched in both labour and resources. This led to an erosion of their economies and impoverished people began to seek opportunities by moving to areas beyond the urban centres, adding to the slow disintegration of the systems of control and interaction established by Memphis and Hattusa. Now, however, the rapid collapse of the Mycenaean palace systems and the kingdoms of Anatolia threatened the very existence of some of the key members of the international club.

The many palace centres on the Greek mainland were already under extreme pressure, probably resulting from inter-state rivalry, as reflected in substantially strengthened fortifications at, for example, Mycenae and Tiryns. At these two sites ambitious building projects included the construction of underground water supplies, suggesting that the citadels faced the threat of siege warfare; indeed, at Athens cyclopean walls were built around the Acropolis. These massive

The painting on this jar, from a tomb at Ialysos (modern Triánda) on Rhodes, is an example of the 'Octopus Style', which was made in several areas of the Mycenaean world after the destruction of the palaces around 1200.
GR 1870.10-8.96 (Vases a 932)

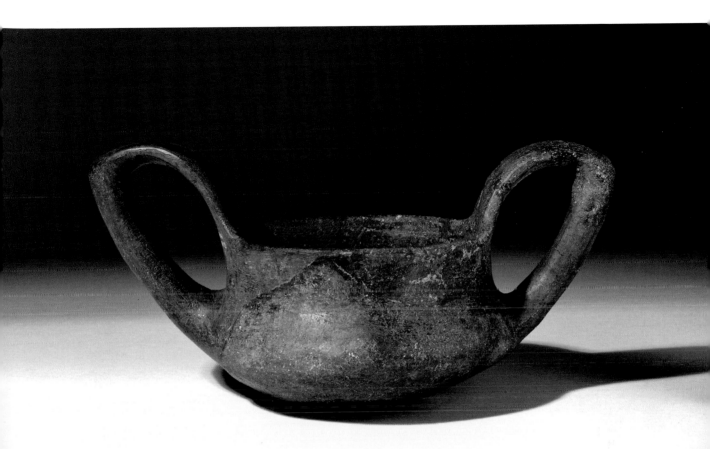

defences and water systems took a long time to build and were expressions of power and wealth but also of great competitiveness. Warfare over resources and territories brought destructions across several generations and the devastations were exacerbated at some sites by earthquakes. Many Mycenaean palaces were destroyed by fire and then abandoned. During these years of conflict the stresses on the economic and social systems were cumulative, leading to greater instability and loss of power by the elite. Drought may also have worsened the situation. These events encouraged some centres to take advantage and attack the weakened defences at other sites. While collapse of the palaces and their associated economies had a limited impact on the wider Near East, the abandonment of surrounding agricultural lands in the face of aggressive forces and perhaps famine and disease devastated the local economies and encouraged traders and skilled artisans to seek new markets by moving. Local leaders and their followers also sought new regions to settle or plunder.

This black burnished cup, dating to around 1200, comes from the mound of Hisarlik in western Turkey, which has been identified as the site of ancient Troy. ME 132376

Under normal conditions the Mycenaean palaces might have been rebuilt, but the critical supply lines with the wider world that had sustained the local rulers were being constricted as neighbouring states fell victim to economic and political collapse. The unsettled times saw movements of people from Europe into western Anatolia, creating additional pressures on the kingdoms of the region; indeed, around 1180 the citadel of Troy was violently destroyed, an event which may form the basis for the story of the Trojan War recounted some five hundred years later by the Greek poet Homer. The already fragmented political world of Anatolia broke further apart as kingdoms succumbed to internal and external pressures. Further to the east, not only did the Hittites face the disintegration of their Anatolian vassals but, as had happened so often in the past, hostile groups, including no doubt their old foe the Kaska people, descended on the kingdom. The advancing storm must have been apparent to the Hittite court since Hattusa had been largely abandoned before it was finally put to the torch. The significant difference between this catastrophe and previous destructions was that on this occasion the Hittite aristocracy were unable to resist the relentless tide of collapse and the kingdom was overwhelmed and swept aside. Any hope of support that the Hittite court might have sought from their subjects in Syria was crushed when the city of Ugarit was destroyed. Always vulnerable to attack from the sea by pirates or hostile neighbours envious of the kingdom's wealth, the ruler of Ugarit watched as the power of his Hittite overlord dissolved in the chaos of Anatolia and probably his own forces along with it. The magnificent trading centre and its sumptuous palace were destroyed, perhaps by hostile bands fleeing the devastations to the north and west or by local armies taking advantage of a weakened city, with the result that a central cog in the engine of interconnections was removed for ever.

Groups of Greek, Anatolian and Syrian warriors, who had previously hired themselves as mercenaries in the armies of the Hittites and other Anatolian states, together with refugees and dispossessed people, saw both opportunities and wealth in the more stable lands of Canaan and, like the Libyans driven to move against the Nile Valley, some of them began to move into Egyptian-controlled territory. A response from Egypt to the events unfolding to the north of their Canaanite subject states was possibly muted by rival claimants to the throne following the death of Merneptah in 1203. The legitimate king, Sety II (1200–1194), may have been deposed for a few years by a certain Amenmessu who, at the very least, ruled an extensive area in southern Egypt. Eventually Sety was able to extend his authority across the whole country but died soon after and was succeeded by his son Siptah (1194–1188). Siptah was a young boy and the country

The traditional enemies of Egypt (known as the 'nine bows') included Nubians, Libyans and Syrians. These glazed tiles show the captive enemies and may have been part of the decoration of a throne room in a palace of Ramesses III (1184–1153) at Tell el-Yahudia in the Nile Delta, placed either on the base of the throne or on the floor in front of the throne. The king would then literally and metaphorically trample on his enemies. EA 12337 (Libyan); EA 12288 (Nubian); EA 12361 (Syrian)

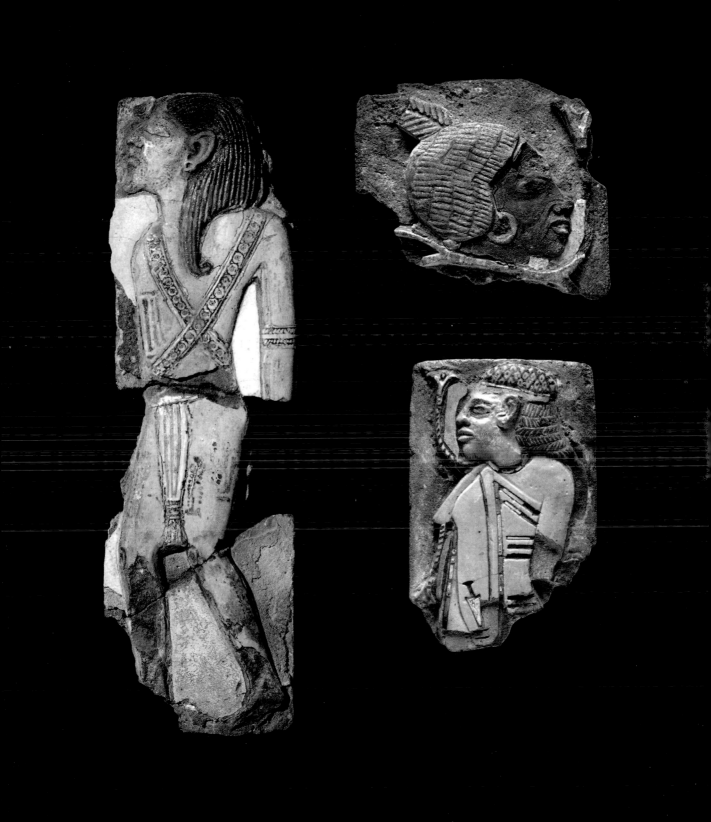

By the Ramesside period the Egyptian army had begun to incorporate many soldiers from southeast Anatolia and the eastern Mediterranean. Their physical features and weapons distinguish them on Egyptian monuments. Many appear as enemy 'Sea Peoples' on the external walls of Ramesses III's mortuary temple at Medinet Habu.

was governed by his stepmother Tausret, Sety's principal wife, who actually reigned as sole ruler for two years after Siptah died. On her death the throne was claimed by a man called Sethnakht who in turn was succeeded by his son Ramesses III (1184–1153).

A few years after Ramesses came to the throne, Egypt was faced by a threat from Libyan groups advancing into the Delta from the west. In the king's fifth year the Libyans had reached as far as the central branch of the Nile where the Egyptian army managed to halt them. Although the hostile bands were routed, many of the Libyans joined others already settled across the region. Three years later Ramesses faced a massive force of people he described as 'northerners coming from all lands' and 'of the countries of the sea' (the so-called Sea Peoples), moving along the coast of Canaan by land and water. Among them were soldiers identified as belonging to some of the same groups who had earlier joined with the Libyans to attack Egypt under Merneptah (Sherden, Teresh, Sheklesh) but they now included new groups called the Weshshesh (from north of Ugarit), Peleset, Tjeker and Denyen, all probably from the region of Cilicia. With the fighters came families moving with their goods and animals. This significant threat was probably only one among other smaller groups that had made their way towards Egypt over the years.

The defence of Egyptian territory in Canaan was largely dependent on the garrisons manned by Egyptian soldiers and, ironically, mercenaries whose original homes had been in the same regions as many of the people now advancing against them. The Egyptian army moved north along the coastal plain and engaged with the forces ranged against them in a land battle near the Canaanite coast, as well as possibly in a sea battle at the mouth of the Nile in the eastern Delta, breaking apart the attackers before they could reach Egypt. Many of the enemy soldiers were simply settled by Ramesses among their fellow warriors in the garrison towns of Canaan. Other groups sought out territory in the hinterland of cities or in the hill country. Although life in Egypt was not dramatically altered by these events, the economy continued to suffer, with widespread corruption and abuses leading to workers' strikes and even an attempt on the king's life by courtiers from within the queens' quarters. In an attempt to shore up the system, Ramesses made huge donations to the economically important temples, especially that of the god Amun in Thebes, whose administrators grew increasingly powerful.

Though Egypt still held sway in Canaan, the region had been dramatically changed by the influx of new people. Along the southern coast, in the cities of Gaza, Ashdod and Ashkelon, new members of the Peleset (Philistines) had settled among those already living there, and other

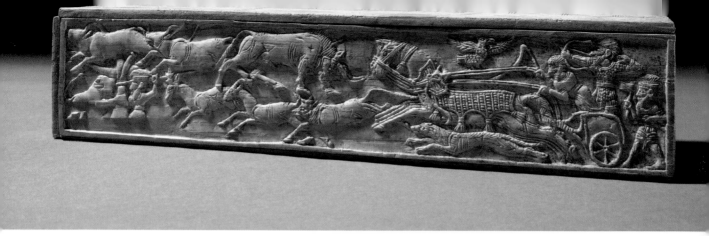

groups were similarly incorporated into both local and Egyptian-dominated towns along the coastal plain. Further inland, especially in the less populous hill country, various tribal groups such as Israel and bands of *habiru* manoeuvred for control of territory. A large number of the Canaanite sites had been strongly fortified and this allowed them to survive the disturbances and arrival of new people. However, the collapse of strong centralized control in Syria caused serious disruptions to the trans-Euphratian caravan trade. Sites such as Kamid el-Loz and Hazor began to decline as a result of the economic downturn. None the less, the destruction of Ugarit presented new opportunities for coastal commercial centres such as Byblos and Sidon. While movements of goods were reduced by the unsettled conditions, these city-states asserted their claim over land and sea routes; links with Cyprus were especially important as inland markets were curtailed. On Cyprus the economies of the coastal trading cities had been booming for at least a century and sites such as Enkomi, perhaps one of the centres of copper export, continued to flourish despite the upheavals around them as old trade routes were replaced by new ones.

Although the power of the Hittites had been swept aside in central Anatolia, some of their administrators in southeastern Anatolia and northern Syria survived to govern their territories as small independent kingdoms. One of the most important of these states was centred on Carchemish, where the ancestors of the rulers had once been viceroys and were descended from the Hittite royal family. Such dynastic continuity

Rich twelfth-century tombs at Enkomi, Cyprus, reflect the fact that the settlement was flourishing despite the destructions elsewhere. Many objects from the tombs were made of ivory which must have been imported from Syria or Egypt.

left and right
This gaming box has its top laid out for the 'game of twenty squares', which was widely played. The style of the hunting scene decorating the long side shows a strong influence from the Near East. In contrast, the ends of the box are very Mycenaean Greek in style. GR 1897.4-1.996

below
Two sides of a beautifully carved and decorated handle which must originally have been attached to a circular bronze hand-mirror. The lion attacking the bull is a familiar motif in Mycenaean art, while the theme of a warrior slaying a griffin owes its inspiration to the Near East. GR 1897.4-1.872

97

provided stability in the increasingly fragmented region. East of the Euphrates the region continued to be held by the Assyrians, who were not immediately affected by the destructions and disruptions in the Aegean and Anatolia. None the less, the rapid growth of the Assyrian kingdom into an empire reaching from the Persian Gulf to eastern Syria under Tukulti-Ninurta I had brought its own problems. Following the king's assassination in 1207, he was succeeded by two of his sons and another claimant. While these court intrigues did not lead to any major loss of Assyria's territories in Syria and northern Iraq, by around 1190 the Babylonian ruler, Adad-shuma-usur (1216–1187), felt sufficiently strong to mount a challenge to Assyria's claim to the southern kingdom and he captured the new Assyrian king in battle.

With Assyria's influence in Babylon severed, the Elamites, who had long sought power over the rich agricultural lands of Babylonia, saw an opportunity to claim the country for themselves through the marriage ties that linked the royal families. The Elamite king Shutruk-Nahhunte (1185–1155), who had married the daughter of the Babylonian king Meli-shipak (1186–1172), presented himself as the legitimate ruler of Babylon through his Kassite mother. Despite fierce opposition, the Elamite armies ransacked Babylonia and in 1158 the Kassite king was overthrown. Shutruk-Nahhunte received vast amounts of tribute from the cities of Babylonia, adding to the immense wealth of the Elamite realm. Towards the end of Shutruk-Nahhunte's reign a Kassite king was able to install himself in power in Babylonia, but the Elamites returned under Shutruk-Nahhunte's son Kudur-Nahhunte (1155–1150), who attacked the region and again plundered many of the major cities. Later Babylonian propaganda claims that he committed the ultimate crime of removing the statue of Marduk, patron god of Babylon, from his temple. The Elamite kings carried to their capital at Susa a huge amount of booty including monuments of some of the region's greatest rulers such as the stele of Hammurabi and Naram-Sin. These were among the final acts in a century of almost continuous conflict between Babylon, Assyria and Elam which fatally weakened the Kassite dynasty's long tenure of the Babylonian throne. The last Kassite king, Enlil-nadin-ahi, was carried off to Elam in around 1155 and a non-Babylonian was established as governor; the international family of great powers had lost another member.

By the middle of the century the upheavals that had sent shock waves across Anatolia and the eastern Mediterranean had begun to subside. Although the palaces were never rebuilt at Mycenae and Tiryns, the sites were not abandoned; at Tiryns the fortification wall was repaired and the settlement below the citadel was constructed on a new plan and expanded

This bronze wheeled vessel stand was made in Cyprus. Among the imagery is a depiction of a sphinx wearing a flat cap of the type common in Mycenaean Greece and Crete. The skills of casting, hard soldering and hammering, and the openwork technique, required to make this vessel stand were adopted in the twelfth century by Cypriot bronze workers under influence from Mycenaean Greece, Egypt and the Near East. GR 1946.10-17.1

with an influx of people. Perhaps Tiryns was the only place where there was some attempt to revive the old order, but without the wider connections it failed. Those Mycenaeans who had not fled the disasters of the previous decades rebuilt their lives but the palace-based economies of earlier generations were not revived. Some large buildings were constructed but there was nothing on the previous scale and the underground water-supply systems went out of use. However, a few of the artistic traditions of the earlier period continued, as demonstrated, for example, by the creation of wall paintings in a chamber tomb at Mycenae, as well as the production of sophisticated forms of pottery. Gradually though, over the second half of the twelfth century, the decoration of pottery came to reflect a growing regionalism as a number of centres developed styles independently of each other. Indeed, the mainland remained unsettled and politically divided; Mycenae suffered another major destruction by fire around 1140, as did a part of Tiryns. Areas of the Acropolis at Athens and within the citadel at Mycenae were given over to

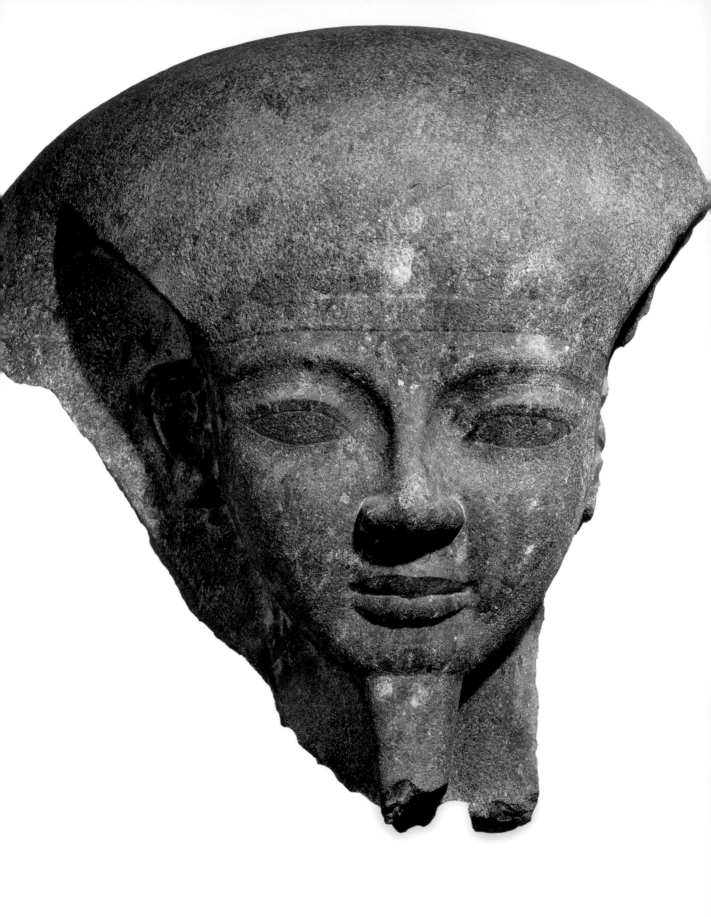

burials as the major centres of settlement shrank or were abandoned. Many groups found refuge on Crete and Cyprus while others ventured as far as the eastern Mediterranean following the old maritime trade routes and, although there were no large-scale migrations, the population of the Aegean declined significantly.

Some trading links were maintained with western Anatolia, and Mycenaean pottery found its way to Troy where the citadel continued to be inhabited. However, the site was no longer commercially important as a gateway for Aegean trade with the Black Sea region, nor, with the disappearance of the Hittites, did it have any strategic significance as a base for the control of western Anatolia. Other settlements such as Millawanda survived, as did a number of other towns on the coast, absorbing Greek-speaking immigrants from the Aegean. Meanwhile, among other people who were migrating into Anatolia from the west were the Phrygians, who may have had their origins in the Balkans. It is unclear if they contributed to the collapse of the kingdoms of Anatolia, such as destroying Troy in their advance, but none the less they gradually came to occupy a wide area of central Anatolia. Further east, the mountainous region to the southeast of the Hittite homeland was occupied around 1160 by the Mushki. These people were possibly connected in some way with the Kaska people, many of whom had also moved south from their northern homelands.

The connections between the Greek world and the eastern Mediterranean also persisted to some extent. The new styles of Mycenaean pottery were carried to ports along the Canaanite coast, probably via Cyprus, but the earlier international exchange system had been seriously weakened. In the Philistine settlements along the southern coastal plain, a local variety of pottery based on Mycenaean styles was produced, although by around 1130, when contact with the Greek world was declining further, a distinct Philistine style had emerged, combining painted motifs derived from Egyptian, Canaanite and Mycenaean traditions.

To the south, Egypt remained powerful, but under a line of ineffectual rulers the country began to lose control of its Syrian and Canaanite subject territories. Ramesses IV (1153–1147) mounted expeditions to the copper mines in Sinai but royal power was increasingly rivalled by the growth in the economically important position of the high priest of Amun at Thebes. After Ramesses V died at a young age, his successor Ramesses VI (1143–1136) also sent expeditions to Sinai, but by this time Egyptian power in Canaan had been withdrawn or lost. Garrison towns were abandoned or left undefended: Tell es-Sa'idiyeh was destroyed by a massive fire around this time. Growing internal difficulties in Egypt were reflected by the price

This finely carved face was part of the sarcophagus of Ramesses VI (1143–1136). It was during his reign that Egyptian domination of Canaan came to an end. EA 140

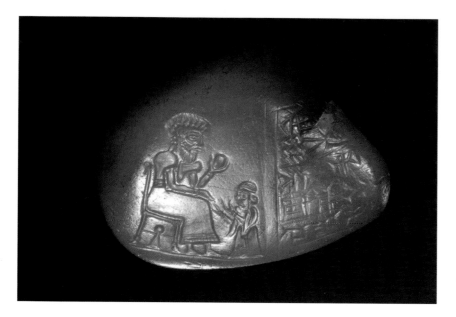

left
This pendant of blue
chalcedony, pierced for
suspension, is carved with
an inscription in Elamite
which reads: 'I, Shilhak-
Inshushinak [about
1150–1120], enlarger of the
kingdom, took this jasper
from [the land of] Puralish.
What I painstakingly made
I placed here, and to Bar-Uli,
my beloved daughter, I gave
[it]'. The scene shows the king
presenting the pendant to
Bar-Uli. ME 113886

of grain, which soared during the reign of Ramesses VII (1136–1129) either because of shortages or through mismanagement by the central authorities; only gradually did the prices come down again. By the reign of Ramesses IX (1126–1108) Libyan nomads were repeatedly troubling the region of Thebes, workers were going on strike and many of the royal tombs were being robbed as security weakened. The loss of royal prestige was reflected in images of the official Amenhotep who, as the high priest of Amun, had himself depicted on the same scale as the king.

opposite
The cuneiform text of
this *kudurru* (boundary stone)
from Sippar describes the
military services of Ritti-Marduk
to King Nebuchadnezzar I
(1125–1104) during a campaign
in Elam. The details of the
king's rewards to Ritti-Marduk
are listed, and nine gods are
invoked to protect the
monument. There are also
twenty divine symbols carved
in relief. ME 90858

As Egypt increasingly appeared to be inward-looking, Elam's revival as a major power reached a high point. Babylonia had been plundered and the Kassite dynasty that had ruled the country for centuries had been brought to an end. The Elamite king Kudur-Nahhunte was succeeded around 1150 by his brother Shilhak-Inshushinak, who organized many of the Elamite territories which had previously fallen within Assyrian and Babylonian spheres of influence into provinces. Although Babylonia was eventually abandoned, Elamite administrators were established through the Zagros Mountains as far north as the Diyala River, thus allowing them to control the important trade route leading to Arrapha and Ashur. This was a significant threat to Assyria under Ashur-dan I (1178–1133), who attempted to ward off Elamite expansion by a military campaign into the Diyala region. But, although the Assyrian king managed to deport people from the area, the Elamite border remained dangerously close to the Assyrian heartland.

Assyria had problems also along its borders in Syria. The weakening of state control over extensive territories in the west not only saw disposed and landless people pressing in against settled communities and trade routes, but pastoralists, especially Aramaean tribal groups who formed a significant component of the mobile populations living between the urban centres of the Syrian plains, now began to raid caravans and farming communities in the absence of armies to keep them in check. They started to penetrate Assyrian territories, attracted by the fertile lands around the Tigris Valley. Ashur-dan's grandson Ashur-resha-ishi I (1132–1115) described himself as the 'avenger of Assyria', and mounted repeated campaigns against these semi-nomadic groups. The western border defences were strengthened and the king established a royal centre at the site of Apku to the west of Nineveh, a more strategically useful area than the capital city Ashur from which to launch military expeditions to the northeast and west of Assyria.

During the time that Assyria and Elam vied for control of the Diyala region, Babylon had been left without a ruler. However, the far south of the country had been less affected by the devastations wrought by the Elamite armies and members of an important family at the city of Isin began to extend their power until, with the backing of a majority of the tribes and cities, they were able to claim the throne of Babylon. Under Nebuchadnezzar I (1125–1104) the new dynasty felt sufficiently secure to launch a series of campaigns against Elam. In the heat of summer Nebuchadnezzar led the Babylonian army as far as Susa itself. A major battle took place but Nebuchadnezzar's chariot forces ensured success for the Babylonians and the Elamite king fled the field. The triumph for Babylon was celebrated by later generations, especially because the statue of the god Marduk was recovered and returned to its temple.

With Elam neutralized by Nebuchadnezzar, Assyria was able to focus its energies against the growing threat from the movements of groups from the

north and west. On coming to the throne, Tiglath-pileser I (1114–1076) was faced by the advance of Mushki and Kaska people who were marching through the mountains in considerable numbers, following the course of the Tigris towards the plains of northern Iraq. The Assyrian army beat back the tribesmen, taking more than 6,000 prisoners, and Tiglath-pileser pursued his enemies into the hills to the northeast, where hostile tribal confederations were broken apart and their villages and livestock plundered. In another campaign the Assyrian king marched again into the mountains but this time to the region of Lake Van, an area known to the Assyrians as Nairi, where numerous tribes were forced to submit and pay tribute. While there were military successes in the mountains, the campaigns directed against the Aramaeans on the northern plains of Iraq and Syria were less decisive in their outcome. The Aramaeans now dominated the Euphrates region south of Carchemish and often raided as far east as the Tigris. Time and again Assyrian forces crossed the Euphrates (Tiglath-pileser claimed twenty-eight crossings during his reign) in an attempt to subdue the tribes but the Aramaeans, without permanent settlements, were able to melt into the landscape.

In the years around 1100 Tiglath-pileser undertook a triumphal march to the shores of the Mediterranean. With no strong state in Syria to bar his passage he reached the mountains of Lebanon where cedars were felled and the beams sent back to Ashur for the refurbishment of a temple. In the land of Amurru, west of the Orontes River, Tiglath-pileser received gifts from the coastal cities of Byblos, Sidon and Arwad, who were keen to supply the consumers of Assyria with their manufactured goods such as metalwork, textiles and fine ivory and wood carvings; among the presents presented to the king were a crocodile and an ape, perhaps originally from Egypt. The highlight of the expedition was provided by the island city of Arwad, whose elites gave Tiglath-pileser a six-hour Mediterranean boat cruise during which the king, renowned as a hunter of wild animals, speared a dolphin. Despite this prestige show by the Assyrian king, he was in no position to establish any permanent control over the region he had traversed and he returned home, albeit with his status abroad enhanced. Increasingly, however, the rulers of the surviving powers, Egypt and Assyria, were unable to look far beyond their own borders as pressure from outside mounted against them.

CHAPTER 6

The Threat of Chaos
1100–1000 BC

Although the causes of the crises of the previous century that had resulted in the disintegration of the Mycenaean and Anatolian kingdoms had receded by 1100, their impact was long-lasting. The fragile economic, social and political systems that had linked and sustained states across the entire region were irreparably damaged. The kingdoms had all been dependent on each other not only for access to symbols and materials which could express status but also for everyday goods and foodstuffs. The collapse of strong centralized control led to reductions in trade, inflation, internal problems, warfare, piracy, banditry and dispossessed people. In the early years of the eleventh century the world of Greece, Anatolia, Syria and Canaan had disintegrated into a mosaic of unstable principalities and tribal groupings competing for territory and resources.

Yet a level of continuity with the past persisted in certain areas. The descendants of the Hittite administrators in southeast Anatolia and north Syria were sufficiently strong to maintain their cities as the centres of small independent states. For example, Carchemish, Kummukh and Melid were ruled by dynasties which could trace their origins to the long-vanished Hittite empire, retaining many of the artistic and administrative practices of the rulers of Hatti. However, as central and southern Syria fragmented into small, widely spaced, urban enclaves, much of the plains were claimed by local tribal groups who spoke the Aramaic language. Although Aramaeans populated the cities and farming villages, a large number were pastoral nomads, moving their animals across grazing lands which in the past had been largely managed and policed by the various state authorities. From the middle of the twelfth century probable changes

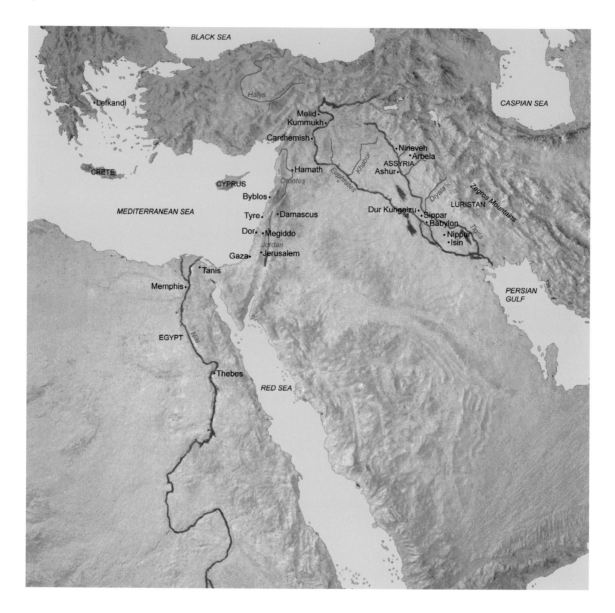

Map showing sites mentioned in chapters 6–7.

in the climate, perhaps for only a few years, had led to a drying of the pastureland. Settled agriculturalists living on the margins of farmland began to adopt a more flexible mobile lifestyle and joined with the pastoralist groups who began to seek new grazing lands, inevitably bringing them into conflict with sedentary groups and disrupting communications.

Despite his triumphal march across Syria to the Mediterranean, Tiglath-pileser I of Assyria was faced by the continual menace of Aramaean groups.

His army campaigned against the Aramaean tribes again and again in the region of the middle and upper Euphrates. The pressure on Assyria's borders was relentless and the kingdom was further threatened by Babylonian advances under Marduk-nadin-ahhe (1098–1081); the city of Ekallate, close to Ashur, was captured by the Babylonian army. Tiglath-pileser was eventually able to expel the Babylonians, but only after nearly a decade, when he took his revenge by plundering Dur Kurigalzu and Babylon. By this time, however, Babylonia was also facing Aramaean incursions and its military efforts were directed against the bands of marauders pushing south following the Euphrates; the attractions of the rich agricultural lands were enormous. By the time of Tiglath-pileser's death in 1076 Aramaean groups may even have reached the heartland of Assyria.

Assyria was not the only state to face a weakening of royal authority as the entire region plunged into an extended period of economic decline. In Egypt the influence of the king, now Ramesses XI (1099–1070), continued to deteriorate, as it had under his predecessors, at the expense of officials such as the high priest of Amun at Thebes who controlled the rich resources and lands of the temples. However, the wealth of Thebes had attracted the attention of Libyan groups who had been raiding the surrounding territory for decades. The situation became critical when famine added to the troubles. A crisis point was reached, and around

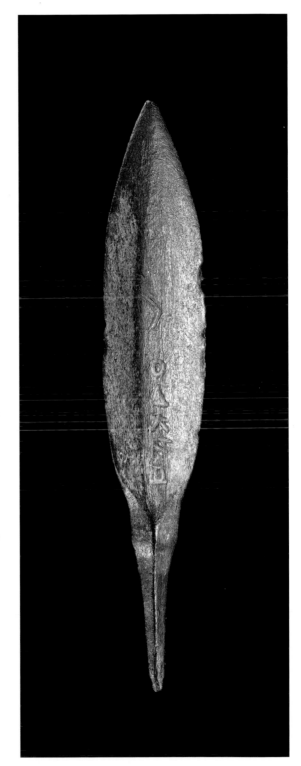

This bronze arrowhead bears an inscription which reads, in the Phoenician language, 'arrowhead of 'Ada', son of Ba 'l'a''. The form of writing, where one sign is used for a single sound, has its origins as early as about 2000 in the eastern Mediterranean, where a variety of scripts developed to record the local Canaanite languages. By the first millennium BC a fully alphabetic script had emerged. ME 136753

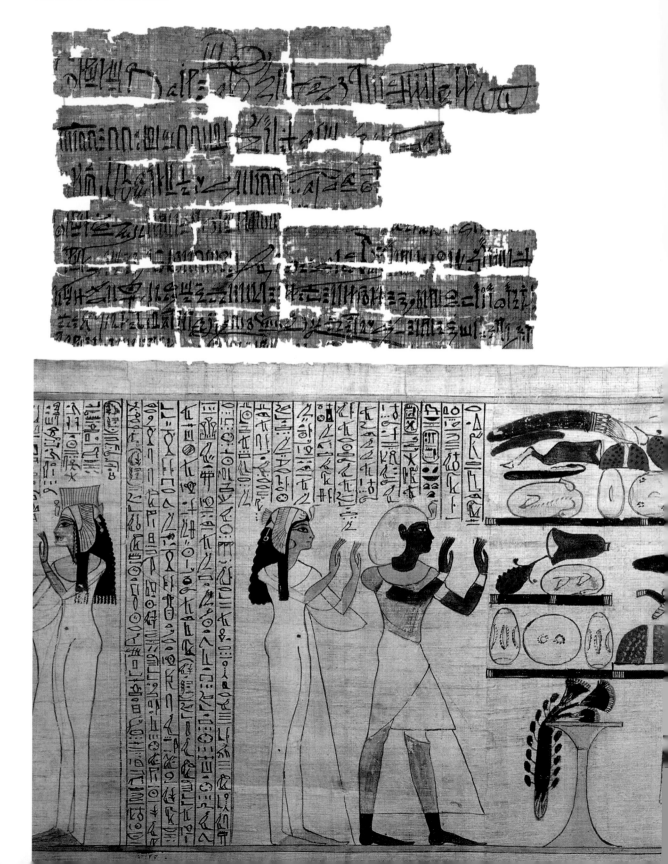

This papyrus letter was sent to the general Piankh of Thebes, who spent much of his time fighting the rebel viceroy of Nubia, Panehsy. It refers to several tasks that Piankh has asked the son of his scribe to undertake. One request was to 'Uncover a tomb among the ancient tombs and preserve its seal until I return'. This might be a reference to Piankh opening the tombs of the earlier kings and stripping them of their wealth to pay for his campaigns. EA 10375

Dating to around 1070, this is part of a *Book of the Dead* which belonged to Nedjmet the wife of Herihor, high priest of Amun. Herihor features prominently in the scenes, probably owing to his significant status. He effectively ruled southern Egypt and was also the first of the high priests of Amun to take on royal attributes, such as placing his name in a cartouche, and showing himself with the royal *uraeus* on his brow. EA 10541

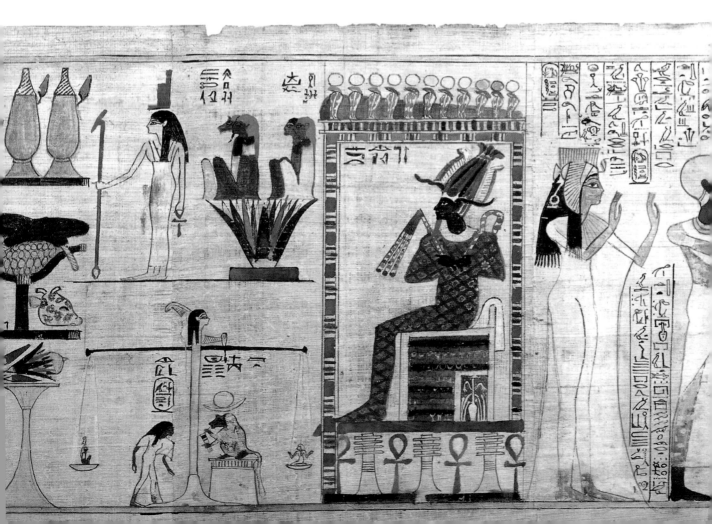

1090 Panehsy, the viceroy of Nubia, marched troops into the Theban region to restore order. In order to feed his army, Panehsy claimed the contents of the temple granaries controlled by the high priest of Amun, who appealed to Ramesses to end this outrage. The situation escalated so that by 1082 Panehsy's army was besieging the high priest in the fortress temple of Medinet Habu. The royal army set out to confront Panehsy's forces that were now marching north. Civil war had broken out. Eventually Panehsy was forced to withdraw to Nubia, but the Egyptian army was not strong enough to pursue him, with the result that Egypt lost access to the region and with it the remaining gold mines and other riches of central Africa. This had a disastrous impact on the kingdom's revenue.

Although Ramesses continued to be acknowledged as king, the titles of high priest of Amun and viceroy were claimed by Herihor and Piankh, generals of the victorious Egyptian army in Thebes. They declared a 'renaissance', that is, the rebirth of the country following chaos.[1] Thus was established a system where the country, although theoretically united, was effectively divided between a line of kings in the north and a line of military generals, holding the post of high priest of Amun, at Thebes. Friendly relations existed between the two courts and only when Ramesses XI died in 1070 did Herihor adopt royal titles. The royal throne in the north was claimed by a powerful man called Smendes (1070–1044), whose base

1 Scholars are divided over whether it was Piankh or Herihor who initiated the 'renaissance'. The generally accepted view is that Piankh succeeded Herihor but this has been challenged.

was in the eastern Delta at the new city of Tanis, constructed from material brought from Pi-Ramesses. Memphis, however, remained the formal residence of the northern kingdom. In the absence of revenue from Nubia, some of the tombs of earlier kings were now officially despoiled as a source of gold and other materials.

The relationship between the two centres of power in Egypt and in turn between them and the small coastal states of the eastern Mediterranean is revealed in the Egyptian literary tale of Wenamun. The story tells how the official Wenamun was sent by Herihor to buy timber from Byblos for the construction of a sacred boat of the god Amun. Wenamun headed north to Tanis where he reported his assignment to Smendes and delivered other dispatches from Thebes. After some time at court, a ship captained by a Syrian was commissioned to take Wenamun along the coast. The first stop on the journey was Dor, described as a town belonging to the Tjeker (one of the peoples established by the Egyptians to garrison the region over a century earlier). Here Wenamun was received by the local ruler Beder. Unfortunately, a sailor from the Syrian ship stole some of Wenamun's goods, including a gold vessel and four jars of silver. Wenamun reported the theft to Beder and demanded that the prince should organize the capture of the sailor and the return of the stolen property. However, Beder refused on the grounds that the sailor was not one of his men and therefore he was not liable for the loss. After nine days of waiting in the hope of finding the thief, Wenamun left on his ship for Byblos but, holding the Tjeker responsible for his loss, on the way he captured one of their ships

This amusing scene comes from a papyrus document dating to about 1190–1070. It is part of a collection of artistic works satirizing society during the reigns of the last Ramesside kings. Scenes show animal figures in reversals of the natural order and parody human activity. EA 10016

and seized the silver on board, telling its owner he would return it as soon as he received his own money back. Once safely at Byblos he disembarked but was not welcome there. In fact he was ordered to leave by the city's ruler Zakar-Baal. After twenty-nine days Wenamun found a ship headed for Egypt and started to load his goods, but by then Zakar-Baal had changed his mind. Brought into the ruler's presence, Wenamun was surprised when informed that Smendes relied on the ships of Byblos and Sidon to undertake any trading ventures. While in the past Egypt might have been able to acquire timber for free, now Zakar-Baal demanded payment. Wenamun sent a letter to Egypt requesting the correct level of payment for the timber, which included substantial amounts of gold and silver as well as perishables such as clothing, ropes, oxhides, sacks of lentils and baskets of dried fish – in other words the kind of commodities that were regularly ferried by boat. Eventually the payment arrived and timber was cut and brought down to the sea shore. Unfortunately, Wenamun was blocked from leaving Byblos by Tjeker ships enraged by his earlier arrogant seizure of one of their vessels. Zakar-Baal, however, gave orders that Wenamun should be allowed to leave his harbour but a storm blew his ship off course and it landed in Alashiya (Cyprus) where Wenamun was saved from a mob only by the intercession of a local queen. At this point the story breaks off. Clearly, Egypt's influence over its former vassals had been completely eroded to the extent that, at least in literary accounts, Egyptian officials could be treated with total contempt.

The attitude of the Tjeker, Peleset (Philistine) and Canaanite (Phoenician[2]) cities to Egypt's loss of influence and prestige was in total contrast with their approach to Assyria. When Tiglath-pileser I had reached the Mediterranean around 1100 he was welcomed and presented with gifts designed to establish and encourage economic ties with this important market. Tiglath-pileser's grandson Ashur-bel-kala (1073–1056) continued to campaign against the Aramaean tribes and, with considerable difficulty, largely maintained Assyrian authority over its territories. His international standing was recognized by a gift, which included a female ape and a crocodile, from the Egyptian king, perhaps Ramesses XI. The Assyrian king further demonstrated his kingdom's continued importance by appointing Adad-apla-iddina as the king of Babylon, whose daughter he then married.

Over the decades from around 1050, however, pressure intensified on Assyria and Babylonia as climatic conditions gradually encouraged the

This statue of a naked woman comes from the temple of Ishtar in Nineveh and is very unusual, as most monumental public art in Mesopotamia was designed to glorify the male king. It may represent one of the attendants of Ishtar in her role as goddess of sexuality. A cuneiform inscription on the back states that it was erected by the Assyrian king Ashur-bel-kala (1073–1056). ME 124963

2 The inhabitants of the trading cities along the coast, Tyre, Sidon, Byblos and Arwad, were termed Phoenicians by the later Greeks after their word *phoinix*, a term possibly signifying the colour purple-red and perhaps an allusion to the production of a highly prized purple dye in these centres.

The so-called 'White Obelisk'
was excavated at Nineveh.
An inscription at the top
names Ashurnasirpal,
probably Ashurnasirpal I
(1049–1031), and refers to
the king capturing goods,
people and their herds and
carrying them back to the city
of Ashur. The carvings show
military campaigns, the
bringing of tribute, victory
banquets, and religious
and hunting scenes; they
are among the earliest
representations of what
would become the main
themes of Assyrian narrative
art. ME 118807

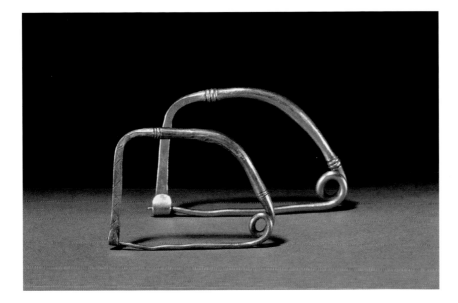

These gold fibulae (brooches) from Maroni, Cyprus, date to about 1050 and are of a type introduced to the island from the Greek world. The same period saw Mycenaean Greek burial practices introduced and the replacement of the Cypro-Minoan script (as yet undeciphered) by Cypro-Syllabic and the Greek language, suggesting that it was only in this period that large-scale immigration from the Greek world to Cyprus took place. GR 1003.11 16.2 3 (Jewellery 818-819)

mobile pastoralists to adopt more sedentary lifestyles in the territories they now claimed. Direct control by the Assyrian king over Syria gradually disintegrated. Although some of his governors managed to maintain a hold of their dynastic centres in the region, much of the intervening territory was permanently seized by Aramaeans. Tribal leaders, often based at insignificant centres, added others by conquest or family relationships to create small states. Other groups took over existing cities such as Halab and Damascus through peaceful integration as well as violent action. The Assyrian kingdom was reduced to the homelands focused on Ashur, Nineveh and Arbela. Further south on the Babylonian plain there were major attacks by substantial tribal confederations against important cities such as Nippur and Sippar; the temples of the sun god Shamash in the latter city were so badly devastated that the cult was not resumed for nearly two centuries. Ultimately, the Aramaeans gathered around their local chiefs and tribal heads in marginal areas between the ancient cities. Other large tribal groupings, the Chaldaeans, established themselves in the south of the country, claiming the Sealand and its control of the vast date plantations and important trade links with the Persian Gulf.

As stretches of land were ravaged or claimed by tribes throughout Syria and Iraq, there were significant disruptions to overland trade. Links between Assyria and Babylonia and the west were severely curtailed. This represented the loss of important markets for the cities of Phoenicia. However, situated on a narrow coastal plain protected by mountain ranges or as island settlements like Tyre and Arwad, they survived the wider

upheavals and maintained many of their traditions and some of their maritime connections, especially with Cyprus. None the less, the deepening economic recession led to a continuing decline in the number of settlements on the Greek mainland, where localized styles of pottery marked this regionalism. While there was little contact between the region and the wider world, Crete maintained some links with the east, probably through Cyprus, where iron working was developing and coming to predominate over the production of bronze. After 1050 Greek pottery began to improve in quality and the so-called protogeometric style was developed. Phoenician traders began to carry their pottery to Cyprus, and some protogeometric pottery was brought to the eastern Mediterranean. However, such exchange remained hazardous, especially for rulers and the elite who had previously maintained and outfitted ships or had employed traders. Trade had always been dependent on merchants establishing local good will and guest friendship but this had now become essential when overseas trade was both small-scale and irregular.

While both overland and sea trade remained important to the Phoenician cities, further south along the coastal plain the Philistine cities initiated a series of military campaigns to control the trade routes running inland from the coast to the Canaanite cities of the hill country. They moved against the *habiru* groups and tribes such as Israel that shared common ancestors and customs and were increasingly settling in farming villages throughout the region. The Philistines, with their origins as soldiers and mercenaries, were well organized with good resources, and the whole region west of the river Jordan, especially the country around Samaria, was captured and the inhabitants disarmed. Tribal leaders attempted to throw off Philistine authority but were able to achieve control over the hill country only by banding together. Saul of the Benjamin tribe was eventually able to attract the support of other tribes and was crowned king, uniting the southern hills and some territories around the northern plains; the majority of Canaanite urban centres remained outside his reach. The combined tribal forces led by Saul now managed to push the Philistines back to their own territory. Similar moves to consolidate tribal lands were also taking place across the Jordan where the fledgling states of the Ammonites and Moabites were forming, while north of the Sea of Galilee Aramaean tribes were establishing their control over centres such as the oasis town of Damascus. The borders between these various peoples were very fluid and raids across them were common.

CHAPTER 7

Survival and Revival
1000–900 BC

As the new century began, there were some signs that across the region the small kingdoms were expanding their connections and with it their economies. In southeast Anatolia and northern Syria tentative moves were made by Hittite dynasts to have palaces, temples and gateways constructed. The new buildings were often elaborated with simple sculptured stone decoration in a manner remembered from the earlier empire period. A shared imagery of gods (the storm god was especially popular), worshippers, warfare, animals and hunting reflected the close relations between these states. Some of the earliest revivals in this artistic production emerged, perhaps with no surprise, at the major city of Carchemish, which dominated an important crossing of the river Euphrates.

Lying to the south of these Hittite centres, across the plains of Syria, many Aramaean groups remained restive and continued to disrupt communications. However, others were establishing large tribal states and seizing cities formerly under Assyrian authority. Among the Aramaean warlords who were carving out their own kingdoms was Hadad-ezer, chief of the region of Zobah between Hamath and Damascus. He clashed with other tribal leaders and at his southern borders he was defeated by David, a ruler who had emerged by challenging Saul's authority as king of the Israelite tribes. David had initially associated himself with Saul but broke away with his own followers and withdrew into the southern hills, where he existed outside royal authority, that is, as a *habiru*. Increasingly David became a dangerous rival to Saul, especially when he allied with the Philistines of the coastal plain.

Eventually Saul died in battle against the Philistines in their continued attempts to expand their control across his territory. David's centre of

power was among the people of the southern hill country but in this politically chaotic period he was able to attract more followers, including Saul's military commander Abner. When Saul's son and successor Ishbaal was murdered, David, as the strongest warlord, reached an agreement with the tribal leaders of Israel and he was recognized as their king. He now began a series of wars against neighbouring regions including rulers such as Hadad-ezer. The Canaanite city of Jerusalem was captured and established as David's royal centre; eventually all the Canaanite cities between Philistia in the west and the river Jordan in the east were incorporated into his kingdom. David's authority also reached across the Jordan into the sparsely populated regions of Ammon, Moab and Edom. Other areas were linked to David's territories through diplomacy – he married a princess of the small state of Geshur (east of Lake Galilee), while relationships were developed with the Phoenician cities, and craftsmen and building materials were sent by King Hiram of Tyre to Jerusalem. Having established his power, David was able to exist independently of the Philistines, and the various groups, tribes and cities of his realm were integrated through a structured army, priesthood and administration. However, the rapid formation of the kingdom led to revolts, especially in the northern territories which were crossed by important trade routes and had greater access to resources than the south where David's strongest support lay. Saul's descendants also posed a threat to David's authority, with the result that the king had nearly every member of the family murdered.

Unification of the hill country and particularly the richer plains to the north under Saul and David represented a danger to the Philistines of the coastal plain, as their access to routes leading into the interior was curtailed. This limited their ability to engage commercially with Egypt, which continued to be politically divided between the rulers of Tanis and Thebes. While friendly relations existed between the two main centres of power in Egypt, linked as they were through family connections, decentralization was now the accepted reality and many different groups were able to exert considerable influence in their own regions of the country. Among the most important local dynasts in the Delta were those whose ancestors originated in Libya. Although the major Libyan invasions of Egypt had been repulsed by Merneptah and Ramesses III, immigrants from the west had been entering the country, especially the Delta, for centuries. Libyans now represented a significant element of the population, and although many were thoroughly acculturated, they looked to their own rulers as the source of authority. The ever increasing influence of these regional princes ultimately gave one of them, Osorkon the Elder

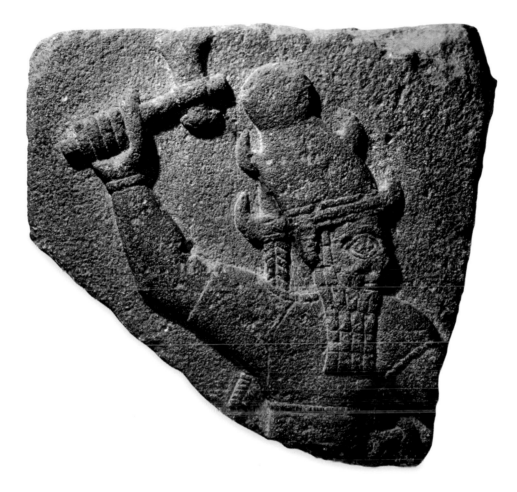

(984–978), son of the Chief of the Meshwesh Libyans, sufficient power to be recognized as ruler of the entire Nile Delta. Even though the Theban rulers abandoned their royal titles and recognized the northern leader as king of all Egypt in their administrative documents, the country remained split. This state of affairs remained very unstable and the throne at Tanis eventually passed to a new family under the Theban high priest Psusennes II (959–945).

During the time that Egypt remained politically fragmented and the economies of the eastern Mediterranean underdeveloped, the Phoenician cities continued to rely on their maritime connections. Links were maintained with Cyprus and Crete, and through these islands Greek protogeometric styles of pottery, which had developed across Greece, were transported to Phoenicia. The impact of these connections on the Greek

This basalt relief fragment depicts the Syrian storm god. It decorated a wall opposite the temple of the storm god at Carchemish. ME 117909

mainland, however, remained limited. Unlike in the eastern Mediterranean, where leaders such as David were able to establish a relatively stable and long-lived political, economic and social organization, in the thinly populated Greek world any similar attempts to control areas could not be sustained. For example, at Lefkandi on the island of Euboea, around the beginning of the century, local leaders had a large wooden building constructed that was nearly 50 metres (164 feet) long and 10 metres (33 feet) wide on a rough stone foundation with some internal walls. At the centre of the building lay a burial containing cremated bones, possibly those of a man, since the remains were accompanied by a spear and sword of iron. In addition there was the burial of a woman wearing gilt hair coils and embossed gold disks. A compartment of the tomb also contained the skeletons of four horses, two with iron bits in their mouths. Perhaps the building was intended as a gathering space for the community but their leaders were unable to prolong their power here as the structure was maintained only for a short period before the site was abandoned.

The generally unsettled conditions across the region continued to limit the activities of the older centres of power. In the east Assyria was restricted to its natural homeland on the river Tigris, its territories stretching from Ashur to Nineveh together with the surrounding countryside. Marauding Aramaean tribesmen continued to prevent strong diplomatic and commercial relationships with the Syrian states to the west or even with Babylonia to the south, which was equally constrained by these mobile populations. The problems were further exacerbated by famine. With Aramaeans dominating the Euphrates route and severing links with Assyria, control of much of Babylonia remained centred on the city of Isin where Kassites held some of the highest offices. Various local groups successively claimed the throne of Babylon but throughout the tenth century there were continual disruptions in the performance of the New Year Festival which legitimized the Babylonian king – claimants were often simply unable to reach

This vessel, possibly from Athens, dates to about 975–950 and belongs to the so-called protogeometric period when techniques of pottery production improved. Most jars of this shape, with the handles attached to the neck, have been found to contain the cremated remains of men and boys.
GR 1978.7-1.8 (Vase a 1124)

Babylon safely. With connections across the plains severely restricted, relations with the people of the eastern mountains became increasingly important; in the region of Luristan an astonishing variety of bronze objects, including weapons, standards, jewellery, horse ornaments and vessels, began to be produced and deposited in graves over several centuries by the predominantly nomadic population.

The rapid formation of a state can lead to instability at the centre, and this was true for David's realm. His hold on the throne was threatened by his own son Absalom, who raised a rebellion with considerable success, forcing David to flee from Jerusalem. A major battle followed between the two camps and Absalom was defeated and killed. Towards the end of David's life another struggle for the throne developed between his sons Adonijah and Solomon. In due course Solomon emerged as king around 970, inheriting David's realm. Control of the Transjordan trade gave the king access to resources as well as diplomatic connections with Hiram of Tyre, who provided him with skilled craftsmen and materials. The result was that Solomon, like many of the contemporary Hittite, Aramaean and probably Philistine and Phoenician kings, had his capital embellished with a palace and temple.

Joint trading ventures were initiated between Solomon and Hiram, and commercial relations linked their kingdoms with the states to the north. Despite these achievements, there were seeds of division in Solomon's kingdom, especially between the southern territories around Jerusalem and the richer north with its fertile plains and trade links to Damascus and the Mediterranean. Solomon fully recognized the north's commercial potential, and the region was heavily exploited, including the use of forced labour. Rebellion was never far away and

The region of Luristan was home to a rich tradition of bronze-working in the early part of the first millennium BC. Objects such as this are unique to this region of Iran, and their use remains mysterious. This possibly late example appears to be made up of a man wearing an elaborate headdress in the form of the 'master of animals', a figure symmetrically flanked by wild animals that he subdues. ME 108816

at one point the official Jeroboam, who was in charge of the forced labour, refused to obey his orders and fled to Egypt. Gradually the surrounding regions began to shake off Jerusalem's authority. By Solomon's death in 930 Damascus had emerged as a powerful centre in place of the weakened Zobah under the Aramaean leader Rezon, and Edom had regained its independence and now controlled trade connections with the Red Sea. The weakening of Jerusalem's authority led to a successful rebellion against Solomon's successor Rehoboam, who failed to resolve the problems of the north's heavy tax burden. Jeroboam, who had returned from Egypt, was made ruler by the tribes of the northern territories, now established as the independent kingdom of Israel. Rehoboam withdrew to Jerusalem, which remained as the capital of the southern hill country, the state of Judah. Weakened by the division of the land, the two kingdoms were vulnerable to attack and when the assault came it was from a revitalized Egypt.

In the Egyptian Delta the powerful political links that the Libyan princes had forged, especially through marriage, had brought another of the great chiefs of the Meshwesh to the throne at Tanis. Sheshonq I (945–924), however, was of a different character from his royal predecessors and he sought to end the political decentralization of Egypt and re-establish the authority of the king throughout the country. He

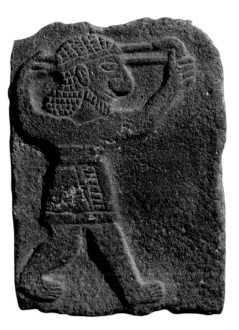

established his control of the rival centre of Thebes by having his son Prince Iuput appointed as the high priest of Amun and, at the same time, gave other members of his family posts as senior officials; existing important officials were tied to the royal family through marriage. An ambitious building programme throughout Egypt reinforced the message that Sheshonq was a ruler from the same mould as the kings who had ruled the earlier empire (indeed, during his reign many mummies of some of Egypt's greatest rulers in the Valley of the Kings were gathered together in a large subterranean gallery just south of Deir el-Bahri). As if in confirmation of these imperial aspirations, towards the end of his reign in 925 Sheshonq launched an invasion of Philistia, Judah and Israel. Following the coastal plain, the Egyptian forces marched through Gaza to Megiddo. At some point Jerusalem was also plundered. Although the campaign had demonstrated Egyptian authority in the region, there was no attempt by Sheshonq or his successors to impose direct rule. However, important commercial relations were strengthened, particularly with Byblos and probably the other Phoenician cities. These connections were maintained by Sheshonq's successor Osorkon I (924–889).

While the small states of the eastern Mediterranean lands attempted to expand their territories or fragmented into even smaller units, the

The city of Guzana (modern Tell Halaf) flourished around the middle of the tenth century under King Kapara. These reliefs come from the base of the south wall of Kapara's palace, which was lined with a series of 187 reliefs carved in black basalt alternating with red-ochre-tinted limestone. Guzana was the capital of the Aramaean state of Bit-Bahiani and grew rich by controlling important trade routes as well as through the agricultural wealth of the region.
ME 117100; ME 117101; ME 117102; ME 117103

Aramaean tribes of the plains of Syria and Iraq continued to establish large tribal states, leading to greater stability across the region and resulting in an Aramaization of the other native populations. During the second half of the century many groups had moved into the north of Syria and formed states between the territories of the old Hittite urban centres, organized in tribal 'houses' (*bit*) such as Bit-Adini and Bit-Agusi. By 900 the Aramaean leaders had borrowed forms of Hittite sculpture to decorate their capital cities but created distinctive styles of their own. The settling of the tribes gradually reduced the pressure on Assyria and the routes were reopened to the north and west. The Assyrian king Ashur-dan II (934–912) now turned the tide on the Aramaeans, conducting regular military campaigns against them to the north, northwest and northeast of Assyria. Territory taken by the Aramaeans at the end of the eleventh century was reclaimed and people who had been driven out of Assyria through want and hunger were brought back and settled. Under Ashur-dan's son, Adad-nirari II (911–891), the Assyrian advances continued against the Aramaeans in the region of the upper Tigris and Greater Zab, but campaigns now ranged further. To the north clashes with various groups in the region of Nairi (Lake Van) included the people of the land of Uruatri that would later emerge as the powerful kingdom of Urartu. There were also a number of campaigns directed to the south against the area east of the Tigris. Although the Assyrian armies did not enter the Babylonian plain, the Assyrians clashed with the Babylonian army. Babylonia had also begun to recover slowly from the earlier disastrous conditions. Apart from the Aramaeans who had settled in territory at the fringes of the urban centres, other tribal groups had established themselves in some of the more significant regions of the country. In the Sealand three major Chaldaean tribes (Bit-Dakkuri, Bit-Amukani and Bit-Yakin) had come to dominate the region and they became increasingly wealthy and powerful through the control of the southern trade routes leading from Elam and the Gulf. Each tribe was centred on a fortified town where their king lived and although nominally subject to the ruler of Babylon they were essentially independent.

By the end of the tenth century the multitude of states, large and small, had established a relatively stable pattern, with the network of interconnections beginning to link the wider region together. Even Greece started to be tied more effectively to the economies of the east. At Lefkandi on Euboea people were being buried with objects which showed wider contacts through Crete and Cyprus. The power of certain groups within society was becoming more durable and there was an economic upturn at many centres throughout the mainland, such as at Athens where people were also now being buried with a few exotic objects. Near Eastern

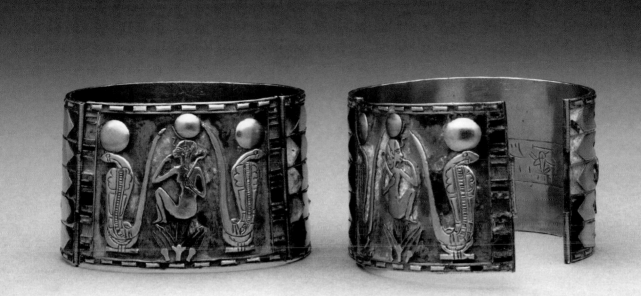

materials, including some gold, and products such as bronze bowls were taken west by Phoenician traders and the imitation of their pottery in the Aegean probably reflects their presence there on a more regular basis.

Despite the growing confidence in commercial enterprises, wider connections between regions of the Near East remained limited. In the highlands of central and eastern Anatolia scattered transhumant societies, including the Mushki and Phrygians, were gradually coalescing around fortified centres, with partial links established with Syria and the eastern Mediterranean world. Elsewhere, growing economies in some regions encouraged conflict as states sought access to resources and markets. There was almost continual warfare between the kingdoms of Judah and Israel, the latter, along with the Philistine cities, controlling the rich coastal plain. The king of Judah, Rehoboam and, following his death around 913, his son and successor Abijah, struggled with Israel over trade routes and access to the Mediterranean.

This pair of hinged bracelets, which belonged to Nimlot, son of the Egyptian king Sheshonq I (945–924), possibly comes from Sais in the western Nile Delta. They are decorated with a child god squatting on a lotus and flanked by two protective cobras. The design is reversed on the two bracelets, which are made from gold with lapis lazuli and coloured glass inlays. EA 14594-5

CHAPTER 8

Expanding Horizons
900–800 BC

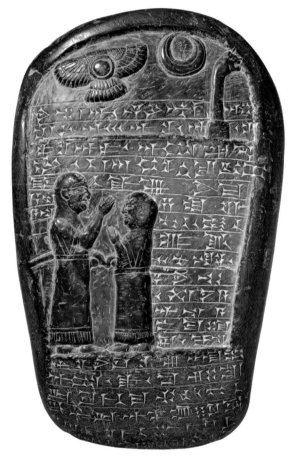

ampaigns against the Aramaeans at the end of the previous century had resulted in a regular Assyrian presence in the fertile lands around the Khabur River, the former territory of Mitanni which the Assyrians called Hanigalbat. Adad-nirari II (911–891) even managed to push across the Balikh River in 899, which brought recognition from the Aramaean state of Bit-Adini with the presentation of a royal gift of two apes to the Assyrian king. In Hanigalbat various groups were defeated and, by 894, Adad-nirari was able to march to the Khabur and then south alongside the Euphrates to receive tribute from the various tribes and states straddling the river. The Assyrian revival led to a reopening of diplomatic relations with Babylonia and, late in his reign, Adad-nirari exchanged daughters in marriage with the Babylonian king Nabu-shuma-ukin. The Assyrian movement against hostile peoples encircling the kingdom continued under Tukulti-Ninurta II (890–884). He maintained a strong presence in eastern Syria and was able to march through the region without apparent opposition. The same was true to the south, where the Assyrian king made a triumphal

This stela was set up in the temple of the god Marduk in Babylon in honour of an official called Adad-etir by his son. The figures carved in relief on the front represent the father and son, their shaven heads showing that they were both priests. ME 90834

128

advance to the very border of Babylonia and, like his predecessor, received gifts from the local populations. These presents included luxury items from some of the wealthier communities. For example, the ruler of the state of Suhu on the Middle Euphrates gave Tukulti-Ninurta a bed and dishes made from an exotic type of wood, a bronze bath, linen garments and purple wool.

Map showing sites mentioned in chapters 8–9.

To the west of the Khabur and Assyrian authority, the Aramaean centre of Hamath had emerged as the main political power in the fertile plains of central Syria. Hamath lay on the Orontes and controlled the passage through which the river flows north from the Biqa' Valley between the Lebanon and Anti-Lebanon mountains. The important caravan routes leading from the Biqa' on to the central Syrian plains remained of central concern for Hamath, and competition for their control was fierce. Further to the south lay the oasis city of Damascus under Ben-Hadad I. He expanded his power at the expense of Israel, which was suffering from political instability. By 900 the king of Israel, Jeroboam, had been succeeded by his son Nadab who, within a year, had been assassinated by Baasha, presumably one of his officials. Perhaps with support from Ben-Hadad of Damascus, Baasha claimed the throne after exterminating all of Jeroboam's family. While Israel was being shaken by internal violence, the southern kingdom of Judah under King Asa (911–870) also faced problems when it was assaulted by a military force from Egypt. Nubian and Libyan troops advanced on Judah, perhaps acting for Osorkon I (924–889) in an attempt by the Egyptian king to emulate his father Sheshonq's earlier campaign of plunder in the region. On this occasion, however, the Egyptian forces were driven back by the troops of Judah. Seizing the moment, Baasha attacked Judah. Having consolidated his hold on the throne of Israel he pushed his southern border to within 16 kilometres (10 miles) of Jerusalem. This put Asa in a precarious position and the king turned to Baasha's ally Ben-Hadad for support by sending a rich gift to Damascus. The Aramaean king abandoned Baasha and attacked, capturing

This steatite bowl may have been used for burning incense. Its style is typical of those produced in the Aramaean states of Syria during the early centuries of the first millennium BC. ME 132056

The owner of this seal can be identified from the cuneiform inscription as Mushezib-Ninurta. He was ruler of Shadikanni (Arban in eastern Syria) in 883, and an Assyrian vassal. The image is similar to that carved on two wall reliefs from the throne room of King Ashurnasirpal II at Nimrud (ancient Kalhu). ME 89135

the territories of Israel in Transjordan and forcing Baasha to withdraw his forces from the south.

Political instability continued to plague Israel, and when Baasha died in 886 his son Elah was murdered by Zimri, a commander of the kingdom's chariot forces, who then butchered the remaining members of Baasha's family. He in turn was immediately challenged by Omri (885–874) who, as army commander, was proclaimed king by his troops. Omri's forces laid siege to the city of Tirzah where Zimri had sought refuge; eventually the city fell and Zimri committed suicide. The army's support for Omri placed him in a strong position to deal with his opponents and Israel now entered a period of relative stability and prosperity. Initially, Omri established his base at Tirzah from where he consolidated his position. Damascus remained a powerful presence to the north, and Israel may have lost further territory to Ben-Hadad at this time. To counter this loss Omri expanded his control across the river Jordan into Moab which became his vassal. Around 880 his capital was established at Samaria where he began the building of a substantial palace complex. The location of the capital allowed for close ties with the Phoenician city of Tyre, a relationship which may have been partly forged by disruptions to the flow of trade through Syria caused by Assyrian expansion.

When Ashurnasirpal II (883–859) succeeded to the throne of Ashur the kingdom was already established as the major power in northern Iraq and eastern Syria. Like his two royal predecessors he first moved to bring the mountainous territory to the north and northeast of Assyria under his control. During his first year on the throne Ashurnasirpal led his forces along the valley of the Greater Zab River to maintain control over this major route linking Assyria with the region south of Lake Urmia. In 882

the army headed north along the Tigris into the mountainous Nairi lands, which were divided among numerous local leaders, and, following an arc westwards, the Assyrians emerged from the mountains on to the Syrian plains around the river Khabur. Here the various Aramaean and Hittite rulers presented Ashurnasirpal with rich gifts as expressions of goodwill. Over the following three years Ashurnasirpal focused his military action on the east, pushing to the headwaters of the Diyala River where Dur Ashur (Ashur Fortress) was established as a strategic base in the Zagros Mountains. The local rulers were required to supply a workforce and materials and these now flowed from the subjugated regions to Assyria.

The rapidly growing wealth of Assyria was invested by Ashurnasirpal in the establishment of the site of Nimrud (ancient Kalhu) as his royal residence. Located near the junction of the Tigris and Greater Zab rivers, the site was considerably better situated than the ancient capital of Ashur as a place from which to launch campaigns to the north of Assyria. Work began in 879 when huge numbers of people from across the region were drafted in to undertake their required corvée work along with gangs of forced labourers. City walls were constructed that enclosed an area of 360 hectares, including the old, much neglected settlement mound where temples and palaces were built from thousands of mud bricks. A canal was

This stone relief, from the North-West Palace of Ashurnasirpal II (883–859) at Nimrud, was originally positioned behind the royal throne. The king, shown from two sides, is protected by winged spirits using what may be a symbolic fir cone to sprinkle purifying water from a bucket. A stylized tree stands in the centre, symbolizing abundance, above which a god appears in a winged disk. ME 124531

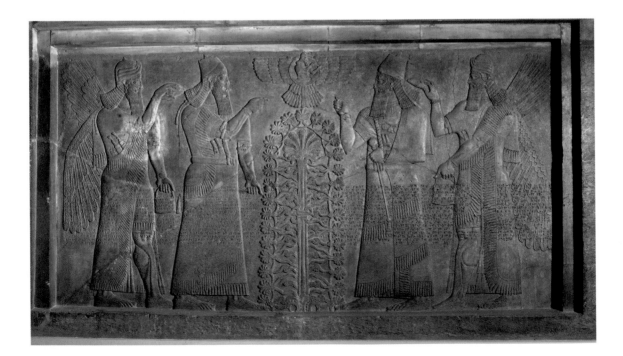

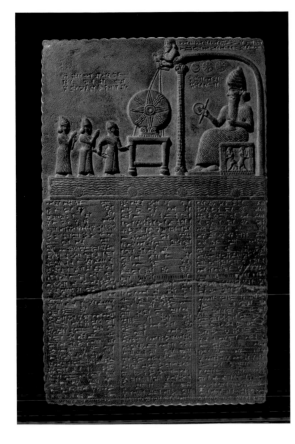

left
This stone tablet from Sippar shows Shamash, the sun god, seated under an awning and holding the rod and ring, symbols of divine authority. On the left is the Babylonian king Nabu-apla-iddina (around 870) between two deities. The cuneiform text describes how the temple of Shamash at Sippar had fallen into decay and the image of the god had been destroyed. The king ordered a new image to be constructed of gold and lapis lazuli. ME 91000

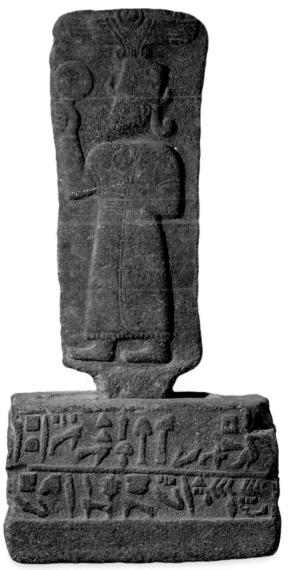

right
At Carchemish the goddess Kubaba, here depicted on a basalt monument, was considered to be one of the most important deities. She holds a mirror and a pomegranate, while above her is a winged disk. The winged disk originated in Egypt, from where it passed via the Syrians to the Hittites and to northern Iraq. ME 125012

dug from the Greater Zab to Nimrud, where orchards and gardens were planted containing regional trees and plants as well as exotic examples gathered while the king was on campaign.

As work was progressing on his building projects in Assyria, Ashurnasirpal set off with the army on a progress down the Khabur to gather tribute and booty. However, he found that states along the Euphrates (Bit-Adini, Laqe, Suhu) were ready to resist him, supported by troops sent by the Babylonian king Nabu-apla-iddina. Like Assyria, Babylonia was re-emerging from the terrible conditions of the previous centuries, as reflected in the restoration of the cult of the sun god Shamash at Sippar. Ashurnasirpal crushed the revolt in Suhu but avoided confrontation with Babylonia, focusing rather on Bit-Adini. Over a decade starting in 877 a series of at least four campaigns were launched across Syria as far as the Balikh River. During one of these the army marched through Bit-Adini, collecting rich goods and equipment. Ashurnasirpal then crossed the Euphrates on rafts and approached Carchemish, from where King Sangara sent him a huge number of luxury gifts including a gold ring, gold bracelet and daggers, silver bullion, objects of bronze, iron and boxwood, two hundred girls, linen and wool, elephant tusks and a gilded chariot and couch.

These riches reflected the control by the north Syrian states of major trade routes, passes and river crossings which provided them with extensive wealth. Chief among these cities was Carchemish, which consisted of a walled inner town and an outer town. A processional route led to the temple of the storm god and a monumental stairway to the citadel. This whole complex was decorated with basalt and limestone sculptures carved with great skill and artistry. Such monuments seem to have profoundly influenced Ashurnasirpal when it came to the decoration of his own palace (the so-called North-West Palace) that he was having built at Nimrud. Enormous blocks of gypsum were quarried in Assyria and transported to Nimrud, where they were carved into huge, human-headed winged bulls and lions to guard the palace doorways. Other stone slabs lined the walls of important rooms and courtyards and were carved in relief with typical Assyrian images of the royal hunt, military campaigns, rituals and protective spirits, accompanied by cuneiform inscriptions extolling Ashurnasirpal's titles and triumphs. No earlier Assyrian sculptures could match in technical accomplishment these magnificent sculptures which became a feature of palatial decoration in Assyria.

The Assyrian presence in Syria was encouraged by repeated rebellions in the mid-Euphrates which brought Ashurnasirpal back to the region on several occasions. The Assyrian forces crossed the Euphrates in rafts made

This is one of a pair of guardian figures that flanked an internal doorway in the throne room of the North-West Palace at Nimrud. Although palace and temple gateway guardians, sculpted in relief or in the round, had a long tradition in ancient Iraq, the use of such colossal stone decoration at Nimrud may have been inspired by stone monuments erected in the cities of Syria. ME 118802

of goatskins and engaged in battle. On another occasion the army crossed Syria to the Orontes and reached the Lebanon without any resistance. Ashurnasirpal washed his weapons in the Mediterranean, the traditional act of a conquering king, and received rich presents from Tyre, Sidon, Byblos and Arwad including more apes, but also exotic sea creatures and luxury materials such as ivory and ebony. The Phoenician cities acknowledged Assyria's military might by such gifts and were keen to set up commercial links, since they recognized that the kingdom represented a huge market for the raw resources and manufactured goods they traded in. From the coast Ashurnasirpal turned back to the Amanus Mountains where he had a stone stela erected and cedars cut.

To ensure the security of the routes leading between Assyria and the Euphrates, the number of fortified depots which Ashurnasirpal's predecessors had established to supply the troops was expanded and governors were appointed over them. Assyrian colonists were settled in these strategically important centres and large numbers of people from eastern Syria and other regions were moved to Assyria as agricultural workers and troops. Many were settled in the new capital city. Indeed, by 865, although the building works at Nimrud were far from completed, Ashurnasirpal celebrated the consecration of his palace with a ten-day feast to which he invited 69,574 people, including 16,000 people of Nimrud itself, 1,500 of his officials, and 5,000 dignitaries from states as far away as Tyre and Sidon.

The commercial links between the Phoenicians and Syrian states joined Assyria with the Mediterranean and the increasingly interconnected lands within and around the sea. At Tyre a port called 'Egyptian' was constructed, reflecting the growing trade with Egypt. In addition, relationships were established with states in southern

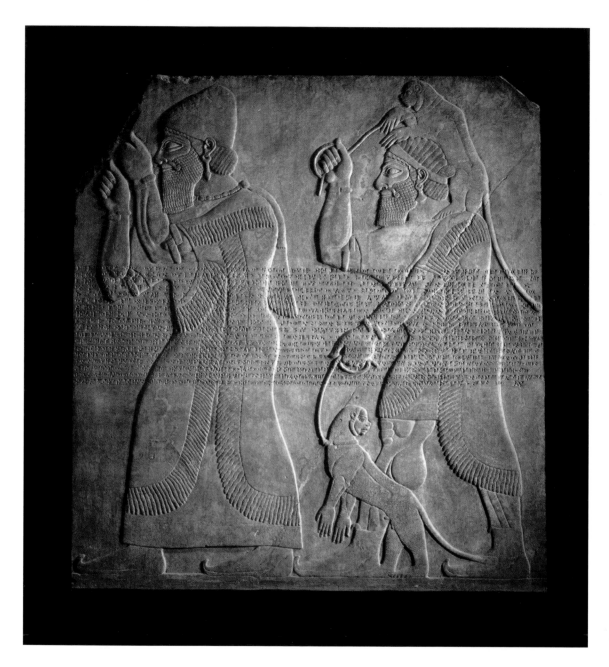

This relief panel comes from the façade of the throne room in the North-West Palace at Nimrud. The scene was part of a series of reliefs showing foreigners bringing tribute. The dress of these individuals suggests that they were from the west. One of them, possibly a Phoenician or an Egyptian, brings exotic monkeys.
ME 124562

Anatolia and inland at Carchemish. There was also more regular contact between the Phoenicians and the Greek world, where the various communities had increasingly closer connections with each other and were becoming much more organized, with some people gathering greater wealth than others. As a reflection of their closer relations with the east, the Greeks had adopted the Phoenician alphabet by the end of the century. The kingdom of Israel was also benefiting from the wider trading associations. The stability brought by Omri's rule was maintained by his son Ahab (874–853), who developed even closer ties with Phoenicia when he married Jezebel, daughter of King Ittoba'al of Tyre. Ahab completed the building work at Samaria, its fine masonry reflecting Phoenician influence. The relationship between Israel and Judah also improved and an alliance between Ahab and Jehoshaphat (870–848) was agreed through the marriage of the latter's son Jehoram with Athaliah; their son Ahaziah eventually became king of Judah in 841.

It was against this ever more closely aligned world of commerce and diplomacy that Ashurnasirpal's son and successor Shalmaneser III (858–824) now advanced. The campaigns of his predecessors had driven together the states to the north and west of Assyria and he found his access to the wealth of the regions increasingly difficult to command. His first action in 858 was to launch an ambitious campaign through Syria. Crossing the Euphrates and the Orontes, he reached the Mediterranean. But unlike his father, who had marched unopposed through the region, he faced a coalition of states which had gathered at Sam'al to confront the Assyrian army. Shalmaneser was able to

This statue of King Ashurnasirpal II (883–859) was placed in the temple of Ishtar Sharrat-niphi at Nimrud. It is made of magnesite, an immensely hard stone, and stands on a reddish stone pedestal. These unusual stones were probably brought back from a foreign campaign. The carved cuneiform inscription across his chest proclaims the king's titles and genealogy, and mentions his expedition to the Mediterranean Sea. MF 118871

defeat the allies but had to content himself with receiving tribute and gifts from the small states he had passed through. The following year Shalmaneser led another expedition in the same direction, but he was still forced to fight his way across Syria to collect tribute. To ease the passage of his armies to the west Shalmaneser created a number of administrative centres in 856, including Til-Barsip, renamed as Kar-Shalmaneser. Having solidified his western front, the Assyrian king turned to confront Urartu. He followed the Tigris north and reached the northern shores of Lake Van. Here the forces of King Aramu of Urartu were defeated and Shalmaneser marched on to Lake Urmia, where he washed his weapons and plundered the neighbouring towns and villages.

The west remained free of Assyrian authority for the time being, but the rivalry that existed among the various states of the region would eventually make it vulnerable to conquest. Adad-idri of Damascus invaded Israel and laid siege to Samaria, perhaps seeking a greater share in the lucrative trade with Phoenicia. He was beaten back by Ahab, with the result that Israel gained special trading rights in Damascus, adding to the commercial wealth of the kingdom. Ahab's prosperity was invested in strong fortifications at the cities of Megiddo and Hazor, as well as in the expansion of Israel's army. Diplomatic and trading relations were also maintained between the states of the eastern Mediterranean and Egypt under Osorkon II (874–837). The Egyptian ruler, like his predecessors, maintained an active interest in the politics and economies of the region, despite or perhaps because of the fact that his authority had been undermined during the first decade of his reign when a certain Harsiese had claimed the title of king at Thebes.

It was the continuing opposition to Assyrian advances towards the Mediterranean that presented the greatest obstacle to Shalmaneser acquiring the riches of the west, particularly authority over the caravan routes of central Syria. Ashurnasirpal II had avoided confronting states such as Hamath, concentrating on gaining passage through the north Syrian steppe. However, Shalmaneser was determined to control the region and in 853 he led his army beyond the bend of the Euphrates into central Syria. During the march west he received tribute from Carchemish and other neighbouring states. Halab opened its gates to the Assyrian king and he received tribute and offered sacrifices to the storm god Adad. From here Shalmaneser moved on to plunder cities belonging to Hamath. However, when he reached the site of Qarqar beside the Orontes River, Shalmaneser was confronted by a huge army of nearly 2,000 cavalry, 4,000 chariots, over 40,000 soldiers, and 1,000 camels. These forces represented a military coalition of twelve kingdoms jointly led by King Irkhuleni of Hamath and

King Adad-idri of Damascus. Other major players in the alliance were Ahab of Israel and Gindibu, an Arabian king. Troops were also supplied by Egypt and Arwad. The battle was fiercely fought and, although Shalmaneser was able to claim plunder and march on to the Mediterranean, he was denied control over central and southern Syria.

The Phoenician centres of Tyre, Sidon and Byblos were absent from the anti-Assyrian coalition despite their reliance on the routes that led from Egypt and crossed through Israel and Damascus. Their interests were increasingly linked to the Mediterranean, where small trading colonies were being established, including one at Kition on Cyprus and, according to tradition, at Qart-hadasht ('New City', Carthage) in North Africa. While the Phoenician cities acted as entrepreneurs between the Mediterranean and inland states, further south along the coast the Philistine cities of Ashdod, Ashkelon and Gaza were restricting Judah's links to the sea. Judah's king Jehoshaphat (870–848) attempted to overcome his lack of direct access to the Mediterranean by having ships built in Edom to engage in the Red Sea trade. His position was further strengthened when peace was established between Judah and Israel and the two kingdoms united against the continuing influence of Damascus east of the river Jordan. However, in the ensuing campaign Ahab was mortally wounded by an arrow. He was succeeded by his sons Ahaziah (853–852) and Jehoram (852–841), and during their reigns close ties were maintained between the

An obelisk, of which only fragments survive, originally decorated one of the central squares in Nimrud. The scenes depict people from Syria and the west bringing various kinds of tribute. Both raw and finished goods are shown: for example, copper ingots, timber, furniture and textiles. This carved panel shows treasure being weighed on a pair of scales.
ME 118800

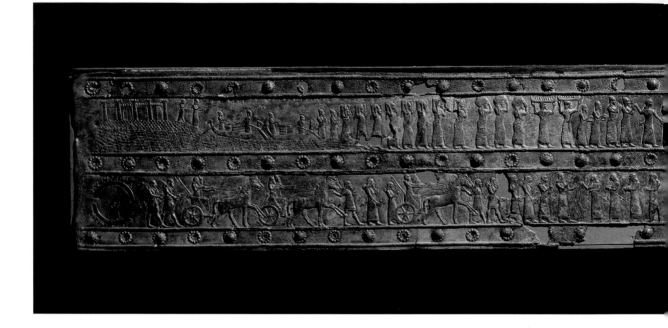

two kingdoms against external threats. One such danger emerged after Ahab's death when King Mesha of Moab took the initiative to rid himself of Israel's dominance. He marched north and captured the main north–south route alongside the Dead Sea. Jehoram, aided by Jehoshaphat and men of Edom, marched around the southern end of the Dead Sea to confront Mesha but they met with only limited success before withdrawing. Indeed, soon after Jehoshaphat's death in 848 a rebellion broke out in Edom which gave the region independence from Judah.

While the small kingdoms of the west struggled with each other over security and control of vital trade routes, the stability of the large kingdom of Babylonia was threatened when, in 851, troubles erupted. The Babylonian king Marduk-zakir-shumi's position was challenged by his brother. Despite the earlier Babylonian support for the anti-Assyrian revolts by the mid-Euphrates states, Shalmaneser went to his neighbour's aid (the two kingdoms were probably still tied together following the diplomatic marriages of 891). The Assyrian army invaded the Diyala region and pursued the rebel brother, who was eventually killed. The rebellion was suppressed and, as a welcome guest in the country, Shalmaneser travelled to Babylon, Borsippa and Cutha to present offerings at their temples. He was also enriched when his forces plundered the wealthy Chaldaean tribes along the Persian Gulf and lower Euphrates. The friendship between Assyria and Babylonia was commemorated by a carved

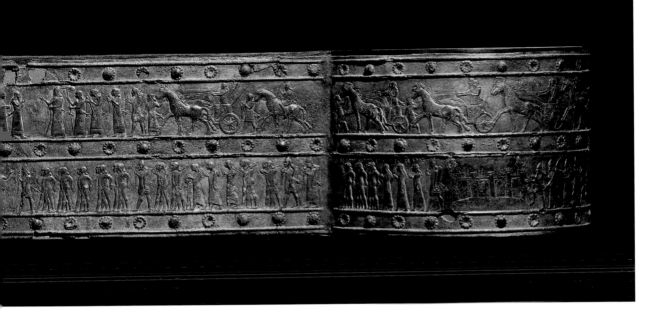

relief of the two kings shaking hands on the throne base in Shalmaneser's new palace (so-called Fort Shalmaneser) at Nimrud.

Although Assyria was demonstrably a major power, Shalmaneser was unable to overcome the formidable alliance of western states that blocked his passage through central Syria. In 849, 848 and 845 the Assyrian army attempted to claim the crucial routes across central Syria but the coalition remained firm under the leadership of Hamath and Damascus, and indeed states such as Carchemish now refused to offer gifts and had to be made to present tribute by force of arms.

After 845, however, the tide began to turn in Assyria's favour, for the pact of western states that had resisted its army started to unravel when Adad-idri of Damscus was assassinated by Hazael (whom Shalmaneser III described as 'the son of a nobody'). In 841 war broke out again between Damascus and Israel. While Jehoram, aided by the newly crowned king of Judah, Ahaziah, campaigned against Hazael, the Israelite army commander Jehu (841–814) usurped the throne. He killed both Jehoram and Ahaziah and ordered the murder of the queen mother Jezebel, who was thrown from a window by some of Jehu's supporters. Every surviving member of the royal family of Israel and their court was found and killed, and their heads put into baskets and sent to Jehu. As the bloody coup was shaking Israel at a time when the kingdom was also engaged in a war with Damascus, the Assyrian army marched once again into southern Syria.

The outer faces of huge cedar-wood gates at Balawat (a site one day's march to the northeast of Nimrud) were embellished with bronze bands decorated with hammered and chased designs showing some of the military triumphs of Shalmaneser III (858–824). This band depicts the Assyrian king receiving tribute from the cities of Tyre and Sidon. ME 124661

Hazael turned to confront the Assyrians but without the support of the old western alliance he was unable to halt Shalmaneser, who rapidly advanced to Damascus. The city was placed under siege and the Assyrians cut down the surrounding orchards and burned the countryside. Although he was unable to take Damascus, Shalmaneser received tribute from Tyre and Sidon, as well as from Jehu of Israel. When the Assyrian army returned to the region in 838 it was able to plunder the cities unopposed and again received rich tribute from the Phoenician cities.

Despite its earlier support of the coalition against Assyrian encroachment in the west, there was no further aid from Egypt as the power of its rulers began to falter and provincial governors extended their authority at the expense of the crown. Over time, important positions, such as the high priest of Amun, were allowed to become hereditary, and princes and Libyan chiefs established their own courts independently of the kings of Tanis. In the final years of Osorkon II, around 840, control of Thebes and southern Egypt was claimed for over two decades by Takelot II. Osorkon was succeeded at Tanis by Sheshonq III (837–798) and during his reign numerous local rulers declared themselves as king. In 818 a man called Pedubast claimed the throne at Thebes in opposition to Takelot's successor and plunged the region into civil war. Each line of kings now attempted to fill the country's key posts with its own men and Egypt once again become fractured politically.

As Egypt broke apart into regional centres and the wealth of southern Syria flowed towards Nimrud, the Assyrian king turned his attention to the states of southeastern Anatolia. Between 839 and 834 Shalmaneser repeatedly invaded Que and Tabal, so that by 833 the Assyrian army was able to march without resistance into the region and collect tribute and booty from numerous cities. While the Assyrian king could now claim tribute from the whole of Syria, in the last decade of his reign a powerful opponent emerged to the north of his kingdom. King Aramu of Urartu had been replaced by Sarduri I, who had established his capital at the rock-fortress of Tushpa on Lake Van. From here he initiated the expansion of Urartu into southern Armenia and northeastern Iran. By incorporating territory in a great arc to the north of Assyria, Sarduri threatened Shalmaneser's hard-won tributary states and peoples. However, the active days of

This is a typical soldier's helmet of the ninth to eighth centuries from Urartu. Holes around the bottom served to attach a lining of leather or felt. The helmet is made of bronze and is decorated with crook-shaped snakes ending in bull's heads that frame the Urartian version of the Egyptian sun disk. ME 134611

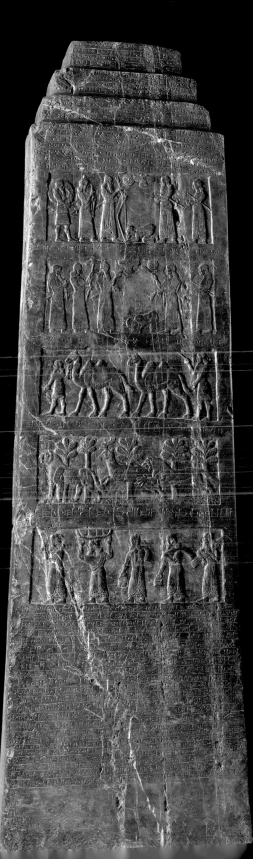

The Black Obelisk of
Shalmaneser III (858–824)
was erected at Nimrud in 825
during a time of civil war.
The relief sculptures glorify
the achievements of the
Assyrian king and his chief
minister Dayyan-Ashur.
There are five scenes of
tribute, each identified by a
line of cuneiform script above
the panel including, second
from the top, Jehu of the
House of Omri (Israel).
ME 118885

campaigning were at an end for the ageing Shalmaneser, who now looked to his commander-in-chief, Dayyan-Ashur, to lead the army.

From 832 to 827 a series of five campaigns were launched into the mountains to ward off the Urartian encroachment. Hubushkia paid tribute and the Mannaeans and Medes were plundered, resulting in much wealth and many supplies, particularly horses, being sent to Assyria.

By 826, however, Dayyan-Ashur's status had become so great that he rivalled the crown prince in power and this provoked the king's sons to launch bids for the throne before Shalmaneser's death in 824. Assyria was engulfed in civil war as powerful individuals vied for the crown. One of the royal princes, Ashur-da'in-apla, was supported in his claim by twenty-seven Assyrian cities, including Nineveh and Ashur. His main rival, and possibly the legitimate heir, was another prince, Shamshi-Adad. The rebellion was finally crushed by Shamshi-Adad only in 820, perhaps with the support of the Babylonian king Marduk-zakir-shumi.

Shamshi-Adad V quickly acted to secure his northern borders. Raids were conducted to the eastern mountains, north to Nairi and into Syria. Urartu had probably taken full advantage of the troubled times in Assyria to widen its authority and it would now represent the greatest threat to Assyria. However, the last years of Shamshi-Adad's reign were devoted to dealing with problems in Babylonia. Although Assyria and Babylonia had enjoyed a relatively harmonious relationship for much of the century, and indeed Shamshi-Adad may have been dependent on his southern neighbour in order to claim the Assyrian throne, around 814 the new Babylonian king Marduk-balassu-iqbi must have turned against Assyria. Shamshi-Adad invaded the region east of the Tigris but was halted by a coalition of Babylonian, Elamite, Chaldaean and Aramaean troops. The Assyrians tried again in 813 and this time the Babylonian king was captured. The new ruler of Babylon, Baba-aha-iddina, together with his family, was also captured the following year and Shamshi-Adad offered sacrifices at the principal Babylonian temples and received tribute from the Chaldaean princes. When Shamshi-Adad died in 811, Babylonia remained kingless and the political vacuum was eagerly filled by the wealthy leaders of Chaldaean tribal groups. Shamshi-Adad's son, Adad-nirari III (810–783) was crowned as the new Assyrian king, perhaps through the influence of his powerful mother Shammuramat.[1] He campaigned in Babylonia but there was no attempt to appoint his own ruler or claim the throne. Instead he contented himself with offering sacrifices in the temples of Babylon and Borsippa and receiving tribute from the Chaldaeans.

1 Shammuramat was the basis for later Greek stories about the mythical queen Semiramis.

Stability and Change
800–700 BC

By the end of the ninth century Urartu had emerged as a major power
and the kingdom continued to expand its influence across the
mountains of eastern Anatolia from its homeland around Lake Van.
Towards the end of his life, King Ishpuini ruled alongside his son Menua,
and by 805 Urartian forces had advanced the borders to the western shores
of Lake Urmia in Iran. Once his sole reign began, Menua (about 800–785)
started the construction of a series of massive fortresses on the northern
shore of Lake Van and undertook a number of campaigns into the region
north of Mount Ararat. Urartian expansion was not restricted just to the
north and east. Manua also annexed to his realm the area around the
headwaters of the Tigris in the mountains bordering the Syrian plains.

The shape of the growing Urartian kingdom formed a giant pincer
around Assyria's territories and threatened to sever the vital connections
between the plains of Syria and northern Iraq and the resource-rich
regions of Anatolia and Iran. Indeed, it was a comparatively short journey
from the region of Lake Urmia through the mountains towards the
heartland of Assyria; Urartu was getting dangerously close. In the valleys
south of Lake Urmia lay the home of the Mannaean people whose rich
farmlands supported numerous settlements including the most important
site of Hasanlu. Ideally situated to develop as a major commercial centre
linking Iran with Anatolia and Iraq, Hasanlu had maintained strong links
with Assyria for around a century, its wealth reflected by an impressive
citadel with elaborate buildings. With the advance of Urartian armies into
the region, the Assyrian king Adad-nirari III (810–783) had sent his own
forces into Mannaean territory as well as even further west to maintain
relations with and receive tribute from the Medes, tribal communities that

controlled the passage of materials from across the Iranian plateau towards centres such as Hasanlu. Attempts by Assyria and Urartu to establish their influence among the Mannaean principalities inevitably led to conflict, as groups and settlements aligned themselves with one power or the other.

Although attempts to stem the advance of Urartu in the east appeared fruitless, in the west Adad-nirari was able to maintain control over the Syrian states conquered by his predecessors and even advance Assyrian authority. This was achieved largely through his increasingly powerful provincial governors who defended their own territories and led the Assyrian armies on behalf of the king, but had sufficient independence to erect their own monuments. The hold of the western territories was threatened in 796 when the ruler of Damascus, Ben-Hadad III, who had succeeded his father Hazael, created a coalition of northern states with the aim of attacking Hamath. An Assyrian army stabilized the situation by reconquering

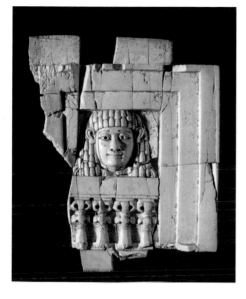

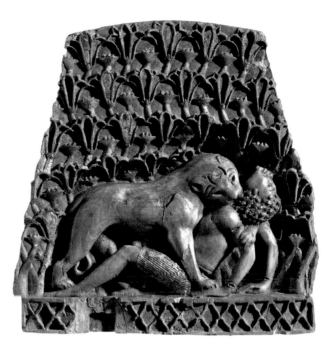

the rebellious state of Arpad and establishing a boundary between it and Hamath in favour of the latter. Damascus was then attacked and forced to pay tribute to Adad-nirari, who also received gifts from King Joash of Israel and the rulers of Edom, Tyre and Sidon. In triumph Adad-nirari marched to the Mediterranean, erected a stela at Arwad, and cut cedars on Mount Lebanon.

An opportunity for territorial gain was presented by Ben-Hadad's weakened position following the Assyrian assault on his city, and it was seized by the kingdom of Israel. In a series of campaigns Joash (798–783) was able to recover the territory in Transjordan lost to Damascus under his predecessor Jehoahaz. Meanwhile, to the south, Judah under Amaziah (796–781) had successfully attacked Edom, probably the commercially important Wadi Arabah linking Judah to the Red Sea. Buoyed by his achievements, Amaziah now challenged Joash but in the war that followed Israel proved victorious; Amaziah was captured and taken to Jerusalem where the king of Israel pillaged the treasure of the temple and carried it back to Samaria. Joash was succeeded by Jeroboam II (783–743) who also went to war with Damascus, restoring Israel's control of all of Transjordan together with the trade routes which linked his kingdom to the wealth and prosperity of the Phoenician cities on the coast.

The subjugation of Damascus revealed that Assyria was still a power to be reckoned with. Indeed, when Adad-nirari died in 783, Assyria held northern Babylonia, where the king had regularized relations with local

above
This magnificently carved ivory panel is one of an almost identical pair. Much of the surface of the ivory was once overlaid with gold leaf and inlaid with carnelian and lapis lazuli. The second of the pair was looted from the Iraq Museum, Baghdad, in 2003. ME 127412

rulers and dominated the plains and northern foothills of Syria. However, pressure continued to build from the north as Urartu shifted Syrian and Mannaean states into its orbit. The result was an increasing loss of direct control by the Assyrian court over the provincial governors. At least six Assyrian campaigns were directed against Urartu during the reign of Shalmaneser IV (782–773), the majority led by an important official, but they had little impact, as Urartu was entering its most powerful phase under a new king, Argishti I (785–765). A principal focus for Argishti's conquests was on the regions to the northwest of Lake Van where, in the early years of his reign, he captured huge amounts of gold, silver, copper, horses and cattle. In the fertile plains close to Lake Sevan in Armenia he established thousands of people deported from other regions. Large numbers of deportees were also settled on farmland and in garrisons within Urartu itself following Argishti's campaigns to the west. As the Urartian king marched through the mountains beyond the Euphrates the local rulers were forced to submit and then tied to Argishti through obligations to supply him with materials as well as labour. At their greatest extent, the conquests of Argishti and his son Sarduri II (765–735) stretched to the region north of Malatya, where they approached the lands lying within the sphere of the Mushki and the flourishing state of Phrygia, which, centred on the fortified settlement of Gordion, dominated central Anatolia with connections to Aegean world.

These finely worked earrings show the extent to which the jeweller's craft had revived in Athens in the eighth century. Both sides of the disks are decorated with fine granulation arranged in intricate wave and zigzag patterns. The centres of the disks and the other settings would originally have been inlaid. GR 1960.11-1.18-19

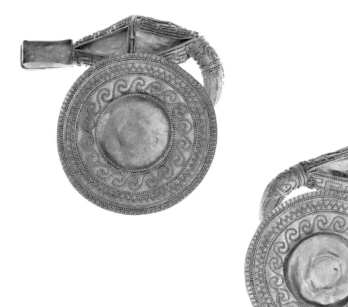

To the far west of Phrygia, along the western coast of Anatolia, on the islands of the Aegean and the Greek mainland, there was a continuing growth in the population and in the general levels of prosperity. The emerging organization of the region was reflected in the building of temples. For example, on the island of Samos in the early eighth century the temple of the goddess Hera was constructed, a large building some 33 metres long and 6 metres wide with an external colonnade. Other forms of co-operation across Greece were demonstrated by the establishment of the Olympic Games, which tradition dates to 776. Although the early games were quite low-key events, there were increasing dedications made at the site of Olympia. Materials became much more readily available, particularly bronze, but also small amounts of gold, amber (from Europe) and ivory (the carving of which was heavily influenced by the traditions of the Near East).

A close relationship between the Greek and Phoenician worlds had developed by around 800 when Greek vases began reaching such regions as Sardinia, accompanied by Near Eastern items. Tyre remained the major commercial centre responsible for the movement of large amounts of goods throughout the Mediterranean, especially by way of its colonies established in Cyprus, North Africa, Sardinia and southern Spain. Merchants from both the Aegean and Phoenicia were particularly concerned with tapping into the supplies of metals, especially iron, tin and silver. Near Eastern artistic and technical influences were carried to Greece while, in the other direction, pottery produced in the small centres of Euboea, Athens, Rhodes and Corinth was brought to the trading centre of Al Mina on the coast of Syria, among other eastern sites. Greek states began to establish their own colonies; the first substantial Greek settlement outside the Aegean was set up by colonists from Euboea around 750 at Pithecusae on the island of Ischia off the Italian mainland. An important market for the Phoenician and Greek merchants was Egypt, which was a significant source of agricultural goods as well as luxury materials such as ivory and papyrus. However, there was continuing political fragmentation of the country, with kings recognized at a number of centres: namely Thebes, Tanis, Leontopolis. A relatively weak Egypt meant it was unable to effectively interfere in the politics of the east Mediterranean states, whose rulers were more wary of developments in Syria, where Assyria remained a significant presence.

Some of the smaller states in northern Syria and southeastern Anatolia began to make common cause with Phrygia and Urartu, and this posed a direct threat to Assyrian domination. For the moment, however, the Assyrians were still able to send military expeditions through Syria, and

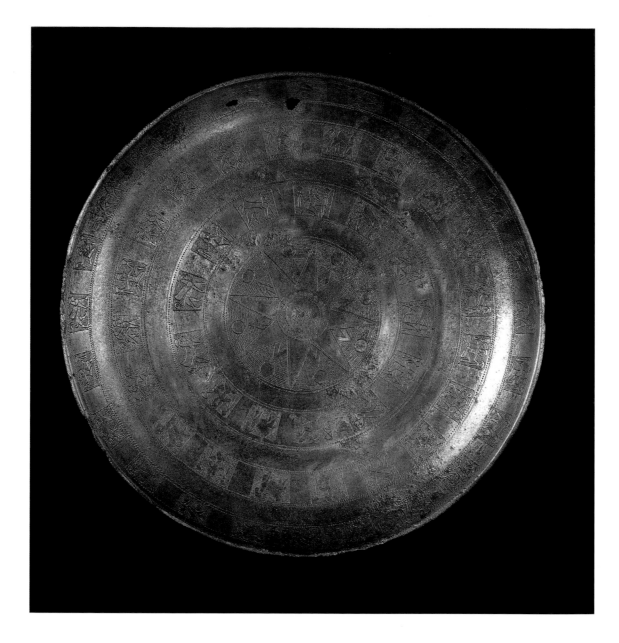

Among the tribute or booty acquired by Assyrian kings from the Phoenician cities were finely decorated bronze bowls. This one, from Nimrud, has Egyptian motifs with alternating sphinxes and kneeling figures in the three bands around the central star. Similar bowls have been found at various places in the Mediterranean, including the Greek mainland, Crete and in Etruscan tombs. ME N59

Shalmaneser IV had cedars on Mount Lebanon felled in 775, while two years later he marched as far as Damascus, where he received tribute. Under his successor Ashur-dan III (772–755), however, the Assyrian hold over their western subjects began to weaken and repeated campaigns were necessary to keep rebellious states in check. Babylon, too, began to break agreements over borders in the area east of the Tigris as political power shifted to southern Babylonia, the region controlled by Chaldaean tribes. Around 770 a leader of the Bit-Yakin tribe, Eriba-Marduk, claimed the Babylonian throne and established control over the Diyala area. Assyrian authority was being undermined in all directions and, perhaps most tellingly, between 763 and 760 the Assyrian king faced rebellions at home in Ashur and Arrapha.

Around 754/3 Urartian forces advanced against the Assyrian army in the foothills of north Syria. The dominance of Urartu and the lack of an effective response by Assyria were probably the underlying reasons for a rebellion at Nimrud which brought Tiglath-pileser III (744–727) to the Assyrian throne. The new king lost no time in attacking the root cause of Assyria's weakening position in the west. In 743 the Assyrian army caught Urartu's military forces to the west of the Euphrates and captured the Urartian camp; King Sarduri escaped but left behind his bed and royal seal. Tiglath-pileser now turned to deal with Arpad, which had been the focus of the Syrian-Urartian alliance. It took a three-year siege to bring the city to heel. By the end of 738, however, northern Syria had been effectively contained, and the region was reorganized into a series of provinces placed under the control of governors appointed directly by Tiglath-pileser. Neighbouring rulers now rushed to pay tribute to the Assyrian king, including those of Tyre, Byblos, Damascus, Carchemish, a queen of the Arabs and even southeast Anatolian states. The king of Israel, Menahem (743–738), sent Tiglath-pileser a large sum of silver to gain military support in order to secure his position on the throne.

Between 737 and 735, with much of Syria now incorporated directly into the developing Assyrian empire, Tiglath-pileser was able to campaign into the east Tigris region, which was recaptured. The Assyrian army then moved further into Babylonia and received tribute from the Chaldaean tribes. The opportunity was taken to demonstrate authority further east with a campaign into Iran, following the main route from the Babylonian plain through the Zagros Mountains as far as the territory of the Medes. Tiglath-pileser was also able to penetrate Urartu, marching unopposed as far as Tushpa itself. This was probably little more than a raid, perhaps at a time when Sarduri was campaigning further north around Lake Sevan, but reminded the Urartian king that he now faced a formidable adversary.

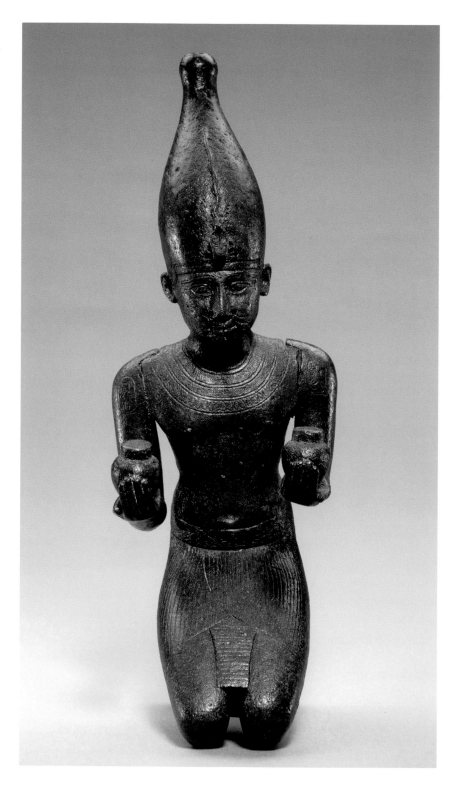

left
This statue shows Pami, a Libyan king of Egypt, in about 770. It is likely that Pami was recognized as king only in the north of the country although he is shown here wearing the white crown of southern Egypt and with writing on his shoulder naming him as king of a unified country. The various kings ruling during this period maintained the symbolism of dual kingship in representations of themselves. EA 32747

opposite
This alabaster panel decorated the palace of Tiglath-pileser III (744–727) at Nimrud. The king is shown in his chariot while, in another scene above, Assyrian soldiers drive out prisoners and flocks from a fortified city. The name Astartu is inscribed in cuneiform above the defeated city. It has been suggested that this is the Old Testament Ashtaroth in northern Transjordan. ME 118908

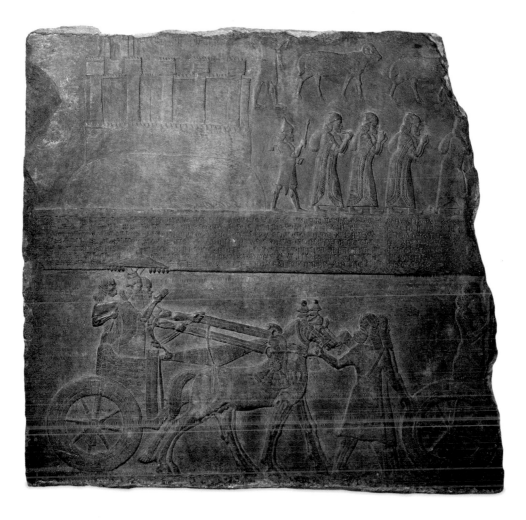

With Assyrian forces busy elsewhere, Rezin of Damascus took the opportunity to ally himself with Pekah of Israel (737–731) against the kingdom of Judah. This may have been an attempt by the two kingdoms to access trade routes when their own were being squeezed by Assyria's expansion. With Egypt politically divided and unable to provide effective assistance, Ahaz of Judah (736–716) appealed to Assyria for help, sending Tiglath-pileser a substantial gift. In response, the Assyrian army marched against Philistine cities on the coastal plain in 734 and then, having secured their rear, turned north and, after a two-year siege, captured Damascus, which was established as the centre of a new Assyrian province. Rezin was executed and some territory of Israel was annexed; in Samaria Pekah was deposed and eventually murdered. Ahaz presented himself to

the Assyrian king in Damascus, demonstrating Judah's loyalty to Tiglath-pileser.

The west was again stabilized in Assyria's favour and, with its authority now stretching to the very border of Egypt, Tiglath-pileser was able to deal with a developing situation in Babylonia. The new king of Babylon, Nabu-nadin-zeri (733–732), was assassinated by a local governor, who in turn was removed by the ruler of the Bit-Amukani Chaldaean tribe. Against this politically unstable country Tiglath-pileser launched a series of campaigns starting in 731. After two years of exploiting the rivalry between cities and tribal groups, Tiglath-pileser was able to claim the throne of Babylon himself, a position which was cemented when he received acknowledgement and royal gifts from the leader of the wealthiest Chaldaean tribe, Marduk-apla-iddina II[1] of Bit-Yakin.

The arrangement of combining the position of king of Assyria and king of Babylon was successfully followed by Tiglath-pileser's son and successor Shalmaneser V (726–722). The region from southern Iraq to the borders of Egypt appeared relatively peaceful after years of war. However, a power was re-emerging in the west; the political divisions in Egypt were being remedied by a line of Libyan rulers based in the Delta city of Sais and by the kingdom of Kush, which by the mid-eighth century was established as a powerful presence stretching northwards from its capital at Napata to the first cataract of the Nile. Around 750 the Kushite king Kashta was recognized as ruler throughout Nubia as far north as the first cataract, where he had himself represented as an Egyptian king. Under his son Piy (746–713) Kushite authority reached into the very heart of the Egyptian political establishment when his sister became 'god's wife of Amun' at Thebes. It was perhaps inevitable that Kush would be drawn into attempts by various northern princes to claim greater control of the country. There were two lines of kings ruling in the Delta (at Bubastis and Leontopolis), while other powerful individuals such as the four Great Chiefs of the Ma (Meshwesh Libyans) and the so-called Prince of the West in the city of Sais acted largely independently. Kingship was also claimed by the rulers of Hermopolis and Herakleopolis further south. Around 730 Tefnakht, the Prince of the West, began to extend his control across the western Delta, Memphis and into the Nile Valley. These conquests were viewed as a potential threat to Kushite authority, and Piy launched a military expedition into Egypt. Thebes was taken without a struggle and

These jars of alabaster and glass were found in the North-West Palace at Nimrud, which had been refurbished by Sargon II (721–705). A cuneiform inscription on both of them reads: 'Palace of Sargon King of Assyria'. The inscriptions are accompanied by an engraving of a lion, which is probably an official mark of Sargon's palace or treasury. The glass jar may be of Phoenician origin, and the cuneiform inscription added for its new owner. ME 91639; ME 90952

1 He appears in the Hebrew Bible as Merodach-baladan.

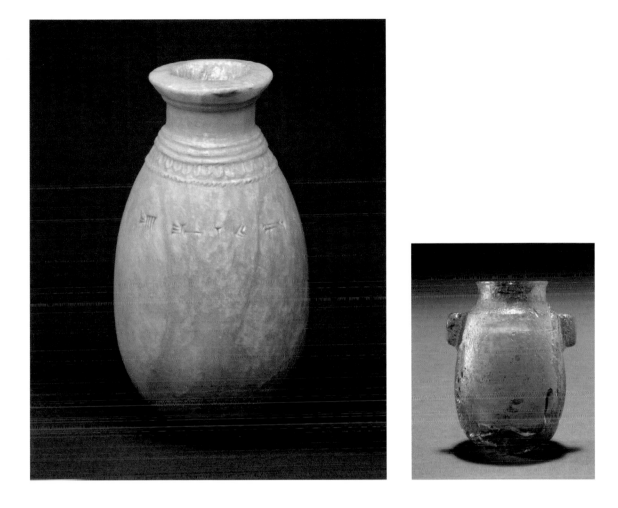

towns in the north rapidly capitulated or fell to siege. Memphis put up resistance to the Kushite army but eventually succumbed and the various dynasts submitted and recognised Piy as their overlord. Piy now withdrew from Egypt, having possibly reached a settlement with Tefnakht, who retained his former authority; Tefnakht's successor Bakenrenef was acknowledged as king throughout the Delta as far south as Herakleopolis.

The expansionist policies of the rulers of Sais reached north as well as south and the traditional Egyptian interests in dominating the kingdoms of the eastern Mediterranean were revived. Indeed, Hoshea (732–724), who had replaced the murdered Pekah as king of Israel, looked for Egyptian support when he rebelled against Shalmaneser V. It was apparently not forthcoming since the Assyrians laid siege to Samaria which eventually fell in 722, marking the end of the kingdom of Israel, which was established thereafter as a directly governed Assyrian province. In the same year the

Assyrian king died. Shalmaneser was succeeded by his brother, who may have seized the throne in a violent coup. The new ruler took the name Sargon 'the true king' (Sargon II, 721–705) and claimed the fall of Samaria as his achievement, deporting large numbers of the population to Assyria.

The result of the instability at the centre of Assyria induced by the change of king led almost immediately to rebellions among some of the remaining independent Syrian kingdoms, as well as among the tribal leaders of Babylonia. In 720 Yaubidi, the ruler of Hamath, led a coalition of neighbouring states in a bid to shake off the Assyrian presence in Syria, while the ruler of Gaza also rebelled, aided by the Egyptians. Sargon moved to crush the opposition; Yaubidi's coalition was defeated and both he and the king of Gaza were captured and flayed. Hamath was turned into an Assyrian province and control was reimposed on Arpad, Samaria and Damascus. In Babylonia, however, Sargon faced a far more daunting threat. Marduk-apla-iddina of Bit-Yakin had allied himself, almost certainly through handsome payments, with the Elamite king Ummanigash (743–717), who led his forces into northern Babylonia and met the Assyrian army in battle at Der. Sargon was beaten back and Assyria had to relinquish the crown of Babylon to Marduk-apla-iddina.

Although the loss of northern Babylonia was significant, Sargon firmly controlled territory stretching from the mountains of Iran through Syria and maintained security at the borders through client states both in southeast Turkey and as far south as Judah. The empire represented an enormous market for the merchants of the eastern Mediterranean, and the demand for metals, especially iron, other raw materials and luxury products by the Assyrian court and its allies further stimulated the flourishing trade in the Mediterranean. Phoenician products were carried to Rhodes, a chief trading partner with Tyre. An easy trip away from Rhodes lay the resources of Crete from where trade moved on to the Greek mainland. Items including faience trinkets such as Egyptian-style scarab seals and luxury objects fashioned from ivory, shell, gold and silver were exchanged across the region, stimulating workshops in the Aegean to imitate and adapt Near Eastern and Egyptian designs. As had been the case for centuries, the traders primarily came from family concerns or were individuals who carried out business on behalf of royal patrons or as private enterprises. Goods were sold and bought at a multitude of ports and there was no clear distinction between Phoenician and Greek activity. The links established by trade throughout the Aegean resulted in shared interests in decorating pottery with geometric designs, although there were regional variations; these gave way by the late eighth century to an interest in figural decoration. The growing prosperity of Greece was

reflected in the greater control wielded by local aristocrats, and this encouraged others to seek prosperity abroad in Sicily and southern Italy, where colonies were established. At home and abroad, a collective Greek identity was forged by the sharing of common sanctuaries, games and mythology, such as in the great poems of Homer and Hesiod. None the less, this panhellenic world was also sharply divided by the often bitter rivalry between the developing independent city-states (*poli*). The result was a spirit of competition where achievements were measured against those of others and increasingly allowed the questioning of old values and taboos.

Greek and Phoenician commercial enterprises were not focused solely on the markets of the Mediterranean and the Assyrian empire. Anatolia represented, as it had to the earlier Mycenaeans, an important region for exchange, and the Greek settlers of the Ionian islands and Anatolian mainland had close connections with the maritime trade. To their east the dominant power was Phrygia, which had expanded to control territory stretching from central Anatolia and beyond the Halys River, through the earlier heartland of the Hittite kingdom and the lands of the Mushki, to the borders of Urartu in the far east. At the centre of Phrygia lay the heavily fortified royal city of Gordion, which straddled a major east–west trade route. The kingdom had developed as a rich and powerful state linking the empires of the Near East to the emerging prosperity of the Aegean. The wealth of the Phrygian nobility was reflected in the huge burial mounds erected over royal and aristocratic tombs; the greatest tumulus covered a burial filled with sumptuous objects which probably belonged to the father of King Midas (around 720–690). The close links between Phrygia and the Greeks were reflected in the Phrygian borrowing of the Greek alphabet. Indeed, later tradition recalls that Midas married a Greek princess and sent an elaborately crafted

This bronze figure of a winged bull with a human torso and head was part of the decoration of a throne. It comes from Toprakkale in Urartu, the site of a major temple of the god Haldi. In the first half of the first millennium BC the Urartian kingdom had the most highly developed bronze production of Anatolia and the Near East. ME 91247

throne to the sanctuary at Delphi, possibly in return for a message from the famous oracle located there.

Although Phrygia had close ties with the west, Midas was also able to influence events to the east of his extensive territories. In 717 he instigated a revolt in Carchemish against Assyrian control, probably with the support of Urartu. The possibility of an alliance between Urartu under Rusa I (734–714) and Midas of Phrygia (or 'Mita of Mushki' as the Assyrians called him) presented a significant threat to Assyria. Following Sargon's defeat at the battle of Der three years before, Assyria had been resisting Urartian attempts to push south through Mannaea into western Iran. Sargon now marched in the opposite direction into Syria and conquered Carchemish, converting its territory into an Assyrian province. Huge plunder from the great trading city was carried to Nimrud and stored in the refurbished North-West Palace. For the next two years Sargon was faced with troubles in Mannaean territory stirred up by Urartu, as well as Phrygian attempts to bring cities of southeast Anatolia into its fold. Of particular concern was the small state of Musasir, which lay on the Urartu–Assyria border and wavered in its loyalty. In 714 Sargon set out from Nimrud on his eighth campaign. He marched through Mannaea and received the submission of the western Medes. It was perhaps at this time, if not earlier, that Hasanlu was violently destroyed by fire; thousands of ceramic, iron, bronze, stone, glass, ivory, and gold objects were buried in the collapsed buildings, along with some 240 inhabitants, many of whom had been brutally slain. Whether Hasanlu fell to rampaging Assyrian, Urartian or even rival Mannaean soldiers is unclear. Passing with difficulty through the rugged, forested terrain of northwest Iran, Sargon's army surprised the Urartian forces in a night attack, but Rusa managed to escape. From the western shores of Lake Urmia, Sargon turned south and fell upon Musasir, which was captured and plundered. Possibly helping the Assyrian advance was pressure mounting on the northern borders of Urartu from Cimmerian nomadic raiders who were moving through the Caucasus Mountains and along the shore of the Black Sea. Rusa gathered his forces against the Cimmerians but he was either killed or, according to the Assyrians, committed suicide following his defeat and was succeeded by his son Argishti II.

With Urartu deflected by the Cimmerian threat, Sargon was able to focus his attentions on the west where he crushed a rebellion by the city of Ashdod close to the Egyptian border in 712. Ashdod's King Yamani fled to the Delta seeking the support of the local rulers, but he had not counted on the real power in Egypt. Piy's successor, his brother Shabako (713–698), launched a new Kushite invasion of Egypt, which was now formally

The Kushite king Shabako (713–698) had this inscription set up at Memphis. It places Ptah, the principal god of Memphis, at the centre of existence. Shabako's intention may have been to secure the allegiance of the priesthood of Memphis, an influential section of the recently conquered Egyptian populace, by giving new prestige to the city's patron deity. The slab was later re-used as a millstone, damaging the hieroglyphs. EA 498

annexed to Kush. Bakenrenef of Sais may have been executed but Shabako left the other dynasts to govern their territories once they had acknowledged him as their overlord. Memphis and Thebes were promoted as important centres for the Kushite kings, who presented themselves as traditional Egyptian rulers. Yamani's appeal for Egyptian support against the Assyrians fell on deaf ears and Shabako, perhaps unwilling to invite hostility from the Assyrians so soon after conquering Egypt, refused the king of Ashdod sanctuary; he was carried back to Assyria in chains.[2]

The one region that had remained outside Assyria's control for ten years was Babylonia. By 710, however, major opposition to Assyrian authority throughout much of the Near East had been crushed and Sargon led his army against Marduk-apla-iddina. There was always the danger that the Babylonians would ally themselves with the Elamites, resulting in a repeat performance of the battle of Der, which had seen the Assyrians soundly beaten. However, Sargon skilfully dealt with Marduk-apla-iddina's allies and, although the Chaldaean leader sent bribes (a throne, footstool, water jug and chain of office) to the Elamite king, no support was forthcoming. In triumph Sargon entered Babylon at the invitation of its representatives and was crowned king. In 709 the Assyrians prepared to attack Marduk-apla-iddina, who had withdrawn to his homeland of Bit-

2 The chronology of Shabako and his successor Shebitko is debated among scholars. It has recently been suggested that Shabako should be dated between 720 and 707 and that Yamani was extradited to Assyria by Shebitko (dated, in this new reconstruction, 707–690).

Yakin. His tribal capital Dur-Yakin was heavily defended but Sargon captured it and seized huge quantities of booty. Marduk-apla-idinna was injured in the hand by an arrow, but he managed to escape into the eastern mountains.

Bit-Yakin had grown wealthy through its trading relations with the Persian Gulf and as the terminus for the main caravan route running across the desert from south Arabia. Now the king of Dilmun (Bahrain) sent an embassy of friendship to Sargon. Of more significance, however, was a request for an alliance from Midas of Phrygia, which encouraged greater commercial interaction between the two powers. Sargon's status was also mirrored by the enormous royal centre he had constructed some 19 kilometres (12 miles) northeast of Nineveh on land he purchased from local communities. It was named Dur-Sharrukin ('Fortress of Sargon', modern Khorsabad) and contained a royal palace of over 240 rooms, many decorated with stone reliefs perhaps carved by craftsmen from the conquered city of Carchemish, as well as temples built on an artificial terrace. The entire city was surrounded by a wall 7 kilometres (4 miles) long. The court moved to the new capital in 707/6, even though the construction was not completely finished.

Although the king could boast of his own royal city, Sargon's provincial governors had their own elaborate residences which could also be used by the monarch as he passed through while on campaign. The primary use of these buildings, however, was as centres for tax collection. The governors, supported by teams of scribal administrators, were responsible for the safe conduct of merchants and the maintenance of a road system equipped with way stations with provisions for royal messengers and officials. The provincial administrators also managed the thousands of people who were forcibly moved as a result of military campaigns and resettled in different areas of the empire where they were established as agricultural workers, set to work on building projects or incorporated into the army.

Creating and maintaining such a vast empire had required the Assyrian king to undertake repeated military campaigns. Instability could be expected beyond the borders of the distant provinces and in 705 Sargon was faced with a serious threat. It is unclear where the trouble erupted, but it was probably connected with Cimmerian nomadic incursions into northwest Iran and eastern Anatolia. Sargon, leading his forces, was killed and the whole Assyrian camp was captured. This was potentially a major crisis, but the Assyrian crown prince Sennacherib (704–681) took the throne and held the empire together. None the less, perhaps because of the inauspicious way in which his father had died, Sennacherib abandoned the

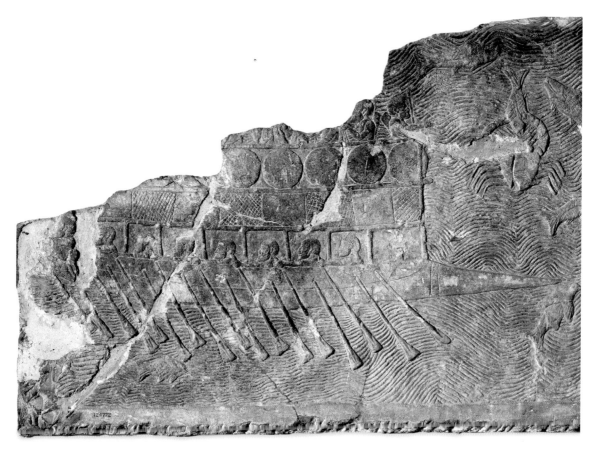

building of Dur-Sharrukin and relocated the capital and its administration at the major city of Nineveh. Here he initiated the construction of an enormous palace, a building he described as one 'without rival' (the South-West Palace). The city was transformed over some ten years into a magnificent metropolis, surrounded by agricultural and park lands supplied with water brought over 65 kilometres (40 miles) by canals and aqueducts from the Zagros Mountains.

Sennacherib's first major challenge was to maintain Assyria's hold over the newly conquered region of Babylonia with its rival tribes and ancient cities. On Sargon's death the Babylonian throne had been claimed by a certain Marduk-zakir-shumi, but he was deposed in 703 by Marduk-apla-iddina who had returned from the mountains. The Chaldaean king now sent ambassadors to Judah seeking an alliance with Hezekiah (716–687) – by fomenting opposition to Assyria in the west he may have hoped to divide Assyria's forces if they moved against him. Hezekiah apparently welcomed these moves and, probably encouraged by Egypt,

A fragment of a stone panel from the South-West Palace of Sennacherib showing a Phoenician ship. By 700 naval architects had developed a compact galley in which the upper tier of men rows from the gunwale and the lower through ports cut in the side. To fit everybody in with economical use of space, the oars of the two tiers are staggered. ME 124772

began intriguing with Philistine and Phoenician cities. None the less, Sennacherib decided to confront Marduk-apla-iddina's challenge without splitting his forces and the Assyrian army marched south. The force opposing him consisted of various Aramaean and Chaldaean tribes along with archers from Elam. Probably because his country was being marginalized by Assyrian control of the region, the Elamite king Shutruk-Nahhunte had on this occasion been persuaded to support Marduk-apla-iddina, who had sent him an immense treasure. With the advance of the Assyrian forces, Marduk-apla-iddina withdrew with his soldiers to his tribal territory in the south of Babylonia, leaving the Elamite army to face Sennacherib. The Elamites were defeated and a certain Bel-ibni, who, according to Sennacherib, had been brought up in the Assyrian court 'like a puppy', was appointed as king of Babylon.

In making diplomatic overtures to Hezekiah of Judah, Marduk-apla-iddina may have been plugging into wider intrigues against Assyria in the west. The Kushite king Shabako pursued an active policy of involvement in the cities and states that had once been Egyptian dependencies to the north of his country. By 701 the Phoenician city of Sidon ruled by King Luli openly rebelled against Assyria. Sennacherib moved to counter this dangerous situation, mobilizing his army and marching through Syria and south into the territory of Sidon. Luli fled by boat, perhaps to Cyprus, and Sennacherib appointed a new king in the Phoenician city. The rulers of Arwad, Byblos, Ashdod, Moab and Edom sent sumptuous gifts to Sennacherib. However, Ashkelon, Ekron and Judah continued to oppose Assyria. In Ekron there had been a rebellion by officials and their supporters against their pro-Assyrian king Padi. He was handed over to Hezekiah who imprisoned him in Jerusalem; the city had been prepared for attack by the strengthening of the surrounding wall and the digging of a 533-metre (1750-foot) tunnel so that water of the Gihon Spring could be reached from inside the city. The rebels also sought help from Egypt, and Shabako sent his nephew Taharqo at the head of an army to secure his interests in the region.

From Sidon, Sennacherib marched south along the coastal plain and plundered the towns in the territory of Ashkelon, whose king, Sidqia, was deported to Assyria and replaced with the son of a former ruler. The Assyrians advanced inland to Ekron, where the rebel leaders and their followers were executed and the loyal citizens released. Sennacherib now demanded that Hezekiah should free Padi and launched an attack against many of the fortified towns in Judah. While besieging the city of Lachish, Sennacherib sent a delegation with a military force to Jerusalem. Padi was released and returned to Ekron, while Hezekiah accepted Sennacherib's

authority with a large payment of tribute and the removal of some of his territory to the loyal kings of Ashdod, Ekron and Gaza. However, while the Assyrians were engaged in the hill country of Judah, the Egyptian army under Taharqo had advanced along the coast to the plain of Eltekeh close to Ekron. The Assyrian forces pulled back from Jerusalem and advanced to meet the Egyptians. Sennacherib claimed a victory in the ensuing battle and then withdrew his forces from the region, perhaps as plague broke out. His successful crushing of opposition was reflected in the fact that both Hezekiah and his successor Manasseh (687–642) thereafter remained loyal to Assyria.

Part of a series of carved stone slabs which decorated the walls of a room in the South-West Palace of Sennacherib (704–681) at Nineveh. They depict the Assyrian army storming the city of Lachish in Judah in 701 followed by the deportation of its people and the execution of officials. ME 124909

CHAPTER 10

From Babylon to Egypt
700–600 BC

Sennacherib's attempts to stabilize Babylonia under Assyrian domination appeared to be working despite the political divisions. Gradually the economy began to revive. In 700, however, his appointee to the throne of Babylon, Bel-ibni, proved less than reliable and began to intrigue with anti-Assyrian groups. In addition, and more dangerously, Marduk-apla-iddina of Bit-Yakin remained at large while Mushezib-Marduk of the Bit-Dakkuri tribe had gathered his forces in opposition to Assyria. The Assyrian army marched into the Babylonian marshes, where it crushed Mushezib-Marduk's rebellion, forcing their leader to flee. As Sennacherib advanced into Bit-Yakin territory Marduk-apla-iddina also fled, boarding a ship and crossing the Persian Gulf to Elam where he would die in exile. Bit-Yakin was devastated by the Assyrians, who reimposed their authority over Babylon; Bel-ibni was captured and taken back to Assyria.

With the troublesome leader of Bit-Yakin now out of the way, Sennacherib appointed his own son and heir, Ashur-nadin-shumi, as the ruler of Babylon and for six years the country enjoyed a period of stability. None the less, the wealthy Yakin tribe remained a potential threat, and by 694 it is possible that intelligence indicated to Sennacherib that its leaders, with Elamite assistance, were ready to make a new bid for the country. A plan was devised whereby the Assyrians would attack the Elamites and exiled Chaldaeans with a naval expedition across the marshes. Boats of Phoenician design were built by Syrian artisans, brought down the Tigris and dragged to a canal connected to the Euphrates. Soldiers, horses and equipment were loaded aboard and were floated down the river while the rest of the Assyrian army, led by the king, marched along the bank. At the

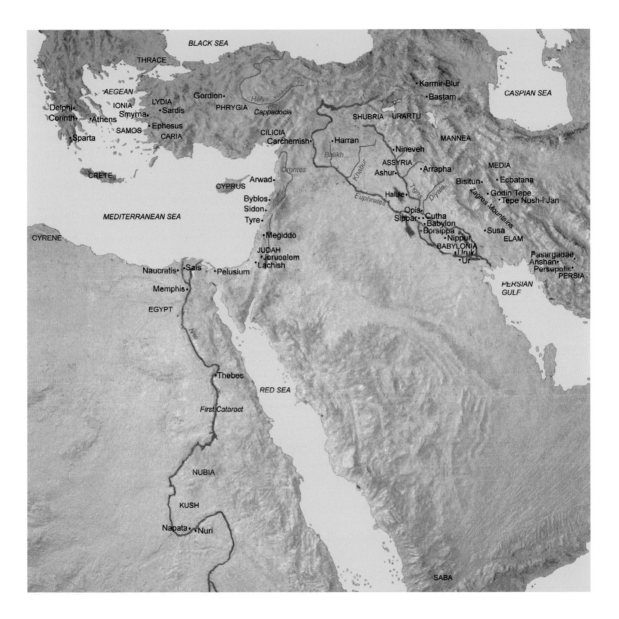

Persian Gulf they waited for the sea to calm before the expedition set sail and, once ashore, engaged the Chaldaeans in battle. The plan appeared to be working, but the Elamites recognized that northern Babylonia was vulnerable with Sennacherib's forces engaged on the coast. The Elamite king, Hallushu-Inshushinak (699–693), moved his army on to the plains around Sippar, capturing the city and receiving Ashur-nadin-shumi, who

Map showing sites mentioned in chapters 10–11.

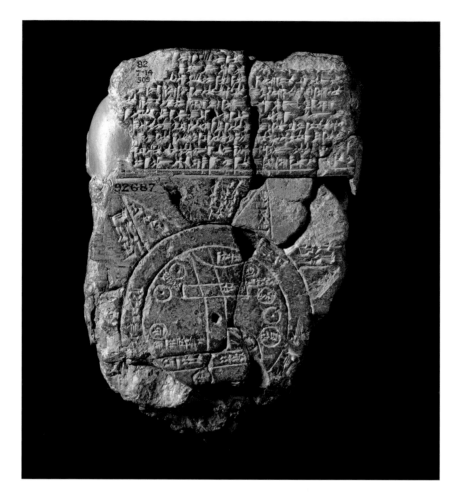

This tablet contains both a cuneiform inscription and a unique map designed to explain the Babylonian view of the mythological world. Babylon is shown in the centre (the rectangle in the top half of the circle), and Assyria, Elam and other places are also named. The central area is ringed by a circular waterway labelled 'Salt-Sea', beyond which are mountainous regions (indicated by triangles) where strange beasts and great heroes live. ME 92687

was betrayed to him by some Babylonian nobles. Sennacherib's son was taken captive to Elam and Hallushu-Inshushinak's forces successfully fought off an attack by Assyrian troops while the Elamite king installed his own representative on the throne of Babylon.

Sennacherib fought his way north and a fierce struggle continued into the following year. Eventually a major battle was fought near Nippur and the Elamite appointee was captured. The Assyrians now turned against Elam, and border cities were sacked. The Elamites deposed Hallushu-Inshushinak in favour of Kudur-Nahhunte, but the new king fled from his capital as the Assyrians advanced towards him. Although Sennacherib had managed to reclaim much Babylonian territory he had been unable to regain control of the northwest of the country, including the city of Babylon, and, as winter approached and the Assyrian forces withdrew, Mushezib-Marduk returned to claim the Babylonian throne.

Instability at the Elamite royal court continued when a revolt in 692 produced another change of ruler, but the anti-Assyrian stance was maintained and the Babylonian king Mushezib-Marduk, seeking military assistance, sent the new Elamite king a huge present of gold and silver taken from the Marduk temple. The result of such payments was the creation of a vast army, which included Aramaeans, Chaldaeans and soldiers from various small kingdoms of southwest Iran. In 691 this mercenary army began to push north, following the river Tigris. At the site of Halule they met the Assyrian army and engaged in a ferocious battle. There was no obvious victor but the Assyrians proved themselves stronger than the amalgam of warriors, and the following year Sennacherib placed the city of Babylon itself under siege. For fifteen months the besieged people of Babylon suffered increasingly terrible conditions of famine and starvation as Mushezib-Marduk's allies gradually abandoned him or were defeated by the Assyrians. In 689 his chief ally, the Elamite king, suffered a serious stroke and in the same year Babylon fell. Sennacherib took

Decorated with repoussée and engrave figures and motifs, this Phoenician silver bowl of the eighth to seventh centuries was discovered in a chamber tomb at Amathus on Cyprus. Couchant Egyptian sphinxes appear with figures in Assyrian dress picking fruit from a stylized tree flanked by Egyptian religious figures. A siege of a city with military figures wearing Egyptian and Urartian gear decorates the outer rim. ME 123053

revenge on the rebellious population that had cost him his son and heir. The symbols of the city's wealth and cultural prestige, the palaces and temples, were looted and ruined. The great religious cults, especially that of the god Marduk, were suspended, which resulted in huge psychological and economic loss for the city. Mushezib-Marduk was taken captive to Assyria and northwest Babylonia was abandoned to poverty. While Babylon was left to its own devices, other areas of Babylonia, particularly the south, with its mixture of peoples and economically important trade connections, could not be ignored for long. In 681 Sennacherib returned divine statues to Uruk and governors were appointed to the regions of the Sealand and the city of Ur.

Assyria's extensive commercial connections now stretched from Iran to Africa. Phoenicians and Greeks continued to establish trading bases and colonies around the coast of the Mediterranean, acting as entrepreneurs in the movement of goods from Egypt and the Assyrian realm and acquiring much demanded iron and precious metals from as far away as Spain. The islands of the Mediterranean acted as stepping stones, with Sardinia and Sicily the home to prosperous colony cities: on the former island, the Phoenician site of Tharros gradually evolved into a well-defended port and production centre, while on Sicily the Phoenicians relocated their trading settlements to the northwest in response to the arrival of Greek colonists in the east of the island during the late eighth century.

The homeland of the Greek colonists remained fragmented between small city-states within which different forms of government were evolving. One of the most powerful states was Sparta where kingship remained important but, during the seventh century, society had become increasingly militarized (traditionally the work of Lycurgus) and the need for agricultural workers led to the subjugation of people (the helots) in the neighbouring state of Messenia. In states without a serf population, such as Athens, the economy became dependent on slavery. Trade between city-states and overseas brought with it increasing wealth for the elite, civic identity emerged and competition between cities and individuals intensified, while there was also pressure on the poor to produce more. Colonization provided answers for people at all levels of society – elites were able to establish their own power bases, the poor found work and agricultural land, and traders tapped into the already lucrative markets. From around 700 Athenian amphorae containing wine and olive oil were reaching the eastern and western Mediterranean, while coming into Greece from the Near East were metalwork, carved ivories, pottery and textiles that influenced local styles; monumental sculpture, for example, was indebted to Egyptian traditons.

A substantial amount of Phoenician trade in the Mediterranean had been established and maintained by Tyre but Sidon remained a significant commercial centre and was given an economic advantage over its southern rival when Sennacherib, following his conquests of 701, rewarded its king with some of the mainland territories of Tyre. The result was that Tyre became even more dependent on its overseas connections. Resources from other areas were also becoming increasingly important throughout the region: the incense trade from southern Arabia was developing and King Karib'il Watar of Saba, the leading power in the Yemen, sent gifts to Sennacherib. This was an acknowledgement of Assyrian domination of the Phoenician cities where frankincense and myrrh carried by Sabaean traders were used in temples, but the gifts were really a diplomatic nicety since many of these cities, especially Tyre, were more closely connected with Egypt's commercial and political interests, and the Kushite dynasty under King Taharqo (690–664) continued to encourage their estrangement from Assyria.

Despite Egypt's unrelenting designs on the Phoenician cities, Sennacherib had secured all the troublesome areas of the Assyrian empire, and when rebellion next reared its head it came not from the provinces but from inside the royal family itself. With the abduction and presumable

This stone monument records the restoration of the walls and the temples of the city of Babylon by Esarhaddon (680–669). The top of the stone is covered with symbols which, perhaps inspired by Egyptian hieroglyphs, can be read as the king's name and titles. ME 91027

death of Ashur-nadin-shumi at the hands of the Elamites, Sennacherib had eventually chosen his younger son Esarhaddon to be crown prince. This had probably occurred through the machinations of Esarhaddon's mother Naqi'a-Zakutu, who had become Sennacherib's principal queen on the death of his wife Tashmetum-sharrat. The young man was renamed Ashur-etel-ilani-mukin-apla ('Ashur, noblest of the gods, confirm the heir') although he would seldom use the title. Esarhaddon's appointment must have caused great frustration among his older brothers since they began to plot against him. It is possible that they were beginning to persuade their father that his choice was wrong when, towards the end of 681, Sennacherib was assassinated. This was probably at the hands of his eldest son Arda-Mulissi, although Esarhaddon, his position as crown prince being undermined, might have engineered Sennacherib's death before withdrawing from Nineveh. Civil war broke out for over forty days when rival forces gathered around Esarhaddon and his brothers and their armies clashed in eastern Syria. By 680 Esarhaddon had emerged with sufficient

Packed inside a bronze bowl, this hoard of silver was buried in the floor for safe keeping at the site of Tepe Nush-i Jan in western Iran. Nush-i Jan was probably the centre of a local Median chieftain. ME 135072-85

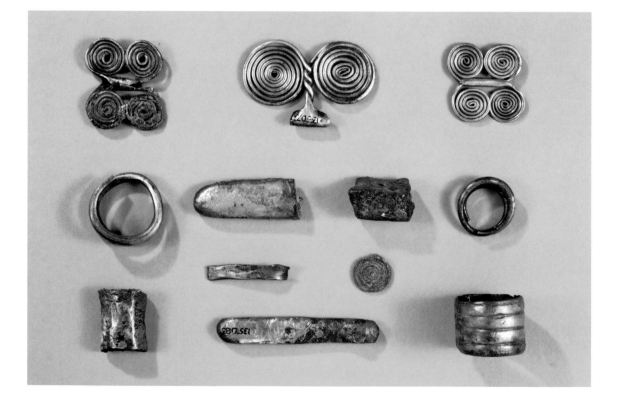

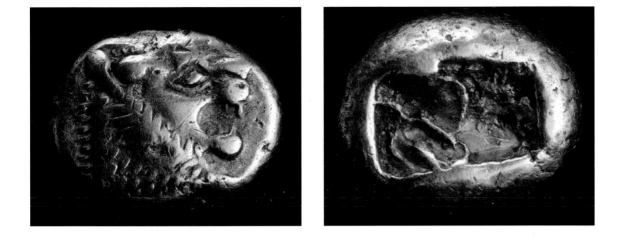

support from within Assyria that his brothers fled, possibly to Urartu, leaving him to enter Nineveh and claim the throne.

The short-lived struggle for the Assyrian throne revealed that Sennacherib had left a relatively stable empire as there were no further major rebellions. None the less, the new king faced enormous pressures mounting at all the borders. Sennacherib may have planned to attack Egypt and its Nubian rulers because of their continued encroachments in Philistia, Phoenicia and Judah, and Esarhaddon recognized this need to check Egypt's ambitions. In 679 an Assyrian army marched to the Egyptian border and captured the city of Arza. There was no opposition to Assyria from any of the western states with one exception: the Phoenician city of Sidon under Abdi-Milkutti saw an opportunity presented by the struggles for the Assyrian throne to establish an alliance with Sanduarri, the ruler of Cilicia. This was an intolerable situation for Esarhaddon but any thoughts of dealing with Abdi-Milkutti were put on hold when the Assyrian army was forced to repel an incursion of Cimmerians and Scythians, probably across the northeastern frontier, dangerously close to the Assyrian heartland.

There were also disturbances in southern Babylonia, where the typical rivalry among ambitious tribal leaders, officials and nobles continued unabated. A son of Marduk-apla-iddina and governor of Uruk, Nabu-zer-kitti-lishir, tried to win over Ur. When Ur refused to acknowledge him the city was besieged by his forces. Esarhaddon mobilized Assyrian troops in the Sealand and Nabu-zer-kitti-lishir fled to Elam seeking sanctuary. Unfortunately for him, the Elamite king, Humban-Haltash II, was supporting his own candidate and the governor was killed. Nabu-zer-kitti-lishir's brother fled to Nineveh and submitted to Esarhaddon, who installed him as governor of the Sealand. Across the region rival factions vied for

The earliest coins were made from electrum, an alloy of gold and silver, and were issued in the area of Lydia. The coins were hand-struck, with the result that each coin had an image on one side and a punch mark on the other. CM 1878,0301.384

171

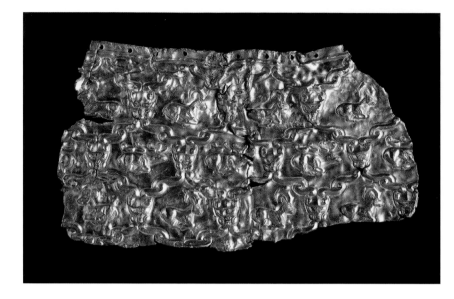

Although the provenance of this fragment of gold sheet is unknown, it may have come from northwest Iran. The style of the stags along the edge is probably influenced by Scythian art produced for horse-borne warrior elites. ME 132825

power, turning from Assyria to Elam and other parties as they saw opportunities opening and closing. Without a strong leader and a capital city for the country to unite behind, Babylonia remained a politically divided land. Esarhaddon therefore began to develop a policy aimed at winning him additional support from the ancient Babylonian cities by presenting himself as a true Babylonian ruler through their local traditions. Gradually he introduced the idea of restoring the city of Babylon to its pre-eminent cultural and commercial position, thereby ingratiating himself with the important citizens. This would also present a powerful counterweight to powerful leaders such as a man called Sillaya who had substantial support from within the tribal lands of central Babylonia.

Of more immediate concern, however, was the continued need to ensure security on the routes passing through the mountains to the north and east of Assyria which were vital for the movement of goods. Assyrian military raids were therefore dispatched into the Zagros Mountains and across the Iranian plateau as far as the desert east of Tehran. Here the power of local Median princes was centred on a number of regional fortress and religious centres such as Godin Tepe and Tepe Nush-i Jan, which contained multi-columned halls and impressive fortifications. The princes were placed under Assyrian protection with the imposition of regular tribute. The Medes brought gifts of horses and lapis lazuli to Nineveh, perhaps seeking security from the Assyrians in the face of Scythian and Cimmerian groups pushing south from the Caucasus. Some of these mobile tribes moved into northern Iran while others headed into Anatolia. In eastern Anatolia the kingdom of Urartu remained sufficiently

robust to resist the nomadic incursions and under Rusa II (about 685–645) remarkable building projects were undertaken at sites such as Karmir Blur and Bastam. The Cimmerians therefore pressed on into central Anatolia and swept into Phrygia. Gordion was sacked – later tradition says that King Midas committed suicide in despair at the destruction of his capital and kingdom.[1] In fact Phrygia survived the rampages of the Cimmerians but was reduced to a small kingdom, its vast territories in central and eastern Anatolia having been lost.

The devastation of Phrygia by the Cimmerians provided opportunities for Lydia in western Anatolia to begin to fill the political vacuum. The Lydian state, which occupied much of the territory dominated in the second millennium by Arzawa, was centred on the city of Sardis. Around 680 Gyges claimed the Lydian throne, possibly by deposing the legitimate ruler. Through a close relationship with the kingdom of Caria, his neighbour to the south, Gyges set about establishing Lydia as a powerful kingdom. Much of his strength lay in the rich gold deposits of the country which allowed Gyges to buy off opposition and recruit a strong army. His capital, Sardis, was turned into a magnificent city. He attacked and captured Greek cities on the Aegean coast and established strong political and economic links with Aegean islands and city-states of mainland Greece. For example, he made immensely rich dedications to the oracle at Delphi.

The dramatic changes to the political landscape in Anatolia with the devastation of Phrygia also had a profound impact on the eastern kingdoms such as Cilicia, which may have spurred its ruler Sanduarri to forge closer ties with Sidon. By 677, however, Esarhaddon was able to devote resources to crushing the rebellion of the Phoenician city. Sidon was captured and sacked but King Abdi-Milkutti escaped by boat. None the less, the next year he and his ally Sanduarri were taken prisoner by the Assyrians and beheaded – their heads were paraded in triumph through the streets of Nineveh having been hung around the necks of two of their nobles. A new settlement and harbour called Kar-Esarhaddon was built to replace Sidon as the commercial centre on this stretch of the coast and settled

In the late third millennium rulers in southern Iraq had themselves depicted in the form of foundation pegs carrying out the restoration of temples. It is possible that examples of these figurines were discovered in the ruins of Babylon during the rebuilding works in the city by Ashurbanipal (668–631), for on this stela from Babylon Ashurbanipal, wearing the Assyrian king's headdress, is shown in the pose of earlier kings, lifting up a large basket of earth for the ritual moulding of the first brick. ME 90864

1 Recent work at Gordion has suggested that the massive destruction visible at the site may date to about a century before the devastation wrought by the Cimmerians around 690.

with deported people. Assyrian oaths of loyalty were imposed on Manasseh of Judah, the rulers of Phoenicia, including Ba'al of Tyre, and Philistia, Moab and Ekron. In addition ten kingdoms of Cyprus recognized Esarhaddon's authority. All these rulers provided the Assyrian king with building materials, especially cedars from the Lebanon, and they had it transported with difficulty to his palace at Nineveh.

The borders of the empire remained the principal concern for Esarhaddon over the following years. In the northeast, frontier fortresses were vulnerable to attack, and a coalition of Medes, Mannaeans and Cimmerians caused considerable damage and loss of territory. Diplomacy between Assyria and the various tribal leaders was as important as military action to stabilize the situation, and at one point Esarhaddon received a request from Bartatua, king of the Scythians, for an Assyrian princess to marry. Peace was also achieved elsewhere by diplomacy. In 675 the Elamite king Humban-Haltash II plundered the Babylonian city of Sippar, but when he died that year his brother and successor Urtak established friendly relations with Esarhaddon before the situation could develop into war.

One kingdom, however, would be central to Assyria's foreign policy for the rest of Esarhaddon's reign. This was Egypt under the powerful Kushite ruler Taharqo. The country presented an enormously attractive partner for the Phoenician cities, being an important market but also controlling trade routes stretching into central Africa. Ties between Egypt and Tyre were therefore strengthened. By 674 Esarhaddon had decided that the maintenance of his dominance over the Phoenician cities demanded that he attack the source of their disloyalty. An Assyrian army marched into Egypt but it was defeated and forced to withdraw. As the Egyptians had demonstrated in 701, they were a power to be reckoned with and it was clear that further conflict between the two great kingdoms was inevitable.

Esarhaddon devoted the following years to preparing for the confrontation with Egypt. This required the other trouble spots of the empire to be contained. In 673 military action was directed against the mountainous kingdom of Shubria west of Lake Van, where political refugees had fled from Assyria. When the ruler of Shubria was unwilling or unable to deliver these people to Esarhaddon an Assyrian army sacked the Shubrian capital city. The refugees were caught and punished and, when some of them were discovered to be Urartian, they were returned to their homeland as a gesture of continuing friendship with the country which was serving to ward off Cimmerian advances.

Loyalty from the Assyrian vassal states and peoples was further demanded when in 672 Esarhaddon had them swear oaths of allegiance

The early Kushite kings were buried on beds placed on stone platforms within their pyramids. Taharqo (690–664) introduced more Egyptian elements to the burial, such as mummification, coffins and sarcophagi of Egyptian origin, as well as the provision of *shabti* figures. This is a granite *shabti* of Taharqo from his pyramid at Nuri in Nubia. EA 55484

recognizing one of his sons, Ashurbanipal, as his heir. In a novel attempt to maintain support from within Babylonia, another son, Shamash-shum-ukin, was presented as the future king of Babylon and depicted wearing the traditional royal robes of the country. Cult-statues were returned to various Babylonian cities and repairs on the damaged temples undertaken. Esarhaddon encouraged commerce through the restoration of secure routes across the region, while impoverished people had their property returned to them.

By 671 Esarhaddon was ready to confront Egypt. Ba'al of Tyre had revoked his agreement with Assyria, and his city of Ushu (the land city opposite the island of Tyre) was besieged and fell to the Assyrian army. Ba'al was again tied to Assyria through a new vassal treaty in which Tyrian merchants were restricted to certain ports and trade roads. The Assyrians then marched on into Egypt with Arabs providing camels to carry water skins to support the crossing of the northern Sinai. In a succession of fierce battles the Assyrians pushed right to the city of Memphis, which was captured. By now Taharqo had lost the support of many of the Delta princes and, although he withdrew along the Nile Valley to Thebes, his family, including the crown prince, were trapped in Memphis where they were caught and dispatched to Nineveh. The dynasts of the Delta now acknowledged the Assyrian king as their overlord, with large payments of tribute (some of which Esarhaddon would invest in his reconstruction work in Babylonia). One of the local rulers, Necho of the city of Sais, was installed as overlord with Assyrian administrators. However, the Assyrian triumph was short-lived as Taharqo moved to restore his authority in the Delta as soon as Esarhaddon's army had withdrawn. Returning with his forces to Memphis, Taharqo received

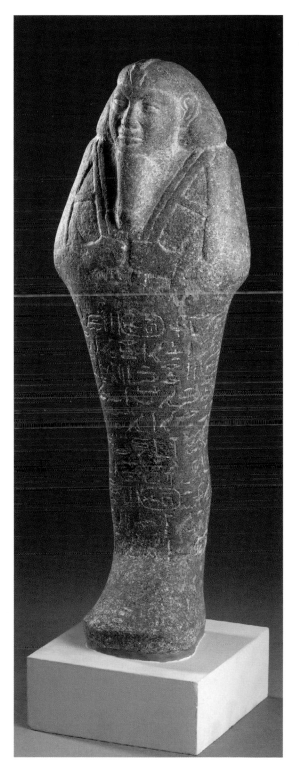

The Assyrian king Ashurbanipal collected a library of thousands of cuneiform tablets in his palace at Nineveh. They record rituals, scientific information and literature. Included among them was a version of the Epic of Gilgamesh. This, the eleventh tablet of the epic, describes the meeting of Gilgamesh with Utnapishtim, who had been forewarned of a plan by the gods to send a great flood. He built a boat and loaded it with everything he could find. Utnapishtim survived the flood for six days while humankind was destroyed, before landing on a mountain called Nimush. He released a dove and a swallow but they did not find dry land to rest on and returned. Finally a raven that he released did not return, showing that the waters must have receded. ME K3375

The reliefs from the South-West palace at Nineveh depicting the Assyrian defeat of the Elamite king Teumman contain several narrative stories told across a number of limestone panels within an apparently chaotic scene of battle. The complexity and quality of the design make this one of the finest accomplishments of Assyrian art. Teumman is identified by his hooked nose and receding hairline, a caricature which represents one of the earliest Near Eastern portraits outside of Egypt that is based on an individual's physical characteristics. Detail of ME 124801

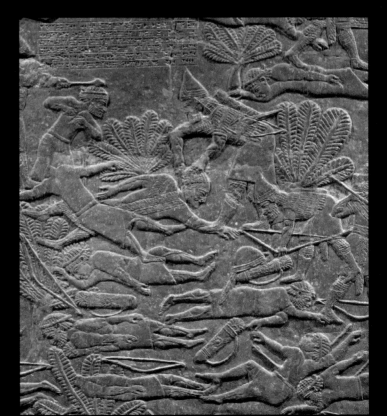

the dynasts, who revoked their oaths with Assyria in favour of the Kushite king. It took until 669 for Esarhaddon to prepare another expedition to Egypt. He had faced a major crisis in Assyria the previous year, which resulted in many of his officials being executed, presumably for treason. Whatever the causes of this predicament the king's position was eventually sufficiently strong to launch his campaign against Taharqo but, as the Assyrian army marched towards Egypt, Esarhaddon was taken ill and died and the expedition was aborted.

In Assyria Ashurbanipal ascended the throne but it would be the following year before his brother Shamash-shum-ukin was crowned in Babylon; it was clear that the latter would play a subordinate role with limited power, perhaps only acting as a figurehead, while real authority lay in Nineveh. This situation, which Esarhaddon had hoped would stabilize relations between Assyria and Babylonia, would eventually lead to friction and rivalry between the brothers. But in 668 the Assyrians returned the statue of the god Marduk to Babylon with great triumph and Ashurbanipal began to undertake major building works in his own name. For the time being peace prevailed and Babylonia entered a period of economic prosperity.

Meanwhile, Ashurbanipal was preparing to take up the challenge of Taharqo. In 667 he dispatched the Assyrian army through Syria and south along the Mediterranean coast. The remaining independent Phoenician cities of Arwad, Byblos and the island of Tyre pledged their loyalty and the expedition continued into Egypt. Taharqo's forces were beaten back and again the Kushite king withdrew to Thebes. On this occasion, however, the Assyians pursued him. A fresh army gathered from Assyrian vassals such as Judah, Moab and Edom as well as troops of the Delta princes moved south to Thebes, which was abandoned by Taharqo. The Egyptian dynasts now conspired to divide the country between them, sending friendly messages to Taharqo in order to gain the support of the Kushite king, but the plot was discovered and the rebellious groups were punished. However, it must have been expedient to show favour to Necho, who presumably enjoyed considerable support in the Delta, and Ashurbanipal restored him to Sais with authority over Memphis while his son Psamtek was given the rule of the city of Athribis.

Friendly relations between Assyria and the kingdoms beyond the borders of the empire now appeared to usher in a period of co-existence. By this time Cimmerian tribes had reached Lydia, and Gyges found himself in a desperate situation as Sardis itself was threatened. He sent a messenger on horse to Nineveh but unfortunately there was no court interpreter there able to understand his language. Eventually the difficulty

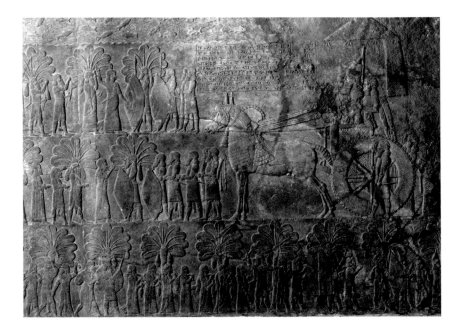

The throne room of Ashurbanipal's palace at Nineveh (the so-called North Palace) was decorated with scenes of his military triumphs in Babylonia and Egypt.

The Assyrian king in his chariot is presented with the royal regalia of Babylonia following the defeat of his brother Shamash-shum-ukin. Detail of ME 124946

must have been resolved because a treaty was established and the Assyrians provided aid to Lydia; Gyges sent Ashurbanipal some captive Cimmerians as a demonstration of their mutual ties. Ashurbanipal also aided the Elamites who were suffering from famine as the result of a prolonged drought. None the less, in 664 the Elamite king Urtak was persuaded by both the governor of Nippur and the leader of the Babylonian Gambulu tribe to invade Babylonia. Ashurbanipal may have expected his brother to deal with the situation because he delayed sending troops, but when the Assyrian army was at last mobilized the Elamites simply withdrew and there were no repercussions. In any case, Urtak died later in the year with the result that Elam was torn apart by bitter rivalry for the throne between competing factions.

Urtak's actions were probably encouraged by the absence of the Assyrian army, which was dealing with a pressing situation that had broken out in Egypt. Taharqo, who had withdrawn to Napata in Kush, had died and his successor Tanutamani brought renewed energy to the Kushite throne. In 664 he launched his own invasion to reclaim Egypt, defeating the local rulers who had sided with Assyria. A huge army was sent against Egypt by Ashurbanipal, forcing Tanutamani out of Memphis and pursuing him through Egypt to Thebes, which was plundered; an obelisk made of electrum was among the treasures carried back to Nineveh in triumph. Necho's son Psamtek had survived his father at Sais and he was again tied to Assyria through oaths of loyalty. Assyrian support for Psamtek probably

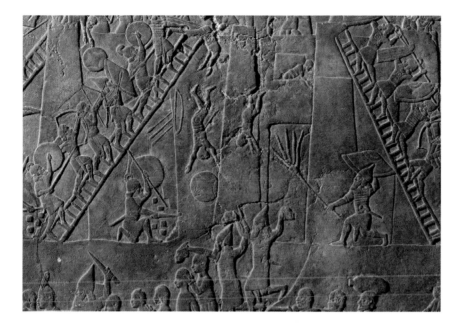

An Egyptian city with distinctive architecture is captured by the Assyrian army. ME 124928

gave him a strong advantage over the other princes of the Delta and gradually, using diplomacy and persuasion to dismantle their power, Psamtek extended his authority. By 656 Psamtek controlled the whole of northern Egypt. An agreement was reached with the Kushite kings, who still claimed southern Egypt as part of their realm, and Psamtek's daughter was sent to Thebes where she was adopted by the 'god's wife of Amun' as her successor. Foreign soldiers from among the Greek cities, Lydia and Caria were recruited to back up Psamtek's own warriors.

Gyges had probably provided Psamtek with support in the hope of building an alliance to counter the increasing problem of Cimmerian attacks on his kingdom. Tradition recounts that Gyges was eventually killed by the Cimmerians in battle, perhaps around 652, and his son Ardys continued the defence of Lydia. The Lydian aid for Psamtek was viewed with hostility by Ashurbanipal, who withdrew his agreement with Gyges, but the Assyrians were unwilling or unable to take action to rein in the Egyptian king, for by the late 650s a series of crises had developed in Elam and Babylonia which would stretch Assyrian resources to breaking point.

Elam was becoming fragmented by rival claimants for the throne. Eventually, the family of the earlier king Urtak as well as that of his predecessor Humban-Haltash sought refuge in Assyria while the crown of Elam was claimed by Tepti-Humban-Inshushinak or, as the Assyrians called him, Teumman. Teumman repeatedly demanded that Ashurbanipal should return the political refugees to Elam, sending the Assyrian king

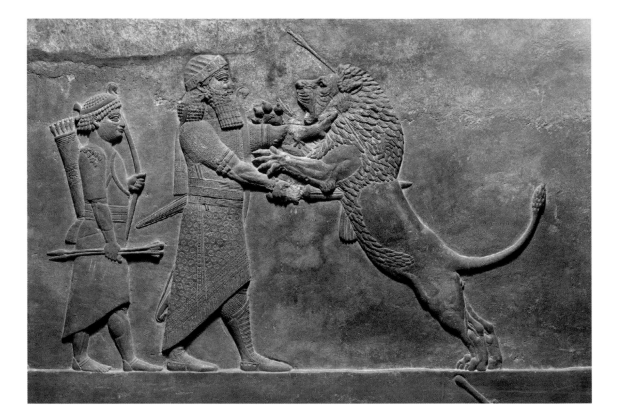

insulting letters. By 653 the situation had reached crisis point and Ashurbanipal sent the Assyrian army south. The Gambulu tribe were punished and Elam was invaded. In a great battle at Til-Tuba near Susa, Teumman and his son were killed. Two Elamite princes were sent from Nineveh and installed as rulers over parts of Elam, which remained a divided country. The Assyrian triumph was depicted in extraordinary detail in a magnificent series of stone reliefs, erected to decorate the walls of the South-West Palace at Nineveh, in which the battle was shown as well as the aftermath when Urartian ambassadors witnessed the punishment of Ashurbanipal's adversaries.

Much more critical for Ashurbanipal, however, was that some of the Elamite kings continued to support a rebellion that had begun in Babylon and was led by Shamash-shum-ukin who for years had ruled in the shadow of Ashurbanipal, his brother and overlord. For some fifty years no leader in Babylonia had been able to forge an alliance between the neighbouring kingdoms and the cities and tribes of Babylonia to confront Assyria effectively. With the country stabilized under Assyrian domination, Shamash-shum-ukin had been able to build a power base and could rely

This sculptural masterpiece from the North Palace at Nineveh captures the power and energy of the dangerous lion, contrasting with the effortless way in which it is dispatched by the idealized Assyrian king Ashurbanipal. Detail of ME 124875

on support from the cities of northern and central Babylonia, as well as many of the Chaldaean and Aramaean tribal areas and Arab groups.

War broke out between the brothers in 652 and it was a ferocious affair. The Assyrians rapidly forced Shamash-shum-ukin to withdraw into Babylon but only in the second of two major battles were they able to inflict a serious defeat on the Babylonians. Elamite troops were also defeated but, despite the setbacks for the southern coalition, the war dragged on. By 650, however, Babylon was under siege, as were the cities of Borsippa, Cutha and Sippar. In the south the pro-Assyrian city of Ur, lying on the edge of the cultivated land, was under extreme pressure from the Chaldaean tribes of the Sealand and the Elamites. Eventually, Assyrian troops arrived and the city was rescued. In 648 Babylon fell and Shamash-shum-ukin died in the flames of his capital. Assyrian rule was reimposed under an Assyrian appointee called Kandalanu (647–627) and with the stability brought by his administration the country gradually regained its economic strength.

Fighting may have continued in the south of Babylonia following the fall of Babylon but by 646 the Assyrian army had advanced into Elam where Susa and other major cities were plundered – the great ziggurat at Susa was destroyed and the sanctuaries stripped of their treasures. Ashurbanipal's revenge on the region, which had proved so troublesome for Assyria, included the desecration of tombs belonging to the ancestors of the Elamite kings. Local rulers now sent embassies to Ashurbanipal. These included Kurash, the king of Anshan. Finally, Arab tribes of the western desert who had supported the Babylonians were attacked and some of their chiefs were deposed.

Ashurbanipal marked the successes of his army with huge celebrations. A new palace was constructed at Nineveh (the North Palace) in which the king had his victories over Egypt, Babylonia and Elam depicted in impressive wall reliefs. However, perhaps the most dramatic and finely carved of these new stone monuments were the reliefs depicting Ashurbanipal hunting and killing lions, symbolic of his divinely sanctioned victory over the dangerous forces of the universe. None the less, although the images evoked a vigorous and powerful monarch, this was perhaps in contrast to reality. The years of military campaigns had severely drained Assyria's resources, and with the burden of supporting a huge bureaucracy there would be no further expensive major military campaigns to maintain the vast empire, which had begun to fray at the edges.

Already Psamtek had extended his authority throughout Egypt and begun to advance in the north through Philistia. He opened Egypt's ports

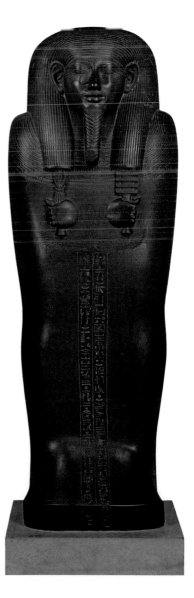

This is the sarcophagus of Sasobek, the vizier of northern Egypt in the reign of Psamtek I (664–610). It may have been found in Sais, the city from which Psamtek's family came. The sarcophagus is one of the finest examples of its type. EA 17

to Greek and Phoenician traders – among the Greek trading stations established in the Delta was the site of Naucratis, where custom dues and taxes were charged on imports and exports. The result was that Egypt saw its treasury rapidly grow. In Judah, Josiah (640–609) undertook religious reforms and established his control over the former territories of Israel. And, although Assyria's hold over much of Syria remained secure, pressures on the northeast frontiers were unrelenting. As late as 643 the Urartian king Sarduri III sent an embassy of friendship to Ashurbanipal but sites such as Bastam had been attacked and abandoned, and soon afterwards the kingdom of Urartu itself disintegrated into smaller kingdoms and tribal lands as Cimmerians, Medes and other groups captured territory. To the south, Assyria loosely held Babylonia under Kandalanu but, to the east, Assyria's wrecking of Elam had removed an important buffer between Babylonia and strong tribal groups in the Iranian interior. Among these people were the Persians, who had possibly migrated over a long period into Iran from Central Asia, along with other cattle herding groups. Some of them had settled in the region of Anshan and had been united under a royal family headed in turn by Kurash, Teispes (640–620) and Cyrus I (620–590). The Persians were closely linked with their northern neighbours the Medes; towards the end of the century, the various Median tribal centres and fortresses had gone into decline, possibly because political power had shifted to the Median centre of Ecbatana (Hamadan) under Cyaxares or his predecessor. The rulers of Ecbatana had benefited from close military and economic links with Assyria and had gathered sufficient prestige to unite the Medes into a loose confederation.

Beyond the direct reach of Assyria's fading empire, other states were re-emerging or developing new forms of political control. By the later seventh century the Cimmerian threat in western Anatolia had run its course and the invaders had withdrawn or dispersed and Lydia began to expand further its authority over central Anatolia and the Greek cities of the Aegean coast. To the west, on the Greek mainland, elites were benefiting from the flourishing economic links with Egypt and the Near East. While Sparta remained militarily the most powerful of the city-states, in other states political struggle was the order of the day. In some cities, 'tyrants' emerged from the governing elite, usually through the

There were many Egyptians living throughout the Near East as a result of trading relations and deportations following the expansion of the Assyrian and Babylonian empires. This small sculptural group depicting the Egyptian gods Bes, Isis and the child Horus was found at Babylon and dates between 700 and 300. ME 113909

mobilization of popular support, and established themselves as rulers. One of the most powerful of these autocrats was Periander of Corinth (625–585) who had close ties with Lydia. In Athens attempts to prevent abuses by the ruling parties led to a series of harsh laws drawn up by an official named Draco around 621, but by the early years of the next century these, too, had been criticized and, under the lawmaker Solon, made less severe.

Some time around 631 Ashurbanipal died and he was succeeded by his son Ashur-etel-ilani. However, the Assyrian throne was contested and for a brief period even an official called Sin-shum-lishir was able to claim it. Eventually, another of Ashurbanipal's sons, Sin-shar-ishkun, became king but by this time Assyria was losing its hold on Babylonia. Kandalanu had died in 627 and new claimants for the Babylonian throne had emerged. Among the powerful individuals who were vying for control was a man called Nabopolassar who had gathered military backing from among some cities and tribal groups. It is possible that he had earlier been appointed as a general in Babylonia by Sin-shar-ishkun and decided to make a bid for power. Initially the Assyrians were able to keep his forces at bay, but in

This shell, from a clam that originates in the Red Sea and the Indian Ocean, was carved and used as a container for cosmetics in the seventh century. Such containers were possibly produced in Syria or the eastern Mediterranean, though they have also been found in Iraq, Egypt, Cyrene, the coast of Anatolia, the Aegean islands, Greece and, like this one, Italy.
GR 1852.1-12.3

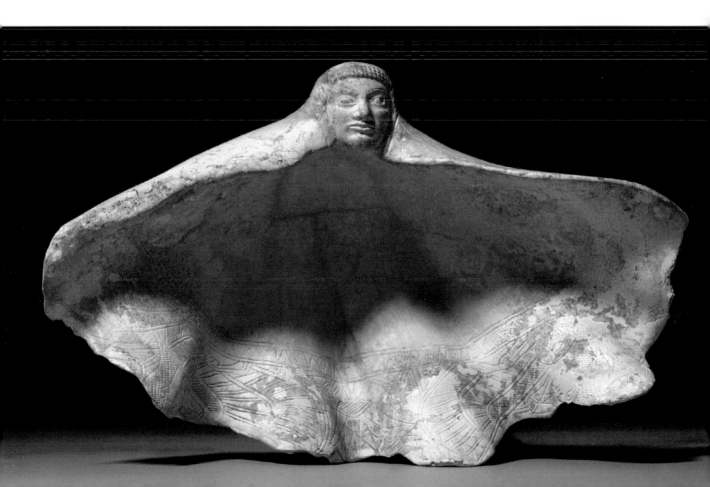

626 the Assyrian army suffered a reverse at Babylon and Nabopolassar claimed the throne. Babylonia continued to be divided between pro- and anti-Assyrian groups but gradually Nabopolassar extended his authority and by 616 he began to launch attacks on Assyrian territory. Assyria resisted fiercely but after many months Nabopolassar had pushed north along the Euphrates into Syria. The following year the Babylonians attacked into Arrapha but the Assyrians managed to repulse them at Ashur.

With Nabopolassar's campaigns diverting Assyrian resources to the defence of the homeland, Cyaxares mobilized his forces and, moving through the mountains, the Medes swept into Assyria in the summer of 614 and attacked Nineveh. The Assyrian capital was well defended and the Medes were driven off, but they laid siege to Ashur, which was captured and plundered. Although badly mauled, Assyria remained a formidable opponent and in 613 its army moved against Nabopolassar. Meanwhile a treaty had been agreed between the Babylonians and the Medes (according to a later tradition it was sealed through the marriage of a daughter of Cyaxares with Nabopolassar's son, Nebuchadnezzar). The two armies joined forces and in 612 they began to besiege Nineveh. For three months the great city resisted. When Nineveh eventually fell, the palaces were plundered and severely damaged. The Assyrian monarch, Sin-shar-ishkun, was killed but, although his country had lost its king and capital, Assyria did not immediately collapse; local governors continued to resist the Babylonian and Median forces and an Assyrian army rallied at Harran, one of the principal cities of the empire, under a man called Ashur-uballit.

It is possible that Ashur-uballit appealed to Egypt for aid since he was joined at Harran by an Egyptian army. This was a remarkable turnaround in the power politics of the region and Egypt, now ruled by Necho II (610–595), was keen to extend its political and economic strength at the expense of Assyria's decline. The Egyptian king invested in the creation of a fleet of war galleys to dominate the eastern Mediterranean and Red Sea. In addition, he started the construction of a canal linking the Nile to the Red Sea to connect his growing spheres of influence. Later tradition credits him with encouraging the Phoenicians to circumnavigate Africa, though this probably reflects their more limited, though still impressive, trading expeditions along the west coast of the continent and Egypt's close economic relationship with such enterprises. While maritime trade brought great wealth to Necho, the collapse of Assyrian authority in the states to the north presented a real possibility for Egypt to claim the region and its land routes. By propping up Ashur-uballit and preventing the Babylonian army from advancing to the Mediterranean, Necho would be able to restore the Egyptian empire.

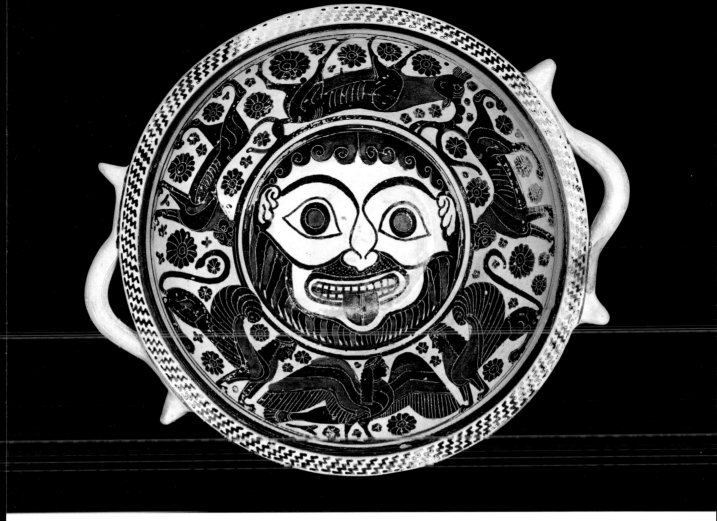

The forces that the Egyptians would have to confront, however, were formidable. In 610 the Babylonian and Median armies once again joined forces and advanced against Harran. Unwilling to be besieged, Ashur-uballit and the Egyptian army withdrew from the city and Nabopolassar's forces fought the remaining defenders of Harran, before capturing and plundering the city and leaving a garrison inside. If Necho was to hold Syria against Nabopolossar he would need to support Ashur-uballit with more soldiers, and the following year the Egyptian king led a large army north. As Necho crossed through the pass near the city of Megiddo he was confronted by the army of King Josiah. Judah's independence was threatened by Egypt's renewed claim to overlordship in the region and Josiah was determined to resist. The challenge failed. Josiah was killed and his son Jehoahaz was required to swear loyalty to Necho. It soon became apparent that Jehoahaz was a bad choice, so Necho replaced him with his

The head of the Gorgon, here depicted on a vessel made in Corinth but found on Rhodes, was often painted in the centre of cups and bowls in the late seventh century. It was possibly designed to ward off the 'evil eye' and derived from popular grotesque images of the Near Eastern monster Humbaba and the Egyptian protective deity Bes. GR 1861.4-25.46

Part of an ivory box (700–600) discovered at Ur in southern Iraq. It is inscribed with a Phoenician dedicatory inscription: 'This box Amat-Ba'al, daughter of Pat-isi, slave of (our master), presents to Ashtart. For this may she bless me in the days of our master.' ME 120528

brother Jehoiakim (609–598) and imposed a heavy tribute on Judah.

The Egyptian army then moved into Syria, joined with the forces of Ashur-uballit, and in the summer of 609 crossed the Euphrates and marched against Harran. Over a period of some four months Harran was besieged, but the city did not fall and the Egyptians established themselves at Carchemish. Any Assyrian hope that they might have been able to restore their authority vanished, as over the following years the Egyptian and Babylonian armies vied for control of Syrian cities in a series of bloody confrontations, with victories and defeats on both sides. Increasingly, Nabopolassar was placing his son Nebuchadnezzar at the head of the Babylonian forces and, in 605, the crown prince engaged the Egyptians in battle at Carchemish. It was no easy victory but eventually Nebuchadnezzar was able to claim the field and pursued Necho's army to Hamath, where a second victory gave Babylon control of Syria. However, any follow-up campaigns to push the Egyptians further south were stalled by the news that his father had died in Babylon and Nebuchadnezzar returned home to claim the throne. This gave Egypt the opportunity to assert its authority in the region once again and immediately after his coronation Nebuchadnezzar marched back to Syria. He fought hard over the coming years to establish his control and by 601 the Babylonians had pushed to the Egyptian frontier, where a major battle produced no clear victory for either side. It was the start of a violent struggle between Egypt and the new ruler of Syria for domination of the eastern Mediterranean.

A World United

600–500 BC

Control of the trade routes running through the lands of the eastern Mediterranean that linked the Aegean and North Africa with the states of inland Syria and further east remained as crucial as ever in the new century. Egypt, which had once competed with the Hurrians, Hittites and Assyrians for domination of the region, now vied with the rulers of Babylon, who were attempting to consolidate their hold over what had been Assyrian provinces. Among the kingdoms that had lost territory but had not been incorporated directly into the Assyrian empire was Judah, which had survived by walking the dangerous tightrope of diplomacy as a buffer zone separating Assyria and Egypt. With the death of Josiah and the appointment of his successor by Necho II in 609 the country had been tied to Egypt. It was apparent that, despite being forced to withdraw from Syria by Nebuchadnezzar's forces, Egypt remained a considerable challenge to Babylonian authority. Necho followed up the indecisive battle between the two powers in 601 by campaigns on the southern coast of Philistia. Jehoiakim of Judah, who had declared loyalty to Nebuchadnezzar when he had passed through the country, now shifted his allegiance back to Egypt. If Babylon was to prevent any attempt by Egypt to advance northward, Judah and other neighbouring states would have to be secured, and the situation forced Nebuchadnezzar to return repeatedly to the region throughout his reign.

In 599 Nebuchadnezzar sent forces based in Syria to attack and perhaps establish alliances with a number of Arab tribes who where fundamental in maintaining connections along the desert routes. This was crucial if there was to be a broader containment of Egypt. The Babylonians were also able to conquer the Lebanon Mountains and drive out an

This stone tablet from Babylon has a very finely carved cuneiform inscription that records the glorification of the god Marduk by Nebuchadnezzar II (604–562) through his many building works in the capital and the nearby city of Borsippa. ME 129397

Egyptian presence; Nebuchadnezzar transported the prized cedar wood to Babylon where it was cut into planks and, once plated with bronze, erected to form the great doors of the city. This was part of the continuation of massive building works initiated by his father in all the major cities of Babylonia, but it was the restoration and beautification of the capital that most clearly reflected Nebuchadnezzar's power and wealth. Babylon was developed into a city that would rival Nineveh for its legendary magnificence. Covering an area of at least 850 hectares, and thus one of the largest settlements of the ancient world, the site was enclosed by huge double walls and a moat. The Euphrates River flowed through the centre of the city and access by boat was controlled by metal gates. A stone bridge spanned the river and connected the western half of the city with the heart of the settlement on the eastern bank. Here lay the royal palaces and the imposing temple of Marduk, patron deity of Babylon, with its associated ziggurat, a solid stepped tower.

During the time that his capital was being transformed into one of the wonders of the age, Nebuchadnezzar was forced to spend considerable time attempting to maintain a firm hold over his territories. In 598

Jehoiakim of Judah, who had turned his allegiance back to Egypt, died, possibly by assassination, and was succeeded by his son Jehoiachin. But, if the change of ruler was an attempt to dissuade the Babylonians from attacking Judah, it occurred too late; by the winter of 598 Nebuchadnezzar had marched to Jerusalem and placed it under siege. On 16 March 597 the city fell and Jehoiachin, his court and several thousand prominent people of Judah were deported to Babylonia. Jehoiachin's uncle Zedekiah was placed on the throne by Nebuchadnezzar, who imposed a vassal treaty upon him.

Trouble for the Babylonians was not restricted to the west of their empire. In 596 one of the rulers of the divided lands of Elam caused problems in the east Tigris region and a Babylonian army marched to crush him. It may have been at this point that the ancient city of Susa became part of the Babylonian realm. There were further signs that Nebuchadnezzar's hold on power was far from secure when the following year there were rebellions in Babylonia itself, probably involving the army, and in 594 a major official was executed after having been found guilty of planning treason. Babylonian control over the western provinces also remained shaky and, despite Nebuchadnezzar's earlier conquest of Judah, there were campaigns to the region in 595 and 594. Much of the opposition was no doubt backed by Egypt, whose ambitions in the area remained strong, especially in relation to the Phoenician cities, its partners in maritime trade. The new king of Egypt, Psamtek II (595–589), continued his father's policies on the international front. He first led his armies into Nubia where Anlamani (623–593), a descendant of the Kushite kings who

Nebuchadnezzar's transformation of Babylon into a magnificent metropolis included the creation of the Processional Way which led northwards from a great gateway dedicated to the goddess Ishtar. For some 180 metres (590 feet) parallel walls flanking the road were decorated with friezes of coloured glazed bricks with representations of sixty striding lions on each wall. On one side of the road the lions had their left foot forward, while on the other their right foot was forward. Louvre Museum AO 21118

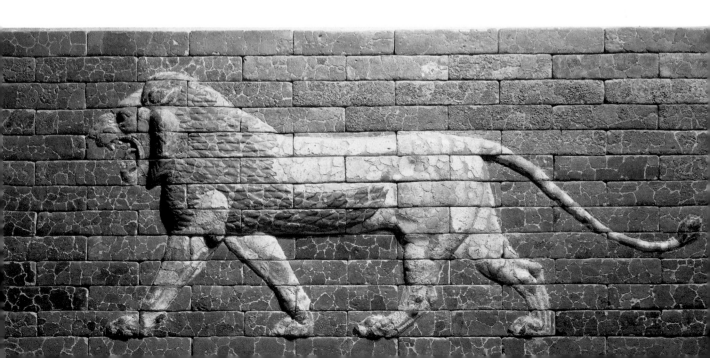

had dominated Egypt in the late eighth and seventh centuries, continued to rule a formidable and wealthy kingdom stretching along the Nile from his capital at Napata. The Egyptians looted temples as they marched as far south as the third or even the fourth cataract but there was no attempt to conquer or govern the region directly.

Psamtek's other interests beyond the traditional borders of Egypt naturally included the eastern Mediterranean. In 592 the Egyptian king marched his forces through the city-states north of the Delta in a show of strength designed to dissuade them from falling into the orbit of Babylon. It may have been an action such as this, in the first year of Psamtek's successor Apries (589–570), which persuaded Zedekiah of Judah to renounce his status as vassal of Nebuchadnezzar. The result was perhaps inevitable: a Babylonian army descended on Jerusalem in 587 and besieged the city for about eighteen months before the walls were breached. Subsequently the other major cities of Judah, Azekah, about 30 kilometres (19 miles) southwest of Jerusalem, and Lachish, about 19 kilometres (12 miles) further on, also fell to Nebuchadnezzar's forces. With no apparent support for Judah from Egypt, Zedekiah was captured and, after being forced to watch the execution of his sons, he was blinded. The Babylonian soldiers rampaged through Jerusalem and the temple was plundered and destroyed. A local aristocrat, Gedaliah, was established by Nebuchadnezzar as governor over the region from the town of Mizpah and hundreds more of the leading individuals of Judah were deported to Babylon, while others fled to Egypt and elsewhere.

Judah was not the only state to oppose Nebuchadnezzar and suffer the consequences. At some point the wealthy island city of Tyre broke away from Babylonian authority. The fact that the main city was on an island had long presented would-be conquerors with formidable challenges, and later accounts claim that it took an incredible thirteen-year siege before Tyre was incorporated into the Babylonian empire. Although initially Tyre retained its local ruler after it fell to Nebuchadnezzar, when its king Ba'al III died in 564 the Babylonians imposed governors rather than a king to replace him.

While Nebuchadnezzar managed through force of arms to hold together the vast territories which had once constituted the Assyrian empire, the Medes, who had been fundamental in its conquest, remained a loose confederation dominating the region from western Iran towards central Anatolia. The numerous tribes recognized the ruler of Ecbatana as paramount chief and, united behind him, they represented a significant power. It was towards their territories that Alyattes (610–560) of Lydia was expanding his control. Having besieged and captured the Greek city of

This Babylonian cuneiform tablet summarizes the principal events of each year from 605 to 594. It refers to the campaigns of Nebuchadnezzar II, including his march westwards in December 598, to confront Jehoiakim, the king of Judah, who had stopped paying tribute. Nebuchadnezzar's army besieged Jerusalem and captured it on 15/16 March 597. The new king of Judah, Jehoiachin, was captured and carried off to Babylon. ME 21946

This is one of a group of letters written on ostraka (pot sherds) found near the main gate of Lachish in a burnt layer associated with the destruction of the city by the Babylonians in 586. Written in ink in alphabetic Hebrew, it is from an officer named Hosha'yahu to Ya'osh, military commander at Lachish: 'To my lord Ya'osh. May Yahweh cause my lord to hear the news of peace, even now, even now. Who is your servant but a dog that my lord should remember his servant?' ME 125

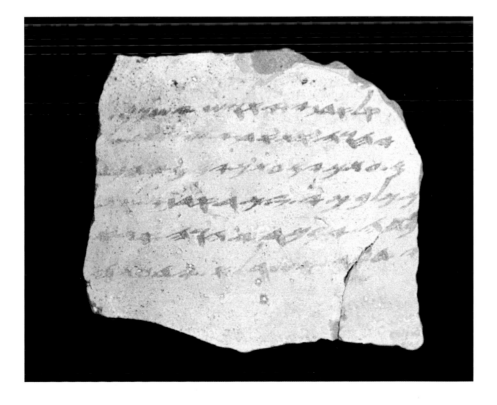

Smyrna, he ruled the richest and most powerful kingdom of Anatolia and now turned to incorporate the remnants of the kingdom of Phrygia into his realm. Lydian forces marched into Cappadocia and thereby penetrated areas dominated by the Medes. War broke out and for six years the two sides confronted each other in skirmishes and major battles. The war appeared unending, but in May 585, as a battle raged, a solar eclipse took place. This was interpreted as a divine message and the warring parties, fearing that it was a bad omen, drew apart. Ultimately, a peace was negotiated by Nebuchadnezzar and his client ruler of Cilicia; the treaty was sealed by the marriage of the daughter of Alyattes to a son of the new Median overlord Astyages.

International relations were by this time revolving around the four great powers that had divided much of the region: Babylonia, Media, Lydia and Egypt. Egypt's strength was partially reliant on its impressive navy. In the years around 574 Apries had used the fleet to launch a series of campaigns against Cyprus and Phoenicia. Egypt's maritime interests inevitably brought it into greater commercial competition with Phoenician and Greek city-states, which led to conflict. On the coast of Libya the Greek colony of Cyrene, which had been established around 630, was extending its power and threatening the authority of the local Libyan leader, who appealed to Apries for help. In 571 an Egyptian army led by general Ahmose was sent against Cyrene. The result was utter defeat for the Egyptian forces, and they mutinied against Apries; the powerful class of Egyptian warriors had come to resent the growing use of Greek and Anatolian soldiers. General Ahmose declared himself king. Apries fled and appealed to Babylon for help. In 567, sensing an opportunity to take advantage of the political problems in Egypt, Nebuchadnezzar sent an army to reinstall Apries as his puppet ruler. However, the Babylonian expeditionary force was beaten and Apries was killed. Ahmose legitimized his position as king by having Apries buried in Sais, as befitted a monarch. The new Egyptian ruler then defused the native soldiers' resentment against Greek mercenaries and traders by ordering that in future all Greek trade be restricted to the settlement of Naucratis.

Political stability and the management of trade brought immense wealth to Egypt under Ahmose. Indeed, there was a period of relative calm across the entire Near East thanks to the remarkable achievements of Nebuchadnezzar in holding the Babylonian empire together. Its solidity was maintained even when there was a rapid change of rulers at Babylon following Nebuchadnezzar's death in 562: his son Amel-Marduk reigned just two years before he was assassinated by his brother-in-law Neriglissar (559–556). There were attempts to extend the empire with campaigns as far

as the Lydian border in western Cilicia, which was brought under Babylonian control, but after just three years Neriglissar died. His son Labashi-Marduk, probably just a child, was accepted as king by only a few of the Babylonian cities and he survived for about a month before being killed in a conspiracy of Babylonian nobles. Out of these bloody intrigues Nabonidus (555–539) emerged to claim the throne. Although not related to the royal family, he was an experienced soldier and was probably in his sixties, with a grown son (Bel-shar-usur, the biblical Belshazzar). The new king faced opposition from some of the major Babylonian cities, but he presented himself as a traditional ruler by installing his daughter at Ur as high priestess of the moon god Sin, a deity to whom he was particularly committed. In Syria Nabonidus had the temple of the moon god rebuilt at Harran, which had lain in ruins since the Medes and Babylonians had wrested it from the Egyptians in 610. It is possible that the king's actions created disquiet in Babylon among the priests of the national god Marduk – these priestly scholars were recognizing deities like Sin only as aspects of Marduk (in a form of monotheism), and they may not have welcomed the focus of Nabonidus' devotions. However, any opposition to the king, reflected in later anti-Nabonidus propaganda, may have related to his lack of participation in the important cultic rituals in the capital. Having concluded that his presence in Babylon was unnecessary, Nabonidus left his son Bel-shar-usur as ruler in the city. The king meanwhile established himself in northern Arabia for ten years. This was considered the act of a madman by later writers, but it may have been an attempt by Nabonidus to stabilize relalations with Arab tribes that were both disrupting and controlling crucial trade routes linking the central Persian Gulf and the Mediterranean.

Although the Babylonians had claimed Susa as a prize under Nebuchadnezzar, there was apparently no attempt to maintain firm control over the city, and the small states that had developed within the eastern mountains following the weakening of Elam posed few problems. However, in the southwest of Iran (the modern region of Fars), the small kingdom centred on the ancient Elamite city of Anshan was extending its power through the mountains under a series of energetic Persian kings. Under Cambyses I (590–559) this expansion presented no immediate threat

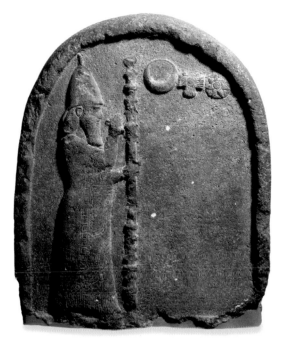

The style of the figure on this basalt stela suggests that it represents the Babylonian king Nabonidus (555–539). Above him are the divine symbols of the moon god Sin (closest to him and larger than the others), the planet Venus of Ishtar and the winged disk of the sun god Shamash. MF 90837 (1825.5-3.99)

either to the Babylonians or to the Medes, with whom the Persians had close cultural and probably dynastic relations. However, the Persians rapidly burst on to the international scene under Cambyses' son Cyrus II (559–530). By the end of his first decade on the throne it is possible that Cyrus had extended his rule over Susa and thus controlled much of what had been Elam. The small kingdom had become a significant potential threat.

It is unclear whether it was the Persians or the Medes who made the first hostile moves, but conflict broke out between the two powers. Cyrus commanded a formidable force and, around 550, the Median army rebelled against their king Astyages and handed him over to the Persians, who marched to the Median royal centre of Ecbatana and carried off its riches – the city, which straddled one of the most important trade routes across Iran linking Central Asia and Afghanistan with Iraq and the west, had grown immensely wealthy. By dominating Ecbatana, Cyrus claimed authority over the various Median tribes, and thus the Persians came to control their vast territories stretching from western-central Iran to central Anatolia.

With the Medes distracted by events in Iran, the Lydian king Croesus (around 560–547) saw an opportunity to extend his power and no doubt his treasury. Thanks to the conquests of his father Alyattes, Croesus controlled all of Anatolia west of the river Halys with the exception of the kingdoms of Caria and Lycia. He had developed close political relationships with Babylonia, Egypt and Sparta, which represented a reinvention of the international club. Lydian dealings with the Ionian islands and the city-states of the Greek mainland were especially close and Croesus became famous among them for his immense wealth. He dedicated enormously rich offerings to the god Apollo at the sanctuary at Delphi and contributed to the rebuilding of the great temple of Artemis at Ephesus. It is also possible that during his reign the first gold coins were minted. Greeks flocked to his court, including the Athenian aristocrat Solon.

In the early 540s, as part of his expansionist aims, Croesus crossed with his armies into Cappodocia but had not counted on the remarkable ability of Cyrus to defend what were now Persian territories. Around 547 the Lydian forces clashed with a Persian army at Pteria. Although there was no clear outcome in the battle, with the advance of winter and the end of the campaigning season Croesus disbanded his army and withdrew to his capital, Sardis. Lydia now looked for support from among its allies. Such an alliance would have presented a formidable coalition and Cyrus, aware that time was not on his side, did not withdraw but marched to Sardis. Croesus quickly reformed his army, but the ensuing battle forced

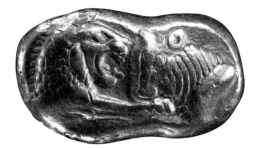

above
Because of his legendary wealth, the earliest coins to be issued in gold have often been attributed to Croesus (about 560–540). This coin, which dates to around 550, may be an example of a gold coin that ancient writers called a croesid.
CM RPK,p146B.1

left
This face is one of the most beautiful of the surviving fragments from the Archaic temple of Artemis at Ephesus dating to about 550–520. The features are east Greek Archaic in style, with fleshy cheeks, a broad nose, long thin lips turning up at the outer edges and long, almond-shaped eyes.
GR 1873.5-5.43 (Sculpture B 89)

the Lydians behind the walls of their capital. The Persians besieged Sardis for two weeks before it fell and, like Astyages a few years earlier, Croesus probably became an honoured guest at the court of Cyrus. It took considerable force for Cyrus to gain control of the whole of western Anatolia. He had tried to buy support from the Ionian islands during his campaign against Croesus, but they had refused to join him. Following the fall of Sardis, some of the Ionian islands revolted under a local official called Pactyas, whom Cyrus had appointed as treasurer. The Persian general Mazares crushed the rebellion, and his successor Harpagus conquered the Greek cities of Caria and Lycia. The wealth of Anatolia was now available to Cyrus and he transported to Persia local materials and artists, possibly including stonemasons working on the unfinished temple of Artemis at Ephesus. In the heart of his homeland he began the construction of a royal centre, Pasargadae (perhaps meaning 'the Persian settlement' and, according to later tradition, established at the place where Cyrus defeated Astyages). Pasargadae was laid out with palaces containing columned halls and porticoes and surrounded by gardens with watercourses. Stone door jambs and other elements were carved with images of guardian figures which drew on Elamite, Egyptian and Assyrian prototypes.

The conquest of Anatolia by Cyrus must have been viewed with alarm by Croesus' allies. Supported by his strong navy as well as Carian and Greek soldiers, the Egyptian king Ahmose reacted to Persia's growth by extending his control over Cyprus: the various kingdoms of the island remained relatively independent but the increased use of Egyptian elements in Cypriot art reflected their subjugation. Ahmose also established relationships with some Greek states, sending rich gifts to sanctuaries including financing the rebuilding of the temple of Apollo at Delphi after its destruction by fire in 548. Such public works were also being undertaken by the autocrats ruling some of the Greek states as an effective way of developing a sense of local pride and unity. In Attica, for example, the economic, cultural and architectural development of Athens was promoted by Pisistratus, who became tyrant on a number of occasions between 561 and 528.

However, it was not Egypt but Babylonia that was the first major power to confront the Persians following the fall of Sardis. Tensions between the Persians and Babylonians had probably already led to hostilities, perhaps over the region of Susa, but now they reached a peak. The two armies met at Opis, east of the Tigris, some time in late September or early October 539, along the traditional route taken by earlier Elamite invaders of Babylonia. Cyrus forced the Babylonian army to withdraw and

This painted terracotta head from the statue of a worshipper comes from the Sanctuary of Apollo at Tamassos on Cyprus and dates to around 600. It is in true Cypriot style but has a Near Eastern type beard. GR 1910.6-20.1

the Persians plundered Opis, massacring the inhabitants. The city of Sippar surrendered to Cyrus and the Persian general Gobryas led his troops to Babylon, where the gates were opened to them and Nabonidus was taken prisoner. Cyrus now made a triumphal entry into the city and, in the tradition of earlier Mesopotamian kings, had himself presented as overturning the disasters, imagined or otherwise, of the previous reign and restoring the order demanded by the god Marduk who supported him. This included generous donations to the temples, the release of people from debt and the return of deportees. Among the latter were some of the aristocrats and their followers whose families had originated in Judah but had been deported by Nebuchadnezzar. They sought to return to Jerusalem, re-establish their positions and rebuild the temple – the foundations of which were eventually laid in 535. The importance of Babylon for the Persian ruler, symbolically as well as politically, was emphasized when Cyrus appointed his son Cambyses as king in 538/7 (just as Nabonidus had earlier established Bel-shar-usur as ruler in the city). However, after a year the arrangement was abandoned and the territories of Babylonia became a vast province under a Persian governor.

With Babylonia secure, Cyrus now turned his attention to the vast eastern borders of his realm. Here important routes crossed Afghanistan and the steppe lands of Central Asia along which flowed people and materials. It was while campaigning in this direction, possibly against the horse-riding nomadic people of the region, that Cyrus was killed in 530. His body was brought back to Pasargadae and interred in a magnificent stone tomb set on a stepped platform created under Ionian and Lydian influences and workmanship. The great conqueror was succeeded by his son Cambyses

(529–522) who, having consolidated his position on the throne, turned to face the one member of the international club that had survived the remarkable conquests of his father – Egypt. It was perhaps inevitable, considering Egypt's wealth and its long-standing ambitions in the eastern Mediterranean, that Cambyses would need to contain or conquer the country. The Egyptian king Ahmose also posed a threat to Persia because he had established relations with powerful allies such as Polycrates, who by 535 had emerged as tyrant of the island state of Samos. Egyptian and Samian strength lay in their fleets of powerful ramming triremes; their development transformed naval warfare for centuries. Gifts of friendship were exchanged between the two rulers and, perhaps with the financial assistance of Ahmose, Polycrates extended his authority across the eastern Aegean islands and became a threat to Persian domination over the Greek cities of the Anatolian coast.

Cambyses devoted the early years of his reign to preparations for the coming conflict. Persia's enormous power and resources gradually peeled away Ahmose's supporters; the kingdoms of Cyprus were brought under Persian authority. To counter his opponents at sea, Cambyses created a navy, calling upon the expertise of the Phoenicians whose cities retained considerable autonomy because of their strategic maritime importance. Indeed, Tyre's own fleet would provide crucial assistance to the Persians. Meanwhile, negotiations with Arab tribes successfully provided a safe crossing of northern Sinai for Persian troops.

The trigger for the confrontation may have been the death of Ahmose in 525. He was succeeded by his son Psamtek III, and the haemorrhaging

This clay cylinder is inscribed in Babylonian cuneiform with an account by Cyrus II (559–530) of his conquest of Babylon in 539. Cyrus claims to have achieved this with the aid of Marduk, the god of Babylon. He then describes measures of relief he brought to the inhabitants of the city, the restoration of its temples and cults, and how he allowed a number of people deported by the Babylonians to return to their homelands. This cylinder has sometimes been described as the 'first charter of human rights', but it in fact reflects a long tradition in ancient Iraq where rulers began their reigns with declarations of reforms, and this convention was adopted by the Persian king to demonstrate his right to rule. ME 90920

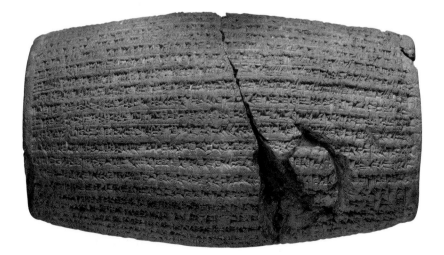

of Egyptian allies continued as a Persian conquest appeared increasingly inevitable. Polycrates of Samos switched sides, offering Cambyses naval support, and Psamtek also experienced defections from among his foreign soldiers. None the less, Egypt remained a significant power and Psamtek gathered his forces on the easternmost branch of the Nile where the city of Pelusium acted as a gateway to the country. Here a major confrontation took place, but after ferocious fighting Pelusium was taken by the Persians and the Egyptians withdrew to Memphis. It is possible that the admiral of the Egyptian navy, Udjahor-Resnet, abandoned Psamtek, since Persian ships were able to penetrate the Delta to the very walls of Memphis. On one of the boats was the Persian herald, who demanded that the city should surrender. However, he was attacked and killed along with his crew. Memphis was placed under siege by the Persians and eventually fell to them. Psamtek was captured, Cambyses entered the ancient capital of Egypt and a Persian garrison was installed in the city. The Libyans and Greeks of Cyrene now sent gifts of loyalty to Cambyses, who presented himself as a model Egyptian king through such acts as burying the sacred Apis bull with traditional ceremony. Persian troops were sent south through the country to ensure control and pressed forward into Kush to prevent any Nubian incursions and stabilize relations with the king of Napata.

The extraordinary conquests of Cyrus and his son made them masters of a region stretching from the Aegean and Egypt to eastern Iran and Central Asia, but their position was vulnerable from powerful factions within the Persian nobility. In 522 news of a rebellion in Persia forced Cambyses to leave Egypt. At the Persian court his brother Bardiya, who had possibly tried to seize the throne, was killed, but, as Cambyses crossed Syria on the way to confront the rebels, he also died. The true nature of the two men's deaths is unclear, since the details are shrouded in an elaborate story which was later disseminated throughout the empire, perhaps to cover the tracks of the rebels. This account asserts that just before Cambyses died he admitted that he had arranged for Bardiya to be secretly killed. Taking advantage of the situation, an impostor called Gaumata, who bore a striking physical resemblance to Bardiya, declared that he was Cambyses' brother and claimed the Persian throne. This deception was recognized by a Persian noble, Darius, who killed Gaumata and, having demonstrated his worth by recognizing the lie, became king. In reality it is possible that Darius had conspired against both Cambyses and Bardiya. The new ruler, who was not a member of the royal family, was immediately faced by a series of major rebellions which threatened to fragment the empire. While many countries sought independence from

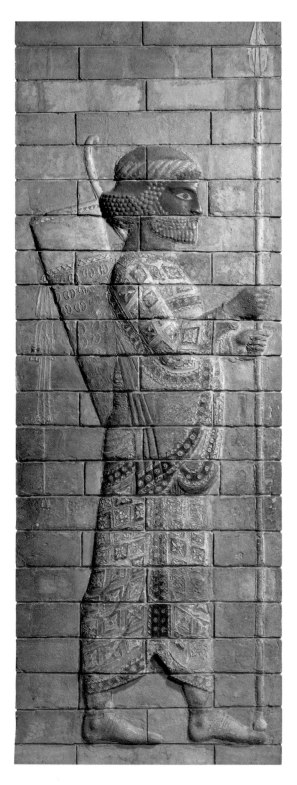

Persian rule, other regions, including Persia itself, probably reacted negatively to a man they perceived to be a regicide and usurper.

However, Darius had substantial support from among the nobility and for over a year their command of considerable forces crushed the uprisings. Among the Persian officials who saw opportunities for extending their own authority was the governor of Sardis. He eliminated Polycrates of Samos but was eventually executed for insubordination to Darius. By 519 the entire region from Egypt to Iran had been brought back under Persian rule. Darius commemorated this great triumph with a huge relief carved on a cliff face at Bisitun, overlooking the main route leading from the Iranian plateau to the plains of Babylonia. He had himself depicted crushing the prostrate Gaumata under his foot, with representatives of the rebellious people roped together at the neck before him (thus adapting a Babylonian image of kingship known from reliefs dating as early as the third millennium). Accompanying the relief was a cuneiform inscription with an account in Elamite of Darius' rise to power and his military successes. To this was later added a version written in Akkadian (the ancient language of Babylonia) and Persian.[1] The latter inscription was written in a cuneiform script developed under Darius and disseminated through the empire to strengthen its Persian character.

There had been several rebellions in the region of Elam, but with Darius' final victory he chose the ancient city of Susa as his royal centre. Here was constructed a huge palace and *apadana* (columned hall). The palace was modelled on earlier Assyrian and Babylonian

1 This trilingual inscription proved instrumental in the decipherment of the cuneiform script during the nineteenth century AD.

examples and was decorated with panels and scenes made from plain and glazed bricks. The buildings were approached through a monumental gate, where an over-lifesize statue of the king brought from Egypt was positioned.

With the entire region that had once formed the international family of powers united under Persian rule, Darius, like Cyrus before, now turned his attention to the fluid and volatile boarders of Central Asia. The Persian armies marched against the Saka-Scythians whose king, Skunkha, was captured – his image was added to the Bisitun monument. Perhaps soon after this campaign, or as an extension of it, Darius pushed on to the Indus Valley and incorporated much of the region into his empire. Other campaigns were directed against other borders. In the west, the Persian hold over Libya was consolidated and, around 513, a major expedition was launched to establish a border with the Scythians of Europe – a bridge was constructed over the Bosporus and the Persian army conquered Thrace.

The small Greek states now lay in the shadow of the mighty empire. Sparta remained the most powerful militarily and had established itself as the leader of an alliance which embraced nearly all the states of the Greek Peloponnese. The leaders of the other city-states disagreed on compliance or opposition and politicians turned for support to either Sparta or Persia. In Athens, for example, Hippias, the son of Pisistratus, continued the tyranny after his father's death in 528, but with encouragement from Athenian aristocrats in exile, Sparta successfully invaded Attica in 510 and Hippias fled into exile in Persia. In the ensuing vacuum a leading aristocrat, Cleisthenes, sought power through the support of the wider population. To maintain his authority Cleisthenes built on the existing system of government by developing one based on direct participation by as many adult male citizens as possible – by 500 a partial democracy had been created. Further west, the Roman Republic was established around 509, when the last king of Rome, Tarquin the Proud, was deposed, and a system based on annually elected magistrates was established. Two systems of government thus stood in clear contrast to a large proportion of the world united under the absolute rule of the Persian king.

While new forms of government were developing on the western edges of the Persian empire, Darius set about consolidating his vast realm. His lands were divided into administrative regions which mirrored to some extent the territories of the earlier kingdoms; their borders were changed as conditions dictated. The governors of provinces were appointed by the king and described by the Persian title 'protector of the kingdom', which was adapted into Greek as 'satrap'. It was the duty of each satrap to collect the regularized taxation and tribute from within his province (satrapy). To

Polychrome glazed bricks, of which this is one panel depicting a royal guard, lined the walls of a courtyard in the palace built by the Persian king Darius I (521–486) at Susa. According to an inscription at Susa, the artisans who made the brick panels came from Babylonia where there had been a long tradition of this sort of architectural decoration. ME 132525

Many statues of men and women lined the so-called Sacred Way
of the temple of Apollo at Didyma, which was among the richest
sanctuaries in the east Greek world during the period 600–480.
This male figure can be identified from the Greek inscription on
the right side of the chair which states: 'I am Chares, son of
Kleisios, ruler of Teichioussa, the statue belongs to Apollo.'
GR 1859.12-26.5 (Sculpture B 278, Inscription 933)

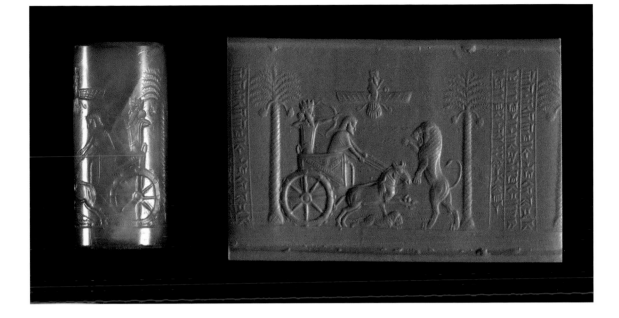

facilitate communications across the empire, the network of dirt roads with hostels and stopping places that had already been well established in the Assyrian empire was expanded; royal roads were broad enough for hunting and war chariots, the best-known road stretching from Susa to Sardis. Rivers were crossed by bridges and major works were undertaken, such as the completion of the canal started by Necho II of Egypt between the Nile and the Red Sea. Commerce was further encouraged by the expansion in the use of coinage and so-called 'darics' and 'sigloi' were minted in the western half of the empire. Aramaic was the written language of administration and used throughout the empire, although the notion of the empire's diversity was recognized in the use of multilingual inscriptions on royal objects and monuments.

In Persia itself, Darius established a new dynastic centre some 30 kilometres (18 miles) southwest of Pasargadae. It was called Parsa; the Greeks named it Persepolis. The complex of palaces was built on an artificial stone platform measuring about 455 metres (1490 feet) by 300 metres (985 feet). The greatest of the buildings included the Apadana, which took thirty years to build. Its main hall contained columns 20 metres (65 feet) in height, while the nearby Hall of a Hundred Columns was large enough to accommodate thousands of people. Stone sculptures and reliefs decorated many of the doorways and staircases and, as at Pasargadae, much of this was accomplished by Greek and Lydian craftsmen. A stairway leading to the Apadana was decorated with stone reliefs depicting rows of

Said to have been found in a tomb at Thebes, Egypt, this agate cylinder seal is engraved with a scene showing the Persian king standing in a chariot and shooting arrows at lions. The cuneiform inscription written along one side is in three languages – Old Persian, Elamite and Babylonian – and translates 'Darius the great king', presumably Darius I (521–486). ME 89132

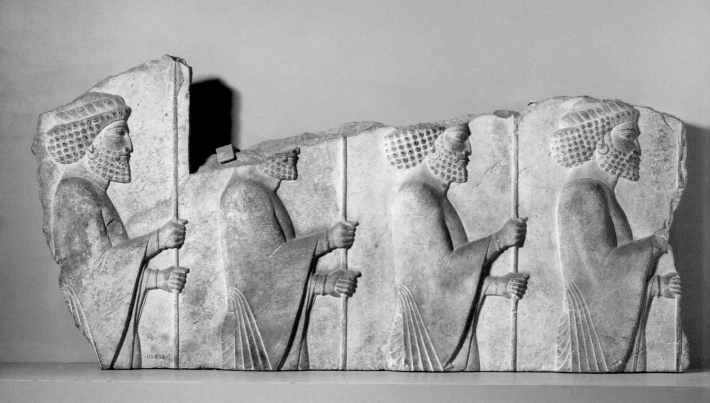

Persian nobles, guards and attendants. Other reliefs designed to express the extent of the empire included people from twenty-three regions bringing presents and tribute or supporting the king's throne. This notion of an empire of diverse people united under the Persian king was a central feature of royal ideology. It presented an image of a harmonious, multinational enterprise that covered some 7,500,000 square kilometres (2,900,000 square miles) from Libya and Thrace to Central Asia and India. Building on the accomplishments of the international age, Darius had created a union of varied peoples and cultures that would survive largely intact for nearly two centuries. This truly remarkable achievement was acknowledged from the foundation of the empire as illustrated by the words carved on the façade of the king's tomb:

I am Darius the great king, king of kings, king of countries containing all kinds of men, king of this great earth far and wide.

This relief from Persepolis depicts a row of guards that may represent the 'immortals' who made up the king's personal bodyguard. It comes from the north side of the east wing of the Apadana, where the figures decorated a staircase. ME 118838

Further Reading

Bryce, T., *The Kingdom of the Hittites* (Oxford, 2005)

Bryce, T., *The Trojans and their Neighbours* (London and New York, 2006)

The Cambridge Ancient History, vols 2–4 (Cambridge, 1973–92)

Chavalas, M. (ed), *The Ancient Near East: Historical sources in translation* (Oxford, 2006)

Curtis, J.E. and Reade, J.E. (eds), *Art and Empire: Treasures from Assyria in the British Museum* (London, 1995)

Curtis. J.E. and Tallis, N. (eds), *Forgotten Empire: The world of Ancient Persia* (London, 2005)

Dickenson, O., *The Aegean Bronze Age* (Cambridge, 1994)

Dickenson, O., *The Aegean from Bronze Age to Iron Age* (London and New York, 2006)

Fitton, J.L., *Minoans* (London, 2002)

Hallo, W.W. and Younger, Jr, K.L. (eds), *The Context of Scripture*, 3 vols (Leiden, 2003)

Kuhrt, A., *The Ancient Near East*, vols I and II: *c.*3000–330 BC (London and New York, 1995)

Manning, S. W., *A Test of Time: The volcano of Thera and the chronology and history of the Aegean and east Mediterranean in the mid-second millennium BC* (Oxford, 1999)

Markoe, G.E., *Phoenicians* (London, 2000)

Moran, W.L., *The Amarna Letters* (Baltimore and London, 1992)

Osborne, R., *Greece in the Making 1200–479 BC* (London and New York, 1996)

Potts, D.T., *The Archaeology of Elam: Formation and transformation of an ancient Iranian state* (Cambridge, 2004)

Reade, J.E., *Assyrian Sculpture* (London, 1999)

Roaf, M., *The Cultural Atlas of Mesopotamia and the Ancient Near East* (Oxford and New York, 1990)

Schofield, L., *The Mycenaeans* (London, 2007)

Shaw, I. (ed.), *The Oxford History of Ancient Egypt* (Oxford, 2000)

Tubb, J.N., *Canaanites* (London, 1998)

Van der Mieroop, M., *A History of the Ancient Near East: c.3000–323 BC* (Oxford, 2003)

Walker, C.B.F., 'Mesopotamian chronology', in D. Collon, *Ancient Near Eastern Art* (London, 1995), pp. 230–38

Welsby, D.A., *The Kingdom of Kush: The Napatan and Meroitic Empires* (London, 1996)

Index